6/29/03

Happy Birthday
to my very special
Texas friend "Sharon"!
You are always in
my heart.

Love...
Janice

P.S. Got carried away
and made a mini
picture album in
addition to the profession
photos. 😊 JT

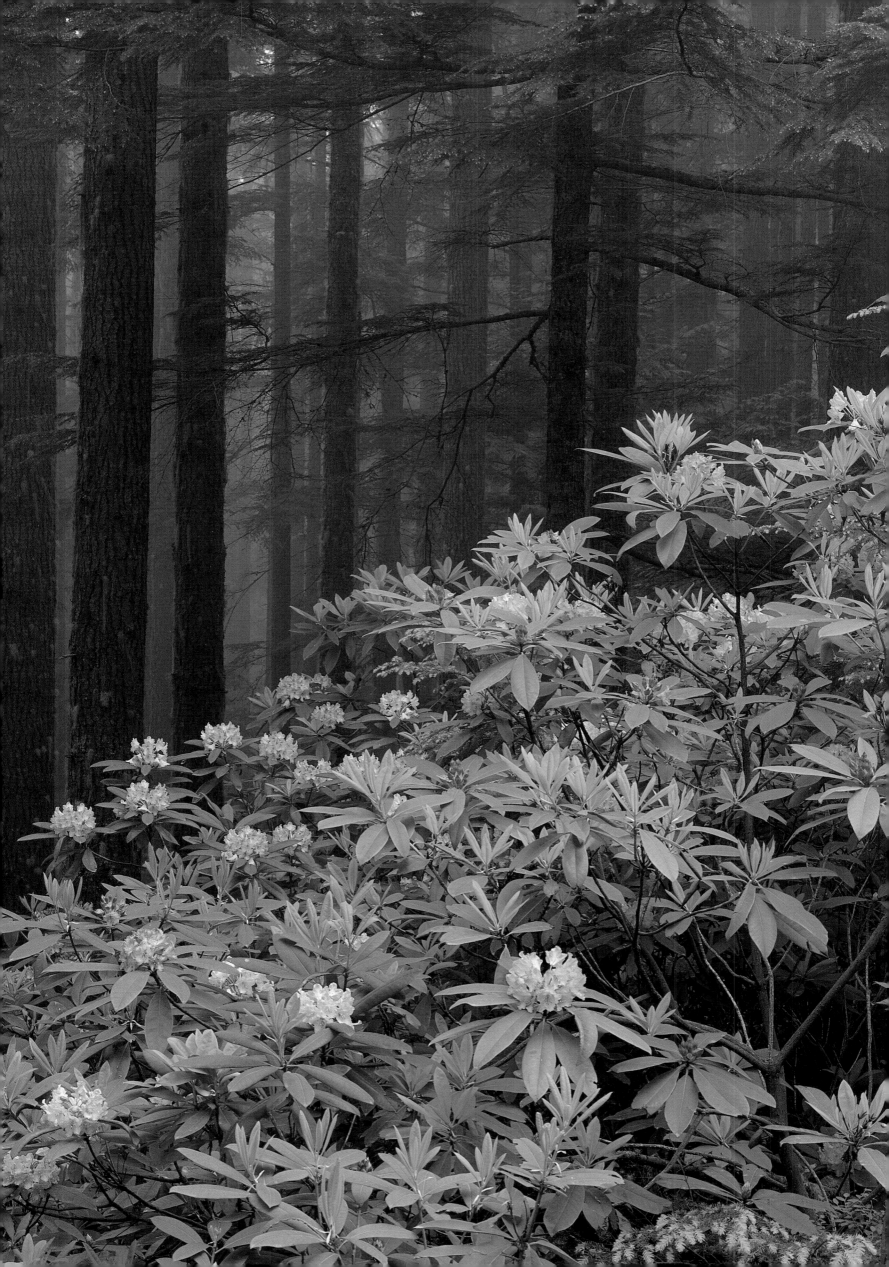

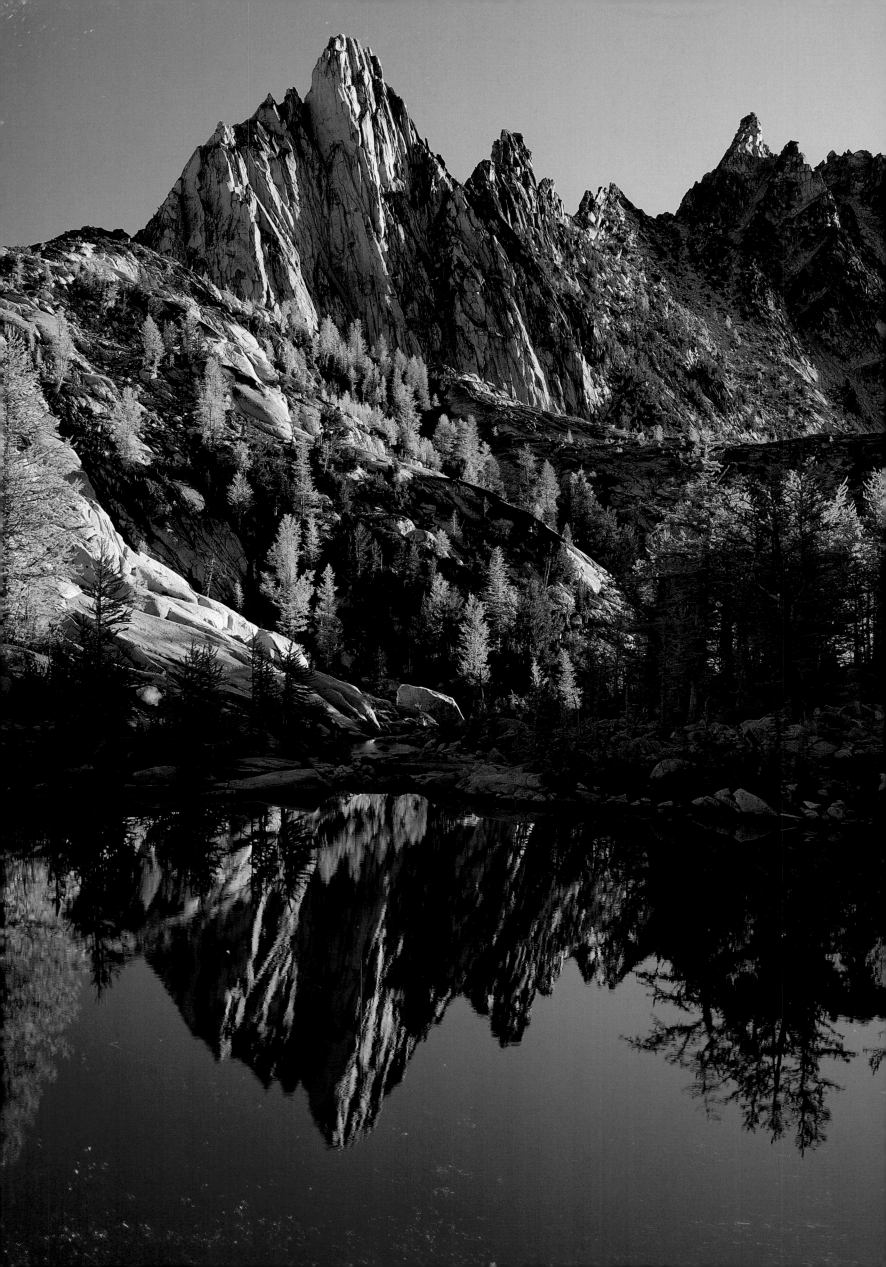

WASHINGTON II

PHOTOGRAPHY BY JOHN MARSHALL

ESSAYS BY
ROB CARSON
PETER POTTERFIELD
JEANETTE MARANTOS

GRAPHIC ARTS CENTER PUBLISHING®

Library of Congress Cataloging-in-Publication Data
Marshall, John, 1951–
 Washington II / photography by John Marshall ; essays by Rob Carson,
Jeanette Marantos, Peter Potterfield.
 p. cm.
 ISBN 1-55868-464-6
 1. Washington (State)—Pictorial works. I. Title. II. Title: Washington two.
F892.M27 1999
979.7'0022'2—dc21 98–54905
 CIP

President • Charles M. Hopkins
Editorial Staff • Douglas A. Pfeiffer, Ellen Harkins Wheat, Timothy W. Frew,
Diana S. Eilers, Jean Andrews, Alicia I. Paulson, Deborah J. Loop, Joanna M. Goebel
Freelance Editor • Don Graydon
Production Staff • Richard L. Owsiany, Lauren Taylor
Designer • Robert Reynolds
Cartographer • Tom Patterson and Manoa Mapworks
Book Manufacturing • Lincoln & Allen Company
Printed and Bound in the United States of America

■ *Page 1:* Blossoms of Pacific rhododendron light up a foggy day on Mount Walker in Olympic National Forest, south of Quilcene.
■ *Frontispiece:* Prusik Peak soars above Sprite Tarn in the high-mountain basin of the Enchantment Lakes, near Leavenworth.
■ *Opposite page:* A field of ripe wheat stands ready for harvest in the rolling farmland of the Palouse country, north of Pullman.
■ *Pages 8-9:* Silhouetted sea stacks dominate a sunset view from Shi Shi Beach at Point of the Arches in Olympic National Park.

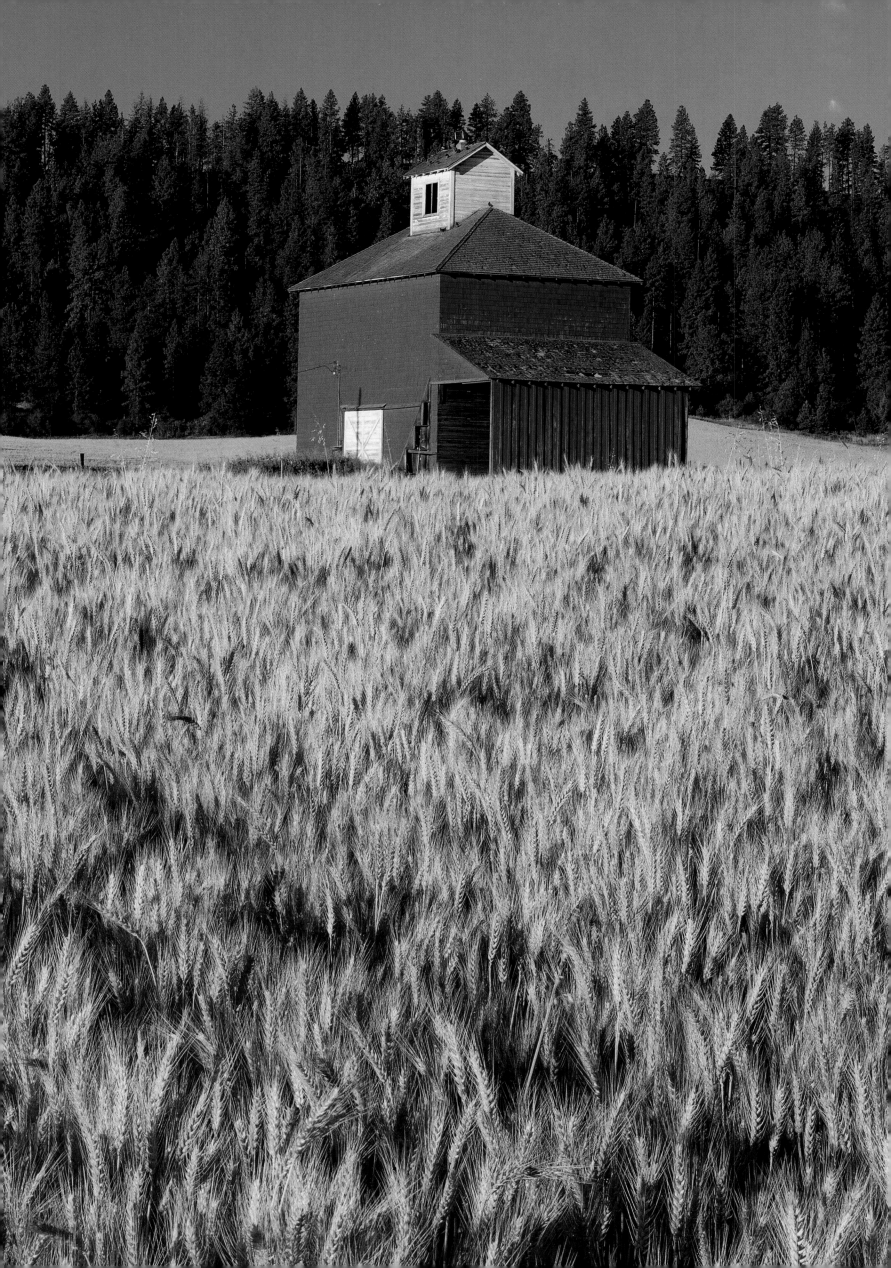

WASHINGTON

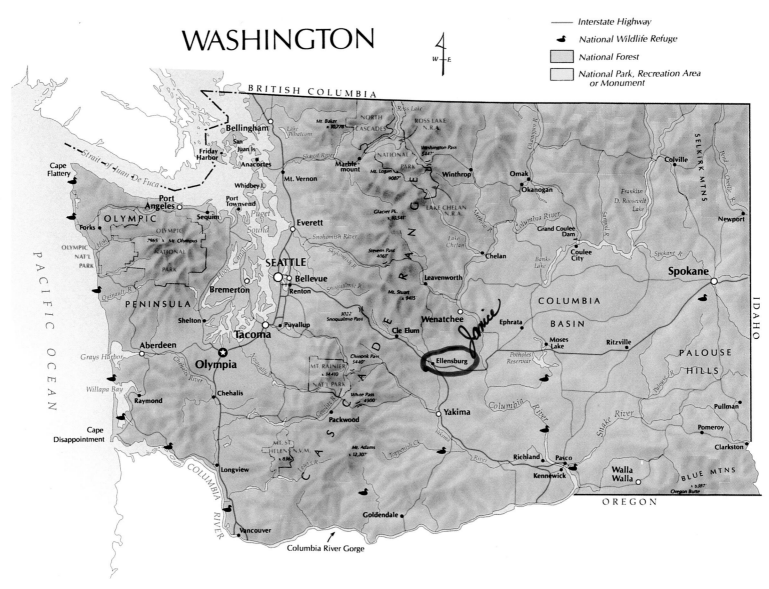

State capital: Olympia

Nickname: The Evergreen State

State motto: *Alki* (Indian word for "bye and bye")

State song: "Washington, My Home"

State flower: Coast rhododendron

State bird: Willow goldfinch

State tree: Western hemlock

Statehood: November 11, 1889, the forty-second state

Area: 68,126 square miles, including 1,545 square miles of inland water

Coastline: 157 miles

Elevation: Highest point at Mount Rainier, 14,410 feet; lowest point along the coast, sea level

Contents

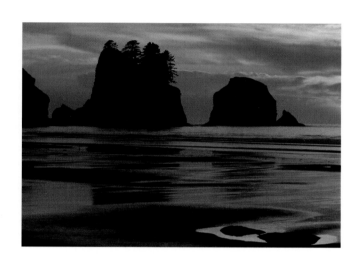

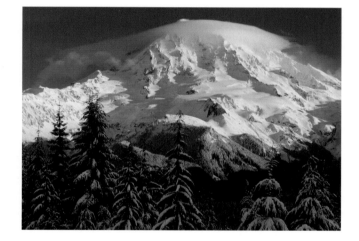

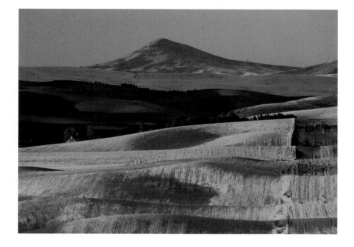

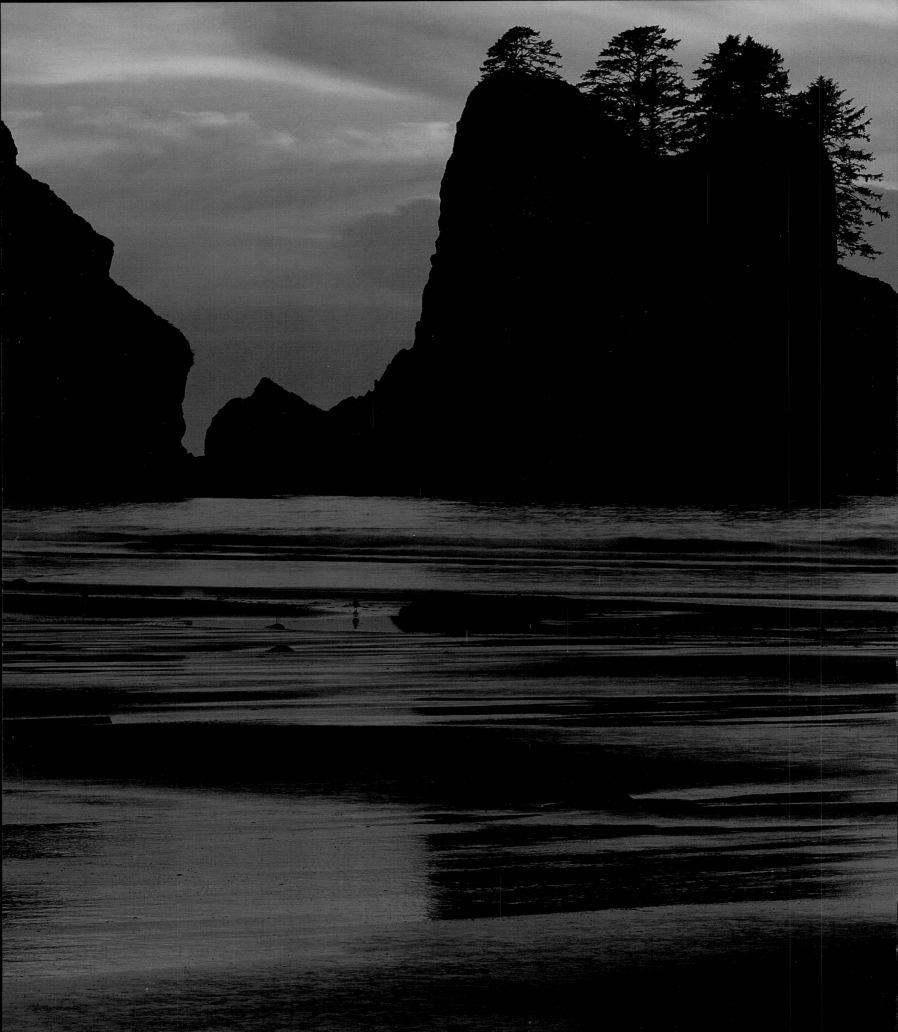

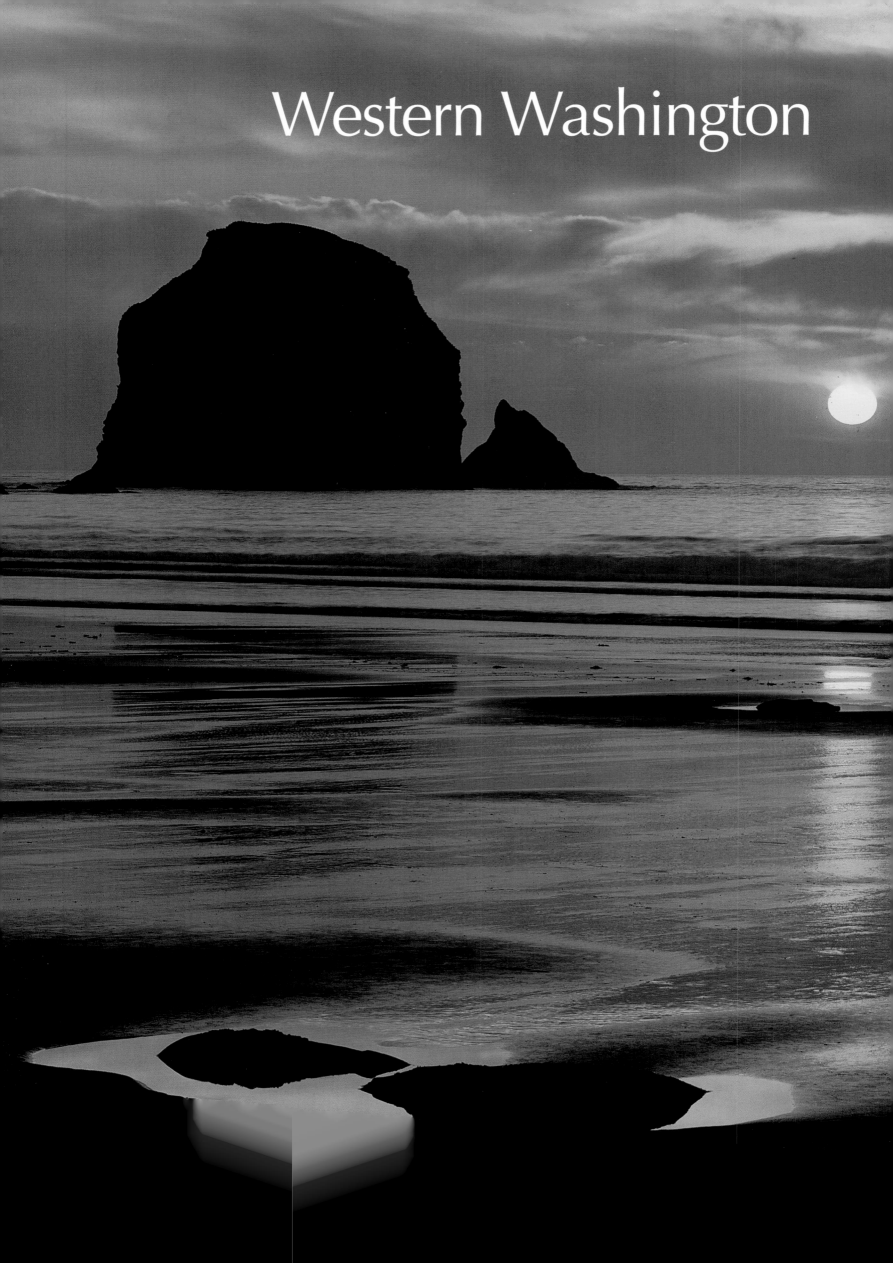

Western Washington

Riding the Currents
by Rob Carson

On the spur of the moment, I decide it's a good day for a boat ride. I walk down to the beach and untie my kayak from the big tree.

It's been a while, so I have to peel back the slugs and clear out spider webs. I carry the little boat under one arm, trailing the rope behind me.

At the water's edge I squeeze into the cockpit and, pushing with my paddle, crunch noisily across the last few feet of gravel. The noise stops when the boat slips onto the water. Everything smooths out. I'm floating again, glad I live where I do.

I'm paddling in Puget Sound, the inland sea that reaches deep into the heart of Western Washington. I'm in Rich Passage, off Bainbridge Island, eighty miles from the Pacific Ocean, fifty miles from Canada, five miles from Seattle's Space Needle, and fifty yards from my front door.

Western Washington is a place blessed with beauty. The land rumples like green fabric between the white walls of the Cascade Range and the Olympic Mountains. Water, everywhere, rushes and rests in heavenly rhythm.

The views are so dramatic they can stop you in your tracks. On the Tacoma Narrows Bridge, the sight of water and headlands receding in shades of blue is so mesmerizing it routinely causes traffic jams. On the streets of Seattle, sudden glittering slices of mountains and water seen between skyscrapers make strangers stop and smile.

Mount Rainier, presiding over it all, adds regal repose and power.

The power of nature in the Northwest is part of its appeal. These ocean tides, glaciers, rivers, and volcanoes are the engines that run the earth.

The evidence of the natural world, so close at hand, has a steadying effect. It corrects your perspective; it retunes your internal A-string; it erases the erroneous equations scrawled on the blackboard of your brain.

* * *

In the kayak, I bump over the knobby bulbs of a kelp bed. A great blue heron, feeling too crowded, grudgingly bounds into the air, flapping overhead like a creature from another epoch.

The smell of salt, seaweed, and countless crustaceans drying on the beach is therapy for me. I fill my lungs with the flavor, savoring it like a nourishing stew. As I paddle away from land, the houses on shore shrink to ornaments on the larger landscape of forest, hills, and water.

I round Point Glover, and there is the mountain, hanging in the sky, improbably huge and silent.

Seeing Mount Rainier comes as no surprise; it's the reason I return here again and again. But even so, I am momentarily stunned. For an ecstatic instant, I feel the way I did as a child staring up at the night sky, shocked into humility by the scale of it all.

I get that feeling a lot living here. Other people do, too, according to Patricia O'Connell Killen, a professor of American church history at Pacific Lutheran University. Killen believes Western Washington's spectacular landscapes function something like religious shrines. For some people, she says, nature replaces the need for organized religion. She thinks views like that of Mount Rainier help explain why Washington state has the lowest percentage of churchgoing people in the nation. It's not a lack of spirituality, Killen told me. It's because there's a natural substitute. "You can't look at Mount Rainier and pretend that you are the center of the universe," she said.

Western Washington's original inhabitants were at home with the spiritual aspects of nature. They didn't worship the natural world; instead, they saw themselves as an inextricable part of it. They were participants within the web of life, not caretakers living outside it.

Washington's Native tribes gave the natural world credit for a whimsical, unpredictable character. The spirits that inhabited forests, mountains, lakes, and beaches could be magnanimous or malevolent—depending on circumstances. When provoked, or confronted with hypocrisy or lapses in moral judgment, nature could unleash all kinds of trouble.

In one story, repeated through generations of Western Washington tribes, a greedy man gets wind of a great quantity of Indian shell money, or *hiaqua*, buried under a rock on top of Mount Rainier. Using an elk horn as an ice ax, he climbs to

Olympic marmot

In the years since, the swaths of mud and stumps have been pushed so wide they now span miles, paved in asphalt and covered with the same quick-lube shops, hamburger stands, and shopping malls you find in any other state.

But nature in the Northwest is resilient. After all but the worst affronts, it gamely struggles back, camouflaging the devastation with remarkable speed. The evergreen forest, decimated by settlers, is determined to outlast us all.

In one year, a clear-cut forest becomes a hummocky meadow of fireweed, Indian paintbrush, and huckleberries. Within five years, it is transformed into a thicket of alder trees higher than your head and too thick to walk through. Within thirty years the accommodating alders give way to hemlocks, firs, and cedars. Beneath them they nurture a profusion of mosses and mushrooms and ferns.

Nature is good at recovery because it has had to be. The volcanoes in the Cascade Range have forced a regular cycle of destruction and rebirth. When Mount St. Helens erupted in 1980, it turned hundreds of square miles of Western Washington forest into ash-blown desert littered with broken wood.

I remember watching one of the warning bursts of ash from downtown Seattle, a hundred miles away, staring uneasily with thousands of others as a dark cloud billowed up into the sky like a malevolent cluster of grapes.

I had worked in the old-growth forests surrounding Mount St. Helens during the summer of 1976, tramping up and down mountains with a reconnaissance surveyor. In our calked boots, we moved like Lilliputians through the giant woods, sometimes walking hundreds of feet along the trunk of a single fallen tree, sidestepping mushrooms as big as dinner plates and bushwhacking through head-high ferns.

After the eruption, I went back to the same places and saw the world transformed. The trees were lying flat or had simply disappeared. Along the Toutle River, I walked through what had been people's yards. An ocean of mud had flowed into houses, over bedspreads and into refrigerators. It hardened like concrete. In one backyard, all that remained was a basketball backboard, the orange hoop now just inches from ground level.

Today, in all but the area closest to the crater, it's hard to tell anything like that ever happened. Flower seeds drifted in, birds and insects followed. The forest marched back.

The power of nature and the barely comprehensible scale of its cycles contribute to a healthy humility, a heightened sense of reality. Life in the Northwest is invigorated by the implicit danger.

* * *

I'm ready to float home, so I let go of the buoy, expecting my boat to fly into the current and carry me back to the beach. Instead, it shoots forward a few feet and stops.

The rope I use to tie up the boat has been dragging behind me, and now it's tangled under the buoy. My end of the rope is tied to the back tip of the kayak—too far back to reach. I am stuck.

I use the paddle to try to circle back to the buoy, but the current is too strong. I paddle backward as hard as I can, but I can't even put slack in the rope. It's a ridiculous thing. I am trapped like a rat by the tail.

It seems funny at first. Then, quickly, it doesn't.

I sit for a while, running through my options. There don't seem to be any good ones. My only life preserver is an old, beat-up boat cushion that I use for a backrest. I'm not even sure it will float anymore. Without a life preserver, there's no way I can swim out of the current.

It's too dark for anyone to see me. I'm too far out for yelling to do any good. I think about crawling out onto the back of the kayak to haul on the rope, but I know that once outside I'd probably never be able to get back into the tiny cockpit.

The boat is caught in a standing wave created by the current, and every once in a while the water catches the stern. I have to fight to keep it from jerking under. A Washington state ferry plows by in the dark, and the ice-cold wash from its wake pours over the side of the boat and into my lap.

On shore I see the lights go on in my daughter's bedroom. A few minutes later they go off again. The thought occurs to me that I could die here, in sight of my own house. Then, for no apparent reason, the rope comes free.

I'm floating again, riding the tide and marveling at the miracle of movement without effort. ■

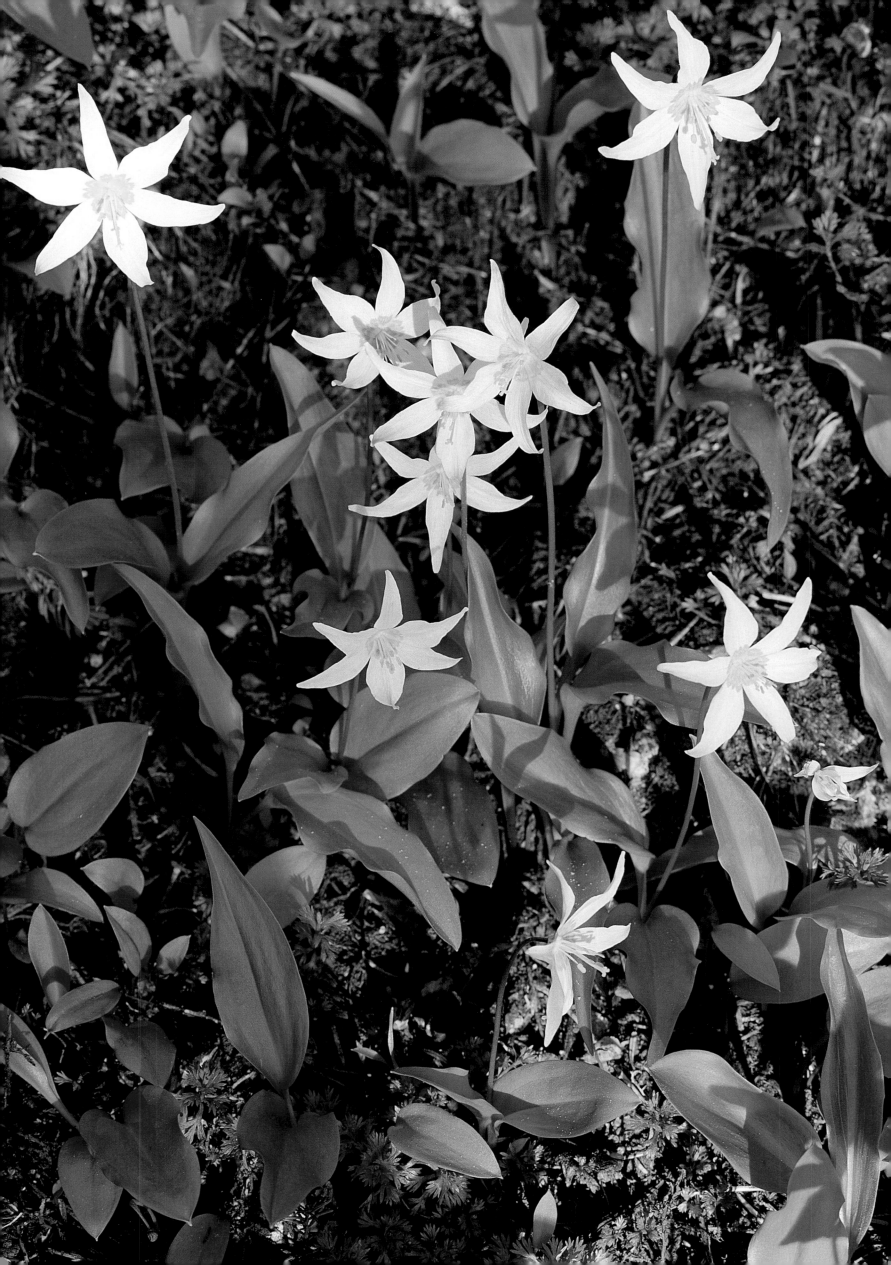

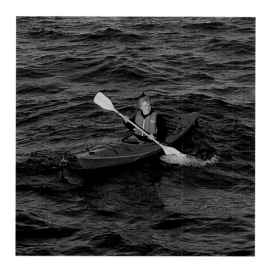

Rob Carson

the summit, where he indeed finds enough shells to make him the world's richest man. He hurriedly starts packing the shells down the mountain, neglecting to leave a thank-you offering to the mountain spirits.

The earth shakes, the mountain explodes with fire, and floods of melted ice pour down the slopes. Above the roar and thunder, the greedy man hears the spirits hissing, *"Hiaqua! Hiaqua! Ha, ha, hiaqua!"*

Nature was to be approached with respect and humility. The Makah people of Neah Bay, for example, on the northwestern tip of the Olympic Peninsula, had elaborate rituals to prepare themselves spiritually for whale hunts. Harpooners soaked for hours in cold water and rubbed themselves with hemlock branches until their skin bled, trying to strengthen their connection with nature.

Micah McCarty, grandson of a Makah harpooner, says the tribe regards the killing and eating of the whale as a necessary, holy part of the cycle of life and death. "That's the magic of the Earth," he said. "It provides life and can take life. When a whale is killed, it is done in the spirit of thankfulness. It's the holy sacrament of the ocean."

That would have sounded like a lot of hokum to Western Washington's white pioneers. Nature appreciation came slow to the colonizers, randy with political notions of Manifest Destiny and with biblical ideas of dominion over the earth. When these newcomers began settling here in the nineteenth century, they thought of the wilderness as something to be overcome. The trees, "as thick as the hair on a dog's back," were overgrown weeds standing in the way of progress.

Seattle's first four white families landed in what is now West Seattle in the cold and wet fall of 1851. The founders at first called their settlement New York "Alki"—the Chinook jargon word for "soon." The pioneers' idea of civilizing the Northwest was to re-create Eastern cities. The ornate Victorian homes they built in the boomtowns of Everett, Bellingham, Port Townsend, Seattle, and Tacoma were positioned for community and commerce, not for the spectacular views of water and mountains. Most often, the houses faced inward, toward one another.

It wasn't until the end of the nineteenth century that the new Northwesterners began to appreciate the splendor around them. Cities began to look outward. There was a new sense that civilization here could surpass the Eastern model by maintaining a connection with the natural world. Mountains and forests began to be regarded as cultural icons, as moving in their way as Europe's cathedrals or New York's Statue of Liberty.

In 1909, when Seattle staged the Alaska–Yukon–Pacific Exposition, the city arranged the architecture of the fair around a view of Mount Rainier. By that time, the Mount Rainier area had been designated a national park. Gradually, Seattle's central district and Tacoma's Hilltop area were left to successive waves of immigrants who couldn't afford better. The wealthy moved to the outskirts, taking advantage of the magnificent views and giving their towns names like Mountlake Terrace and Lake Forest Park.

The nineteenth-century assault on nature that had all but destroyed the region's forests and fish stocks began to be replaced with reverence. Loggers, once folk heroes, eventually were transformed into pariahs in the burgeoning environmental movement. The woods, rather than being merely utilitarian sources of timber, became places of pilgrimage for hikers toting backpacks and cameras.

The power of this place can change people, opening up a clear, peaceful spot in their souls. It changed me that way. I arrived in Washington frazzled from the Army and graduate school. Through a series of flukes I wound up with a job as a backcountry ranger in the Olympic Mountains.

I was an unlikely choice for the job. I didn't own a pack, my boots were military issue, and I could get lost walking around the block. My job was to hike wilderness trails, watching for fires and chatting with backpackers. I was on a 10-4 schedule: out for ten days, in for four, and then out for another ten.

The job was mostly public relations. But after the first few days, I started avoiding people. I stuck to game trails and camped on high ridges. My only regular contact was by radio. Every few days I'd talk to the pilot of a spotter plane cruising high overhead, looking for forest fires.

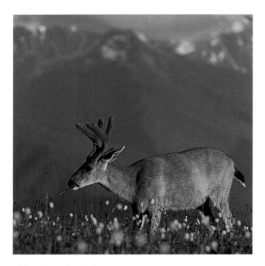

Black-tailed deer

I ate canned sardines and read Gary Snyder poems and talked to myself. I listened to roomfuls of people laughing and gabbing in the sound of the Dungeness River. I skied down scree slopes to hidden lakes. I sat on top of Mount Townsend, gazing out across the Strait of Juan de Fuca to Vancouver Island and across Puget Sound to the Cascade Range.

At the end of the summer I felt like the Tin Man: I had a new heart. And I had a home.

* * *

When I started paddling today, it was slack tide—the regular pause in Puget Sound's tidal pulse. Now the tide is rising, and water is running like a river through the narrows of Rich Passage. There's no way to fight the flow. I could coast home, riding the tide, but I'm not ready yet. I paddle over to a small buoy and hang on, admiring the view as the water rushes by. Behind me, Mount Rainier fades in gathering clouds and darkness.

As I sit there, it starts raining. The rain hisses on the open water and spatters against the hull of my boat. I zip up my jacket and pull on a wool stocking cap. I figured out long ago that being out in the rain doesn't usually hurt. Most of the time the rain isn't really rain at all, but droplets suspended in the air. Living here in winter is like living inside a cloud. The water is in the air you breathe, it fogs up your glasses, but it doesn't necessarily get you wet.

Tonight, though, it's a regular rain, the kind that soaks your clothes and sends cold rivulets running down your neck, the kind that seeps through your shoes and stains your socks.

The rain makes algae bloom and turns roofs into shaggy pastures of moss. It turns metal to rust and gives unwashed cars paint jobs of fungal green. I remember being amazed the first time I saw mushrooms growing in the rain gutters of the old truck I keep in the backyard. Now I take them for granted.

In Western Washington, bright colors vanish with the autumn leaves. The winter world is filtered through gauze. At times, sky and water and forest merge into indistinguishable white.

People here joke about the damp and the rain, but after months of steady sog and gray skies, it really is no laughing matter—particularly in places like Forks on the ocean side of the Olympic Peninsula, where the annual rainfall is measured in feet. The lack of sunlight can make you crazy. For some people, the hunger for illumination is so acute, they set up powerful light boxes in their homes and offices to create their own sun. One company markets a "light visor," a battery-powered hat that hangs a string of light bulbs around your head.

The plants love the rain, and once you've lived here long enough, it's possible to convince yourself that you do, too. On dark, dim days, people splash around with shoulders hunched, hats pulled low, smelling of damp wool and wet hair. Occasionally, a person reacts by jumping off a bridge or driving a car off the ferry and into the dark water of Puget Sound. Some move back to California. Others find solace in the changing seasons, sitting out winters cradling coffee cups in a warm room by a fire.

* * *

The first time I saw Western Washington was in 1967. My father and I were on our way to Alaska, riding in the old family Plymouth we had outfitted as a camper.

He was a schoolteacher, free for the summer. I was coming up on my last year in high school, watching the news about Vietnam and wondering what I was supposed to do with myself next.

My father had hacksawed out the partition between the Plymouth's back seat and the trunk to make a place where he could stretch out at night. I packed a tent and a sleeping bag, and we tiled the floor of the car with cans of beans and Campbell's soup.

A half hour or so north of Portland on Interstate 5, after we'd crossed the Columbia River into Washington, the land started looking as if few people had been there before us. The freeway was still under construction, and the swath of mud and stumps looked like something bulldozed out of a jungle in the Third World.

Even though Seattle had hosted a World's Fair five years earlier, the state's in-between places were still not far from the frontier. The new interstate seemed absurdly oversized for the amount of traffic it carried. Logging trucks cast us in shadow as they passed, loaded with logs the size of rocket ships.

Western Washington was a rougher and lonelier place then, back before Microsoft and the Mariners and Starbucks coffee.

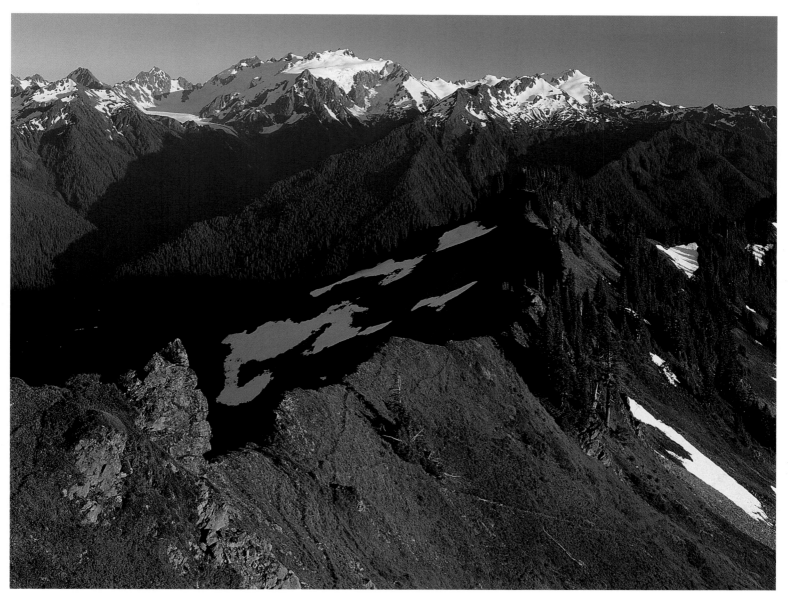

◄ Avalanche lilies bring their annual summer smile to a meadow in the area of Olympic National Park known as the High Divide. ▲ With 7,965-foot Mount Olympus towering in the background, numerous tracks of marmots, deer, and elk crisscross the face of an open slope. The mountain oversees a vast domain of peaks and deep valleys in Olympic National Park.

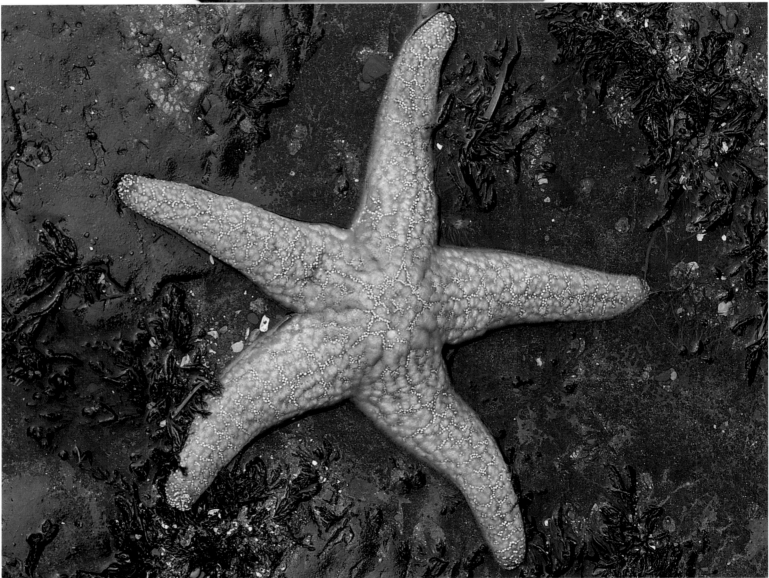

▲ Ocean sands at Olympic National Park are home for a sea star.
► The sun casts an end-of-the-day glow on Second Beach in Olympic National Park, south of La Push.

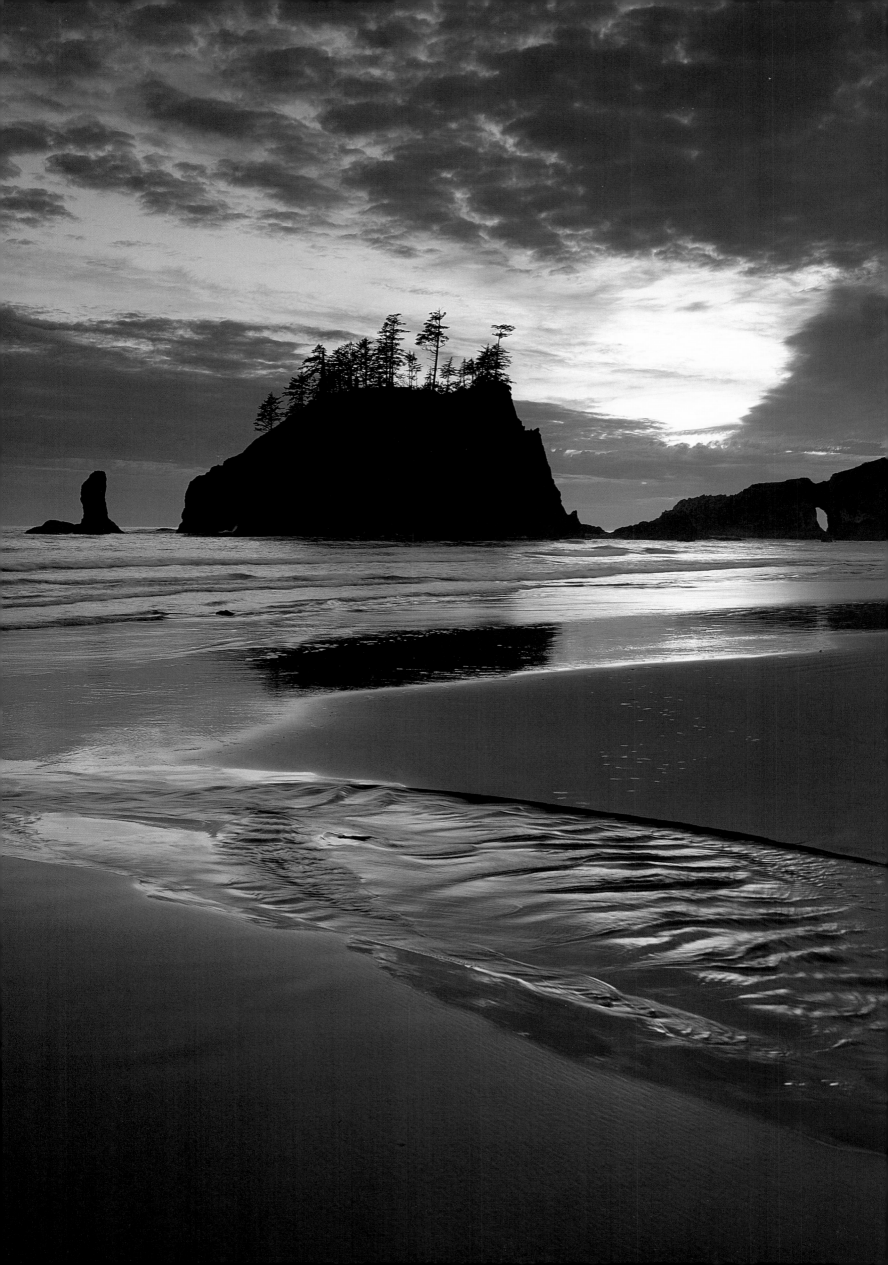

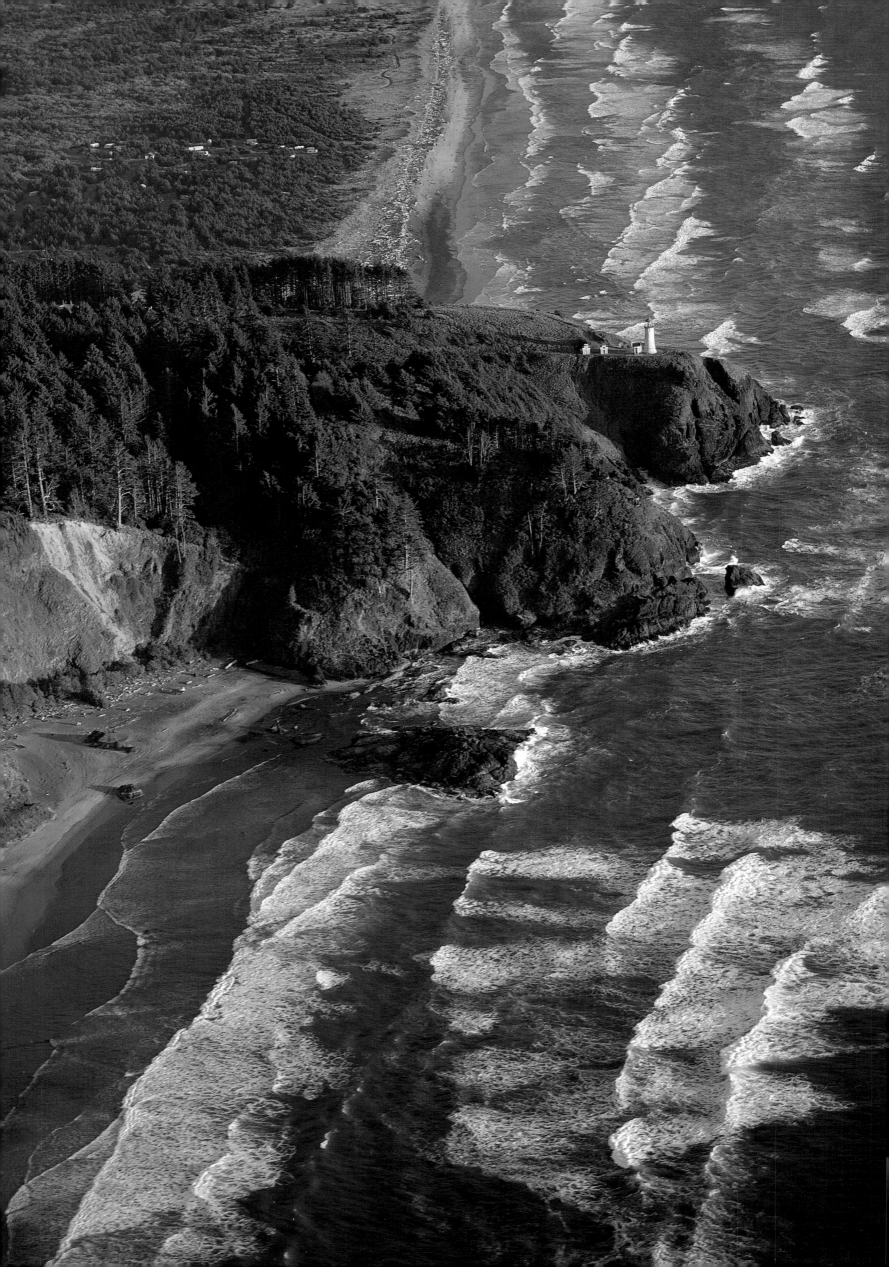

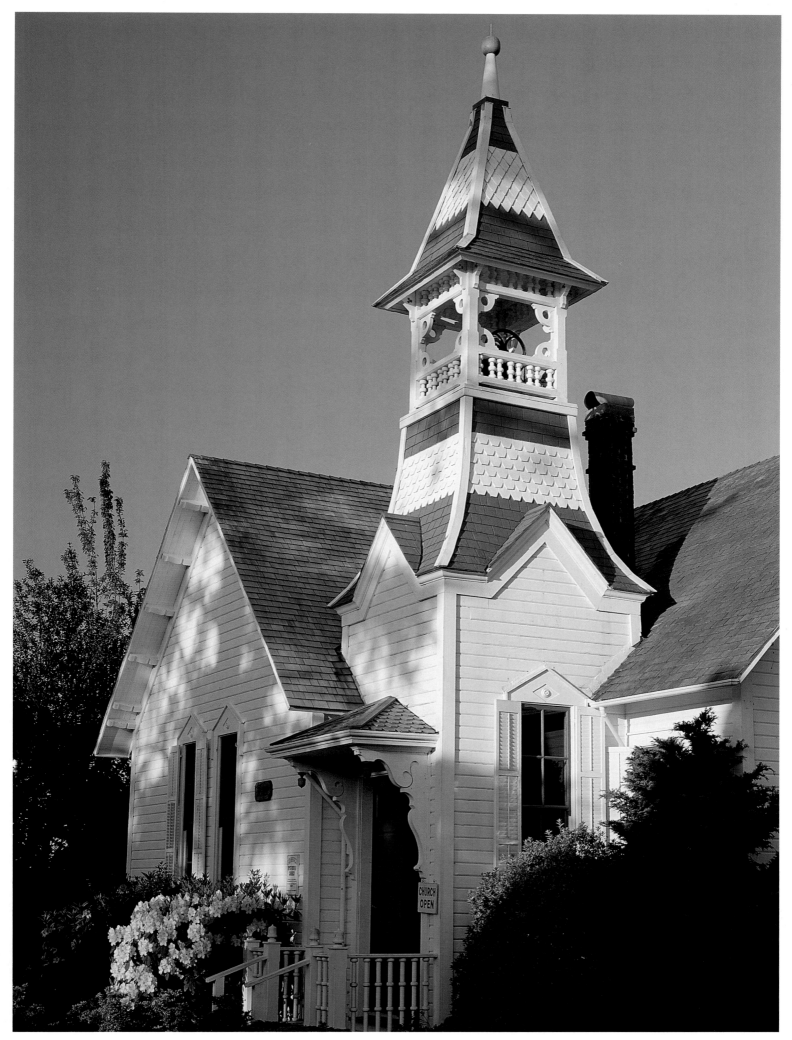

◄ The North Head Lighthouse guards the state's southwestern tip.
▲ An 1892 church graces Oysterville, in southwest Washington.
►► Icy winter waters cradle the fishing fleet berthed at Ilwaco.

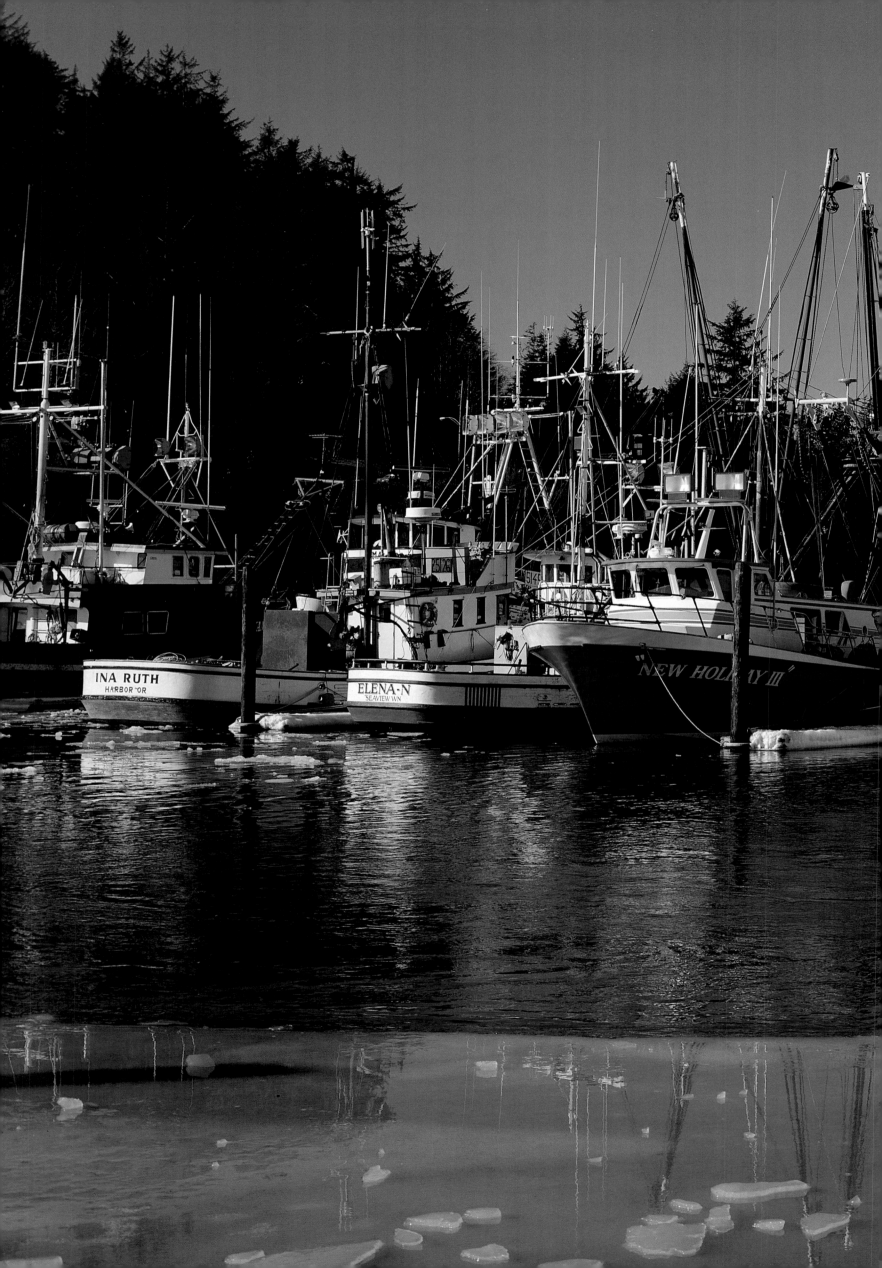

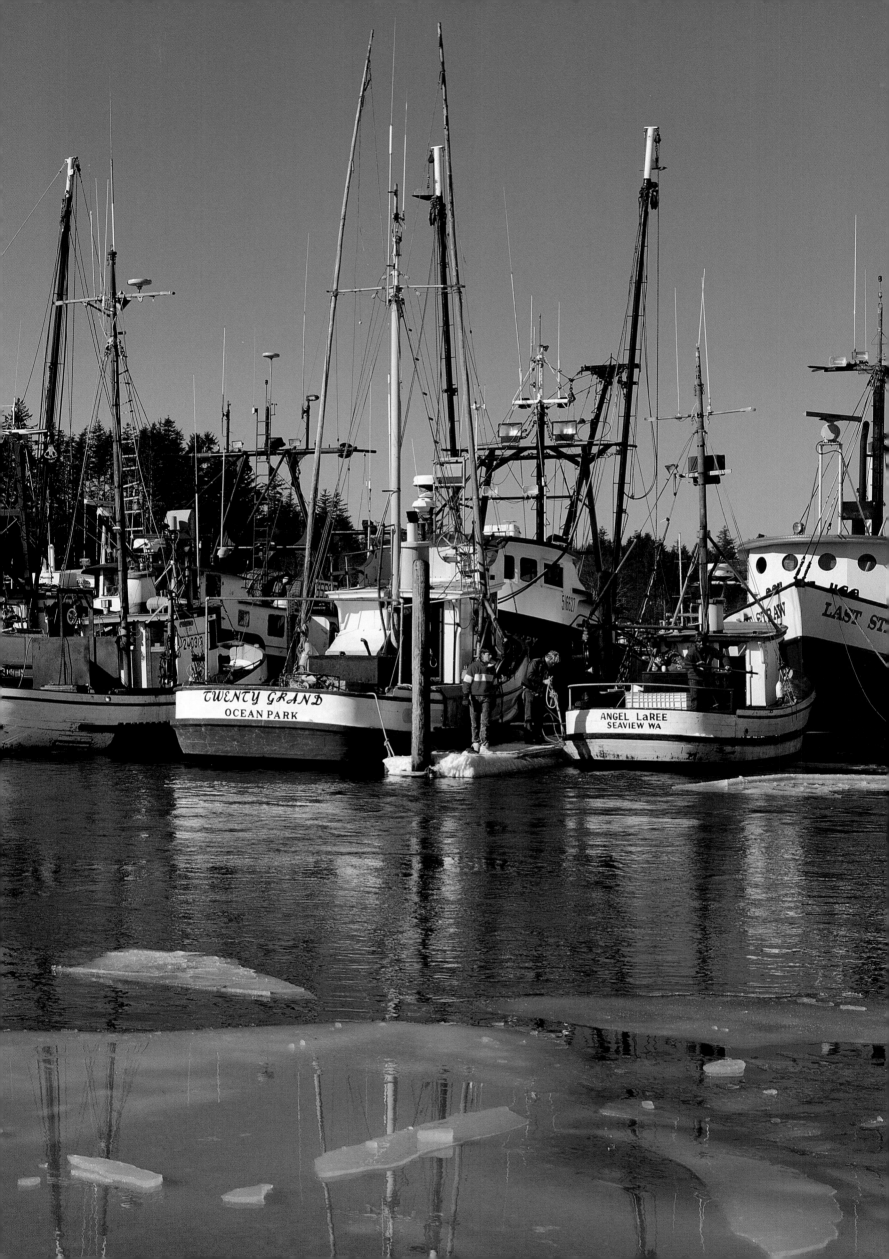

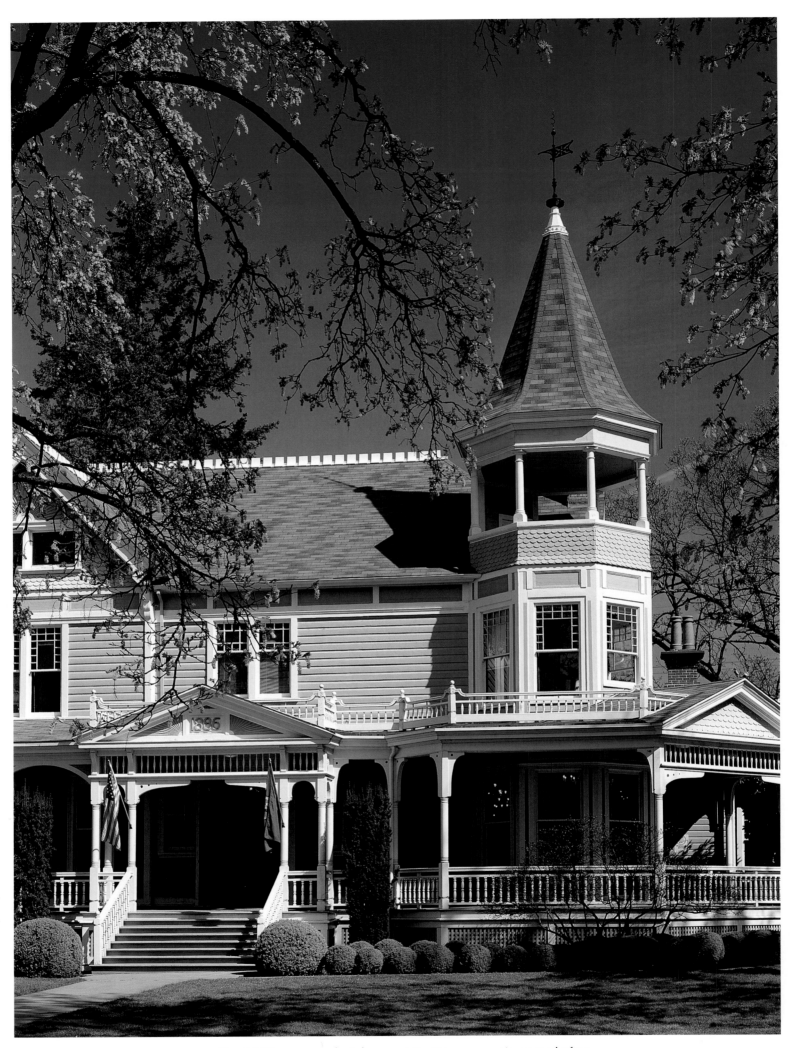

▲ The 1886 commander's home at Fort Vancouver is named after George C. Marshall, who lived there 1936–1937. He initiated the Marshall Plan in 1947 and won the Nobel Peace Prize in 1953.

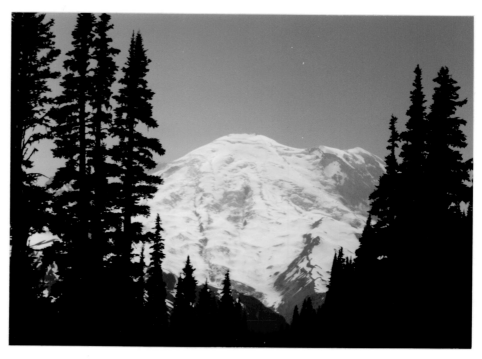

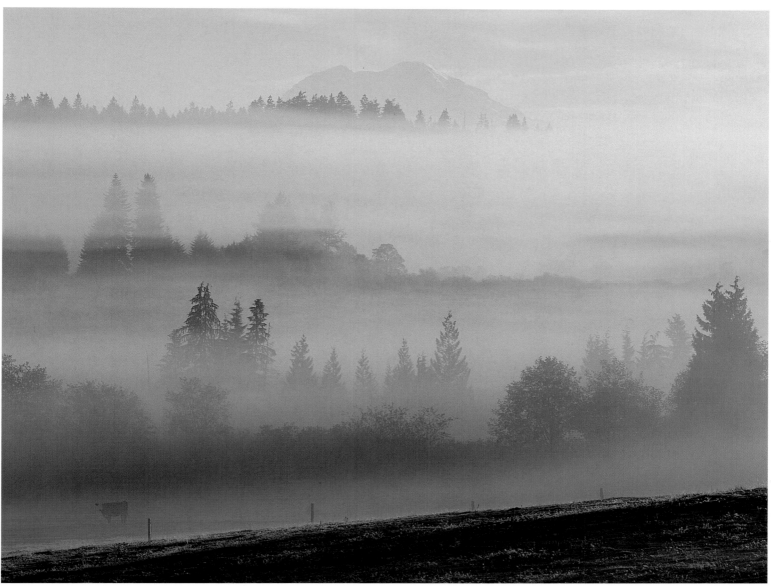

▲ Layers of ground fog swallow landscape and livestock near Silver Lake, with the summit of Mount Rainier as a backdrop.
► ► Vehicle taillights, captured in a time exposure at dusk, stream past Tacoma's historic Union Station, now a courthouse.

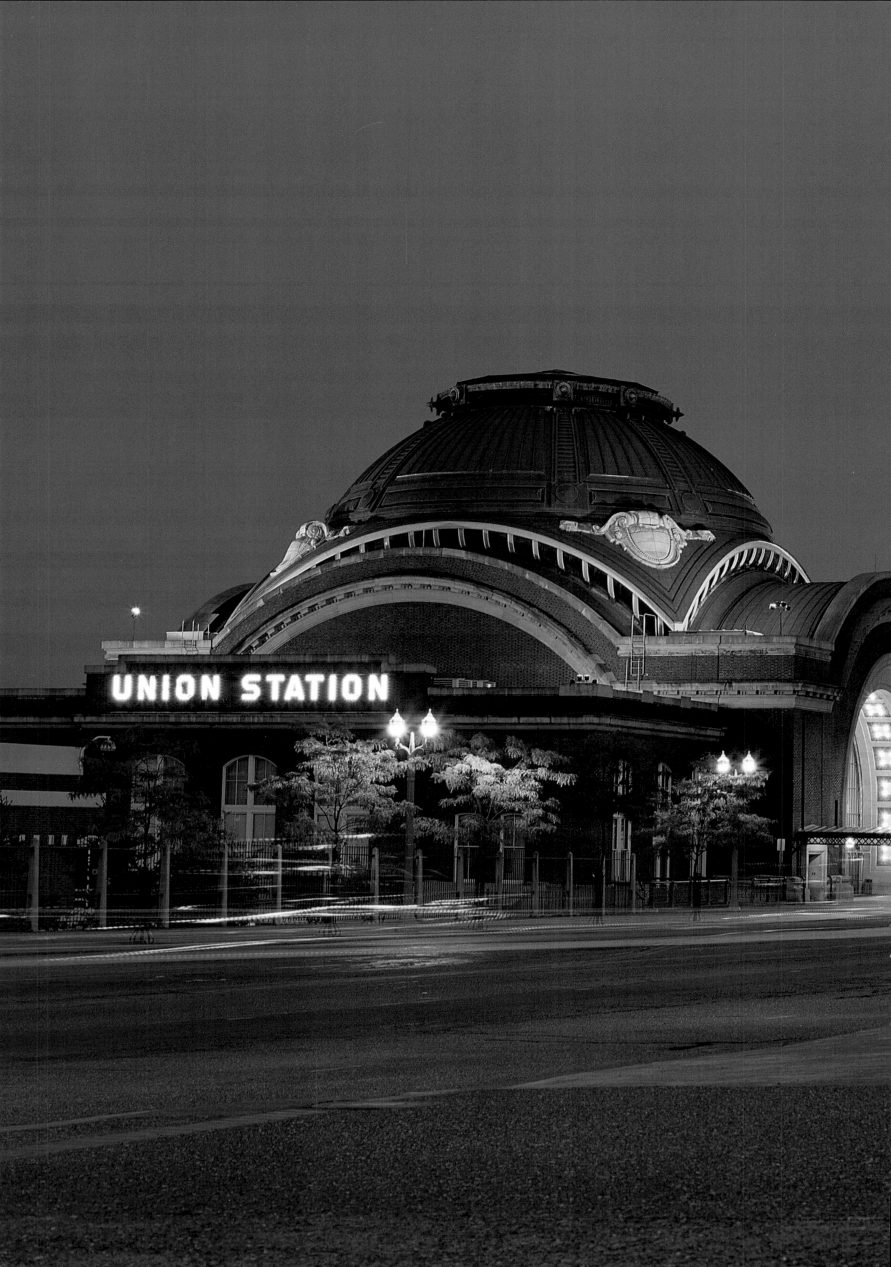

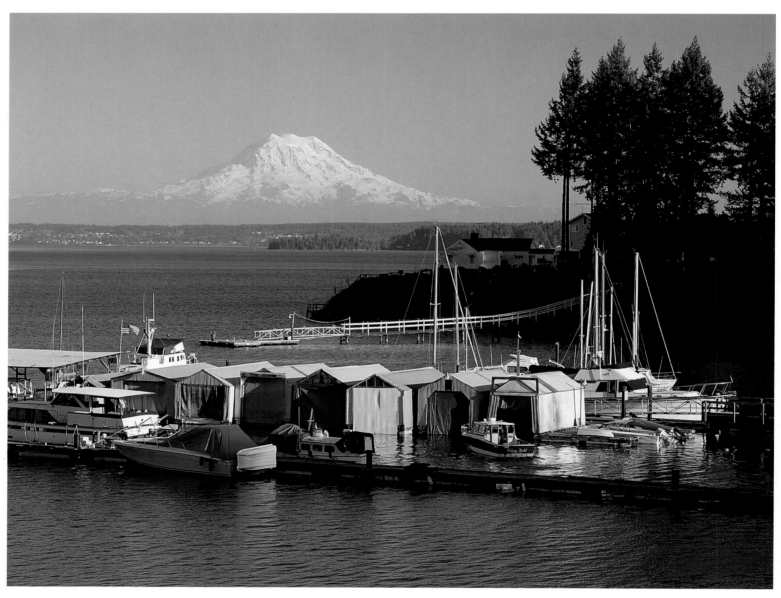

▲ An omnipresent Mount Rainier fills the horizon southeast of a yacht basin at Longbranch, on the lower reaches of Puget Sound.
► A line of maples in full fall color fades into the fog at a park in the Mount Baker district, one of Seattle's many neighborhoods.
►► The downtown Seattle skyline, marshaled behind the Space Needle, reflects the light of the moon and the evening sky.

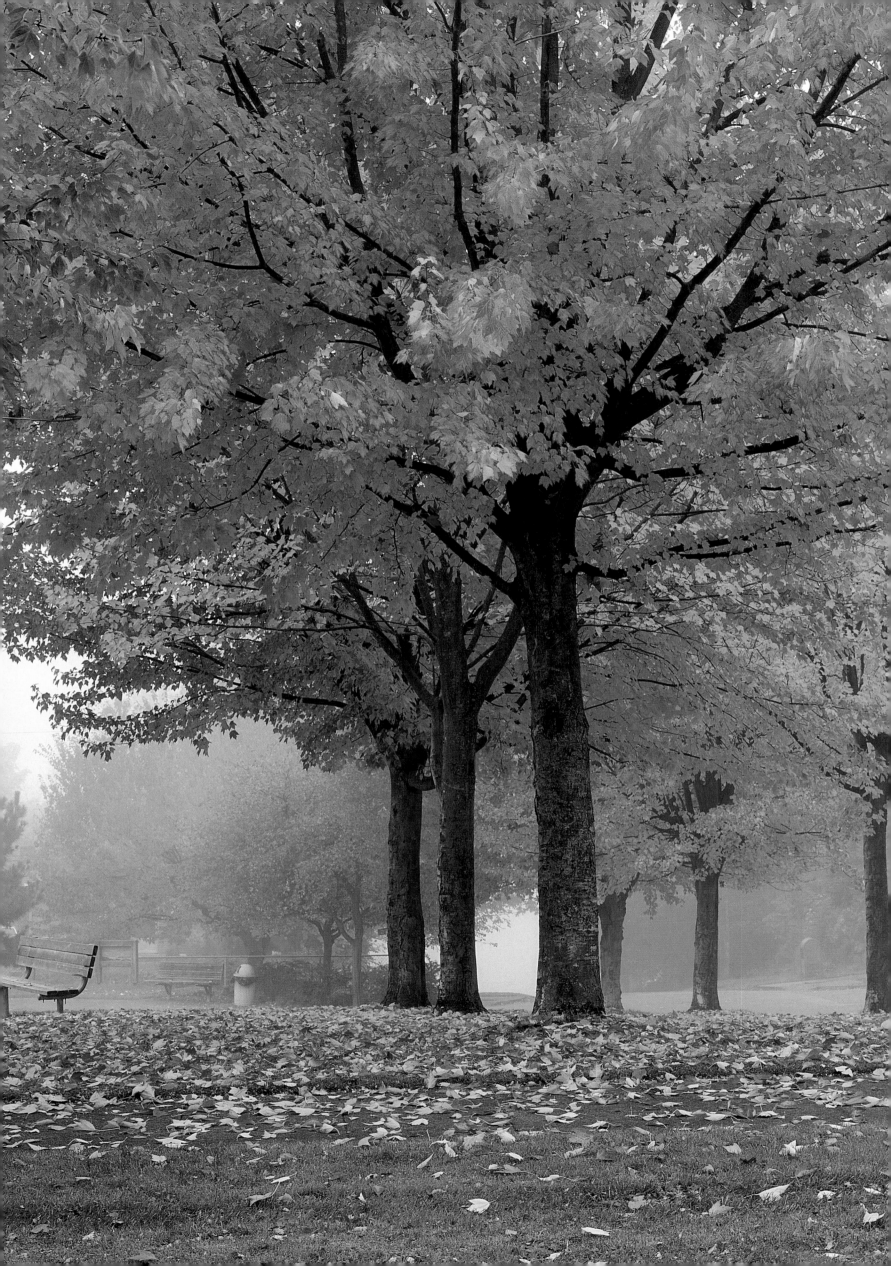

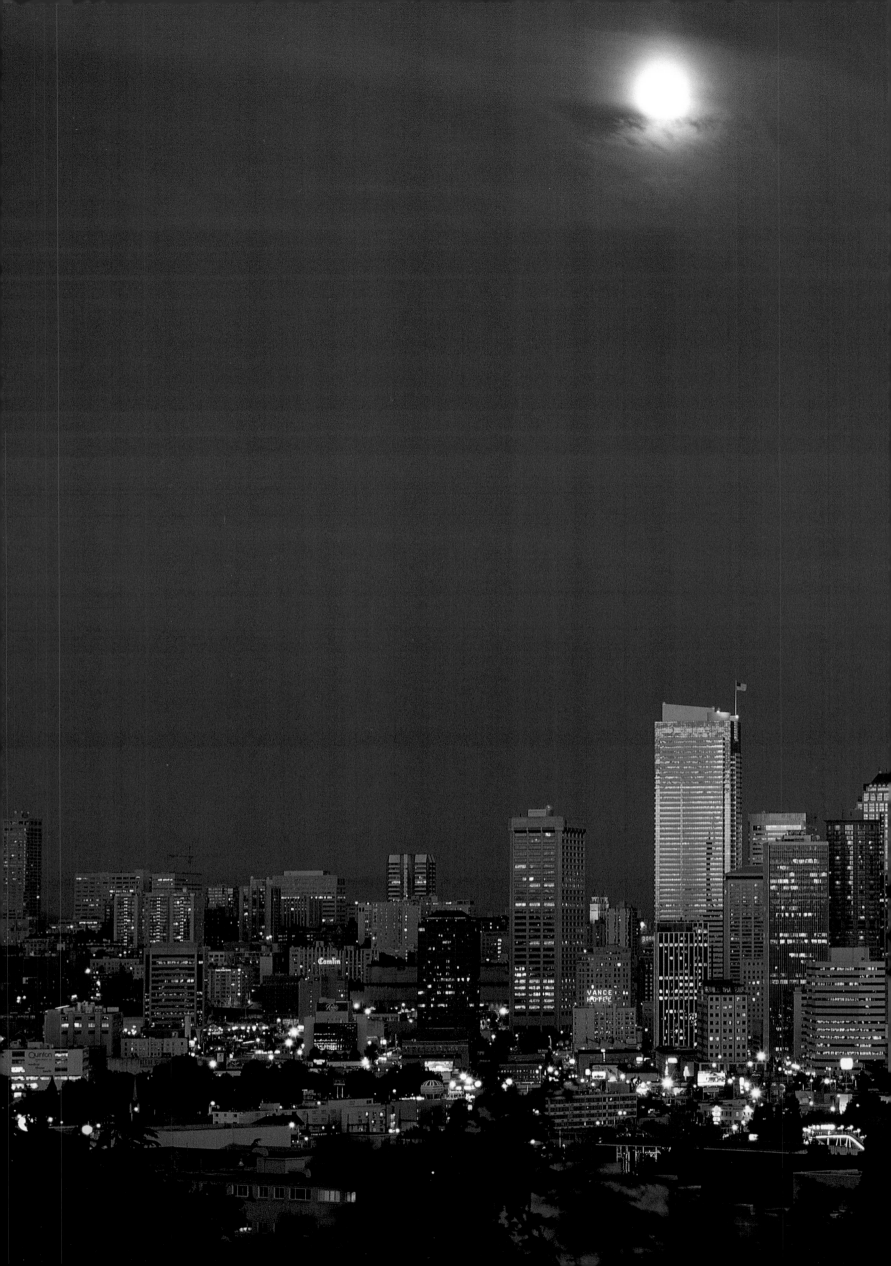

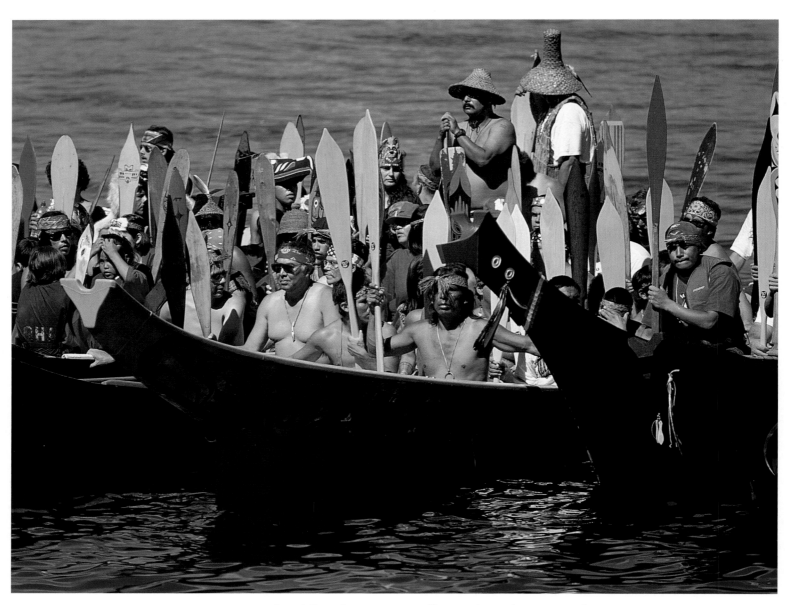

▲ Boats and paddlers from Native villages along the coasts of
Washington state and British Columbia come together in Tacoma.
▶ Farm-fresh produce at the Pike Place Market is a year-round
lure for Seattle residents and visitors alike. Choi's fruit and
vegetable stand is the proud operation of Korean immigrants.

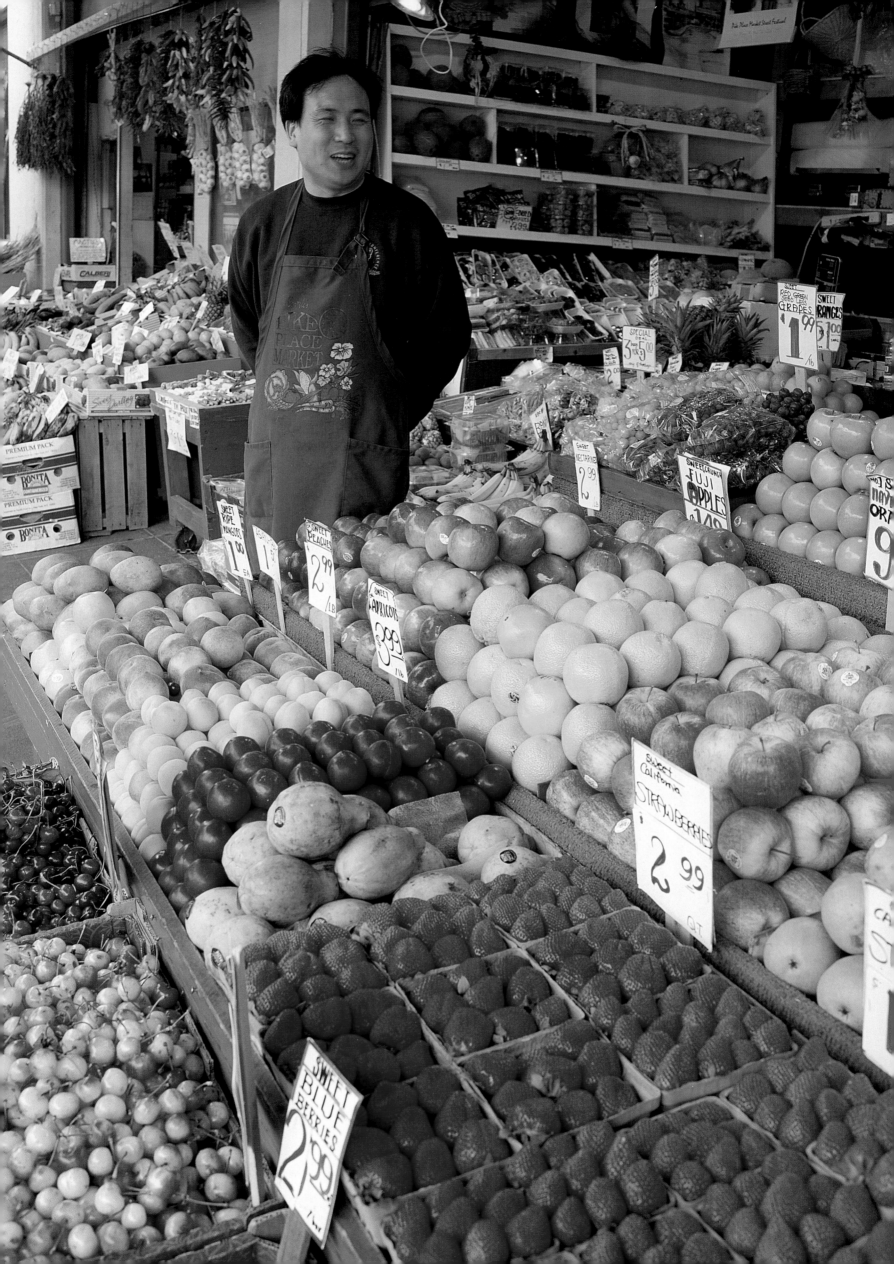

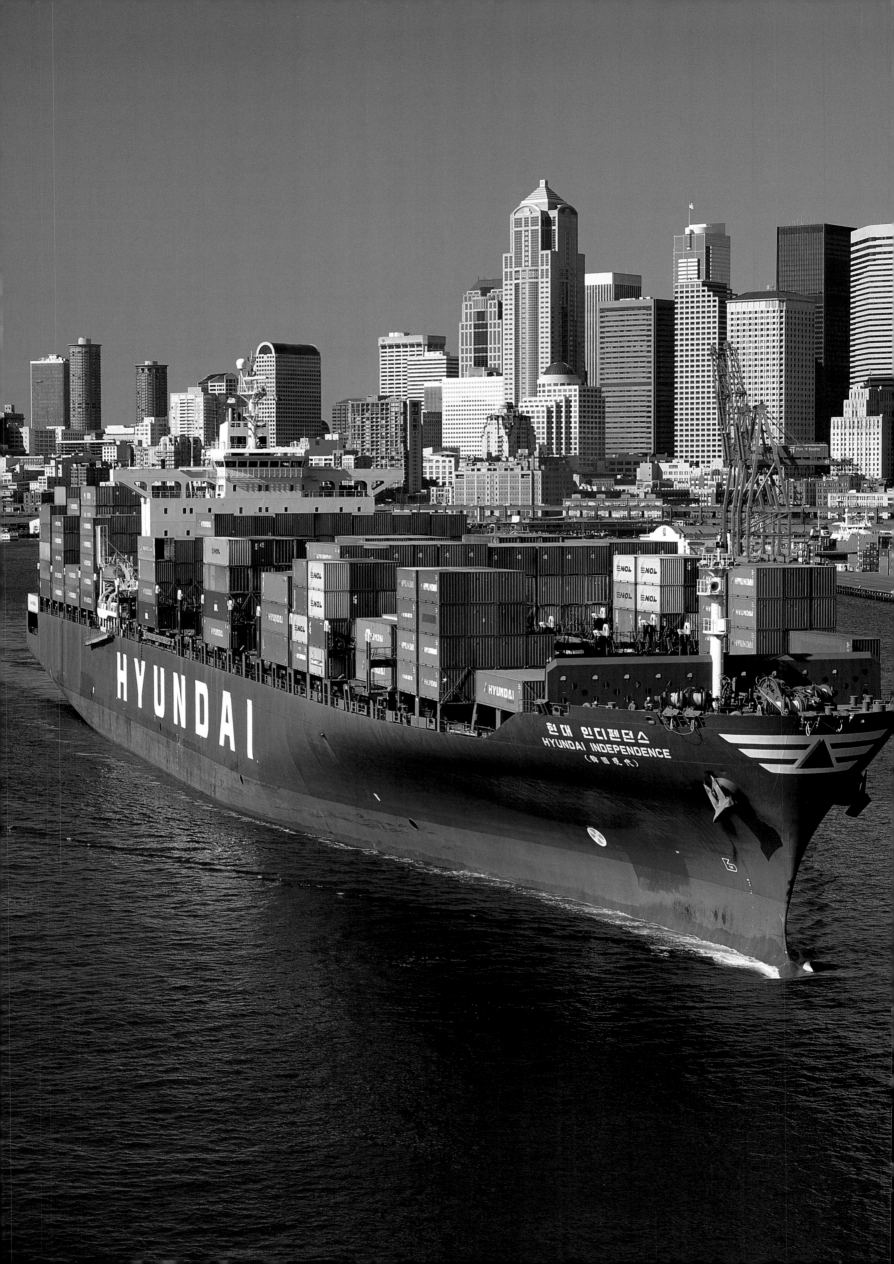

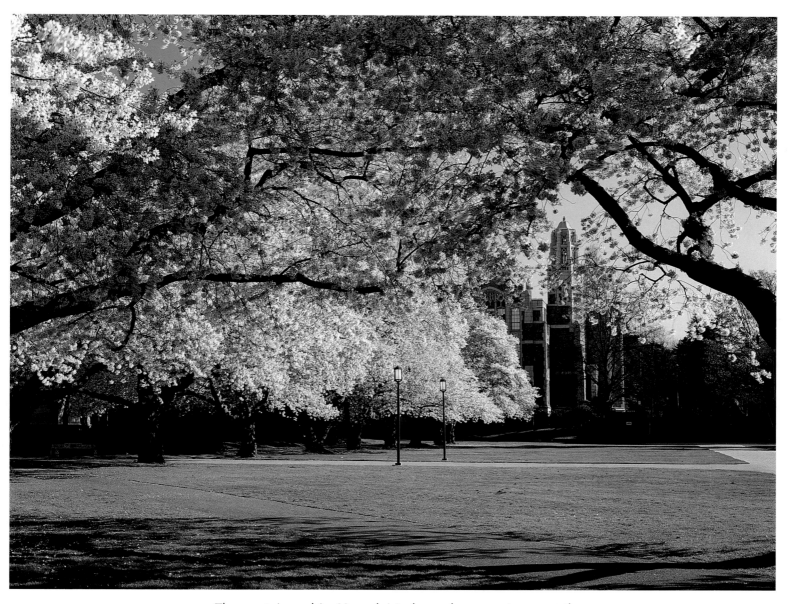

◄ The container ship *Hyundai Independence* cruises past the downtown waterfront on its way to dock at the Port of Seattle.
▲ Japanese cherry trees massed in springtime bloom adorn the quadrangle on the University of Washington campus in Seattle.

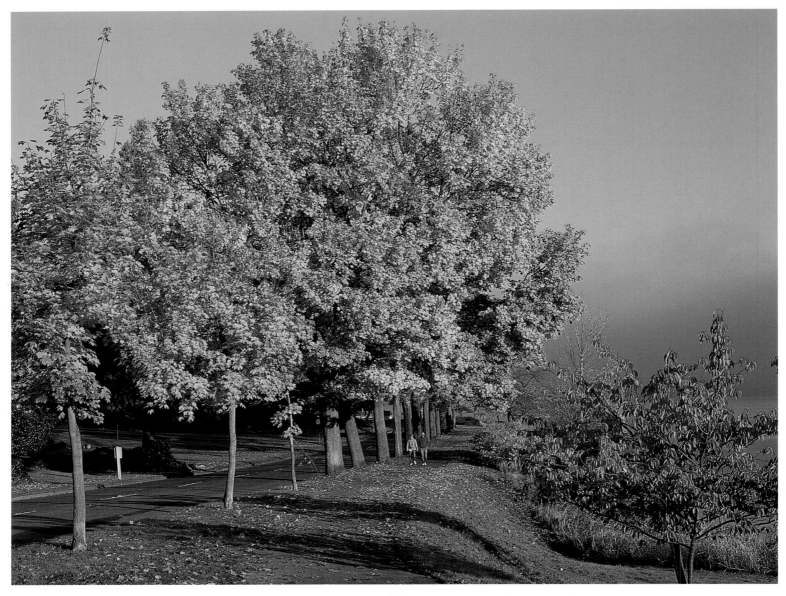

▲ Fog on an autumn morning brings added serenity to a quiet stretch of Lake Washington Boulevard that skirts the shore of Lake Washington in the Mount Baker neighborhood of Seattle.
▶ Glass is star of the show at Bellevue's City Center Building.
▶ ▶ Masts stand straight and still above the placid waters of Liberty Bay, on Puget Sound at Poulsbo.

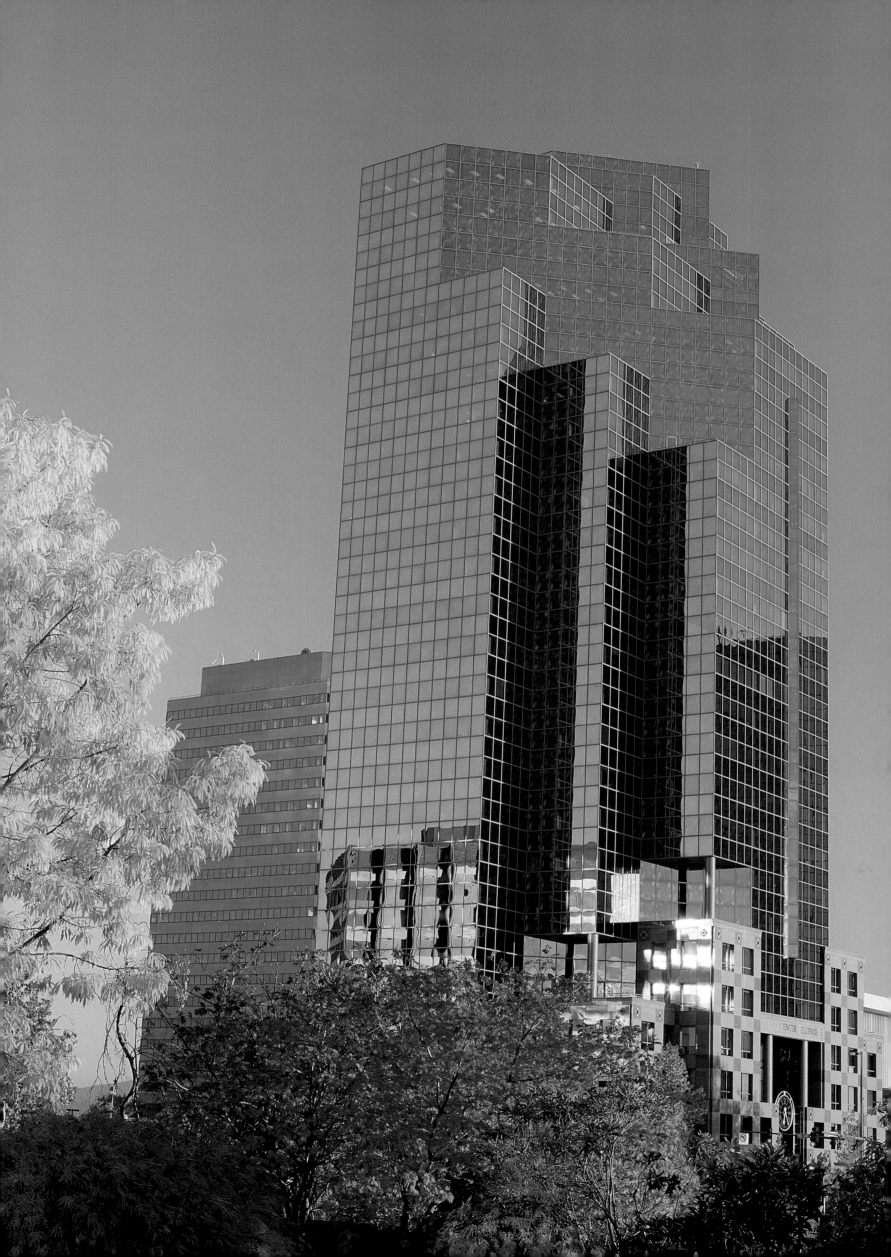

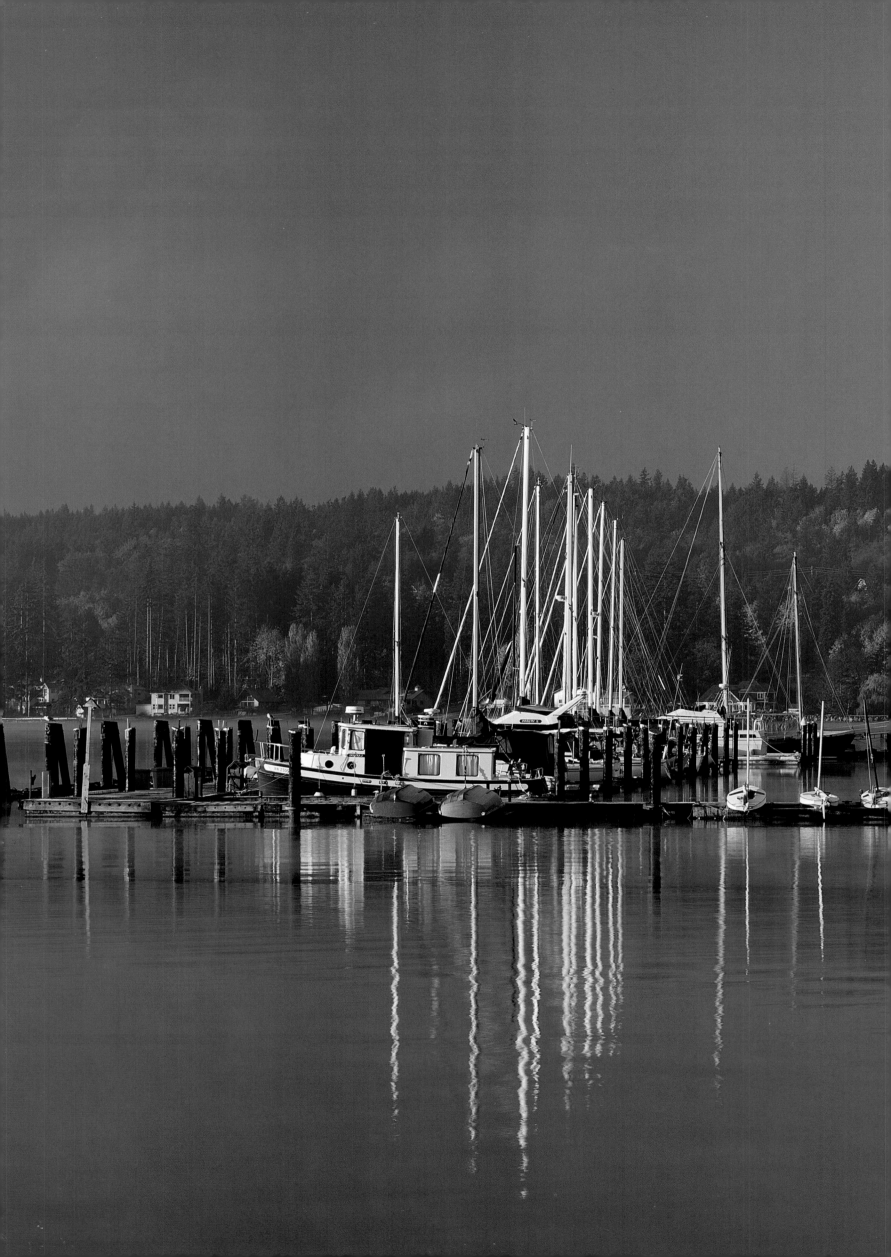

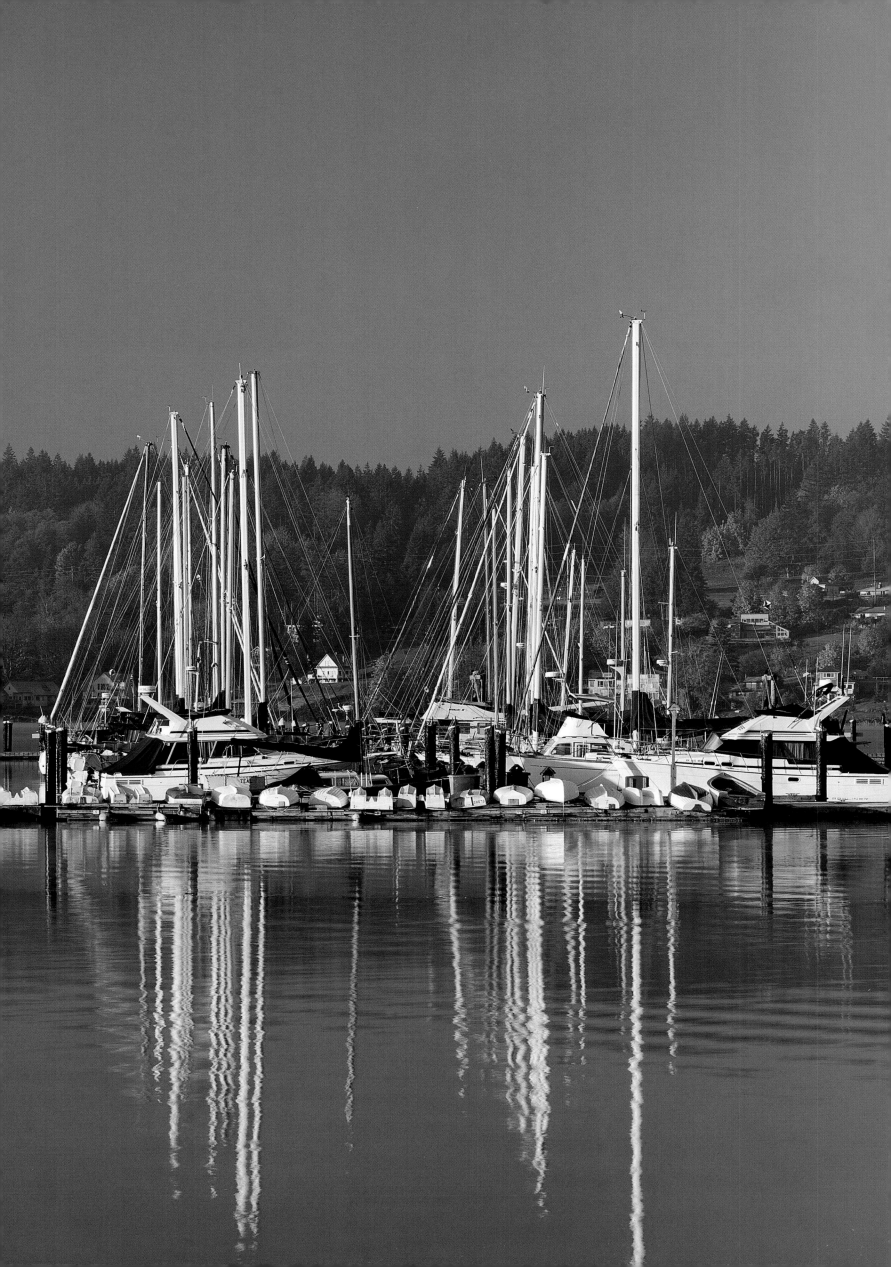

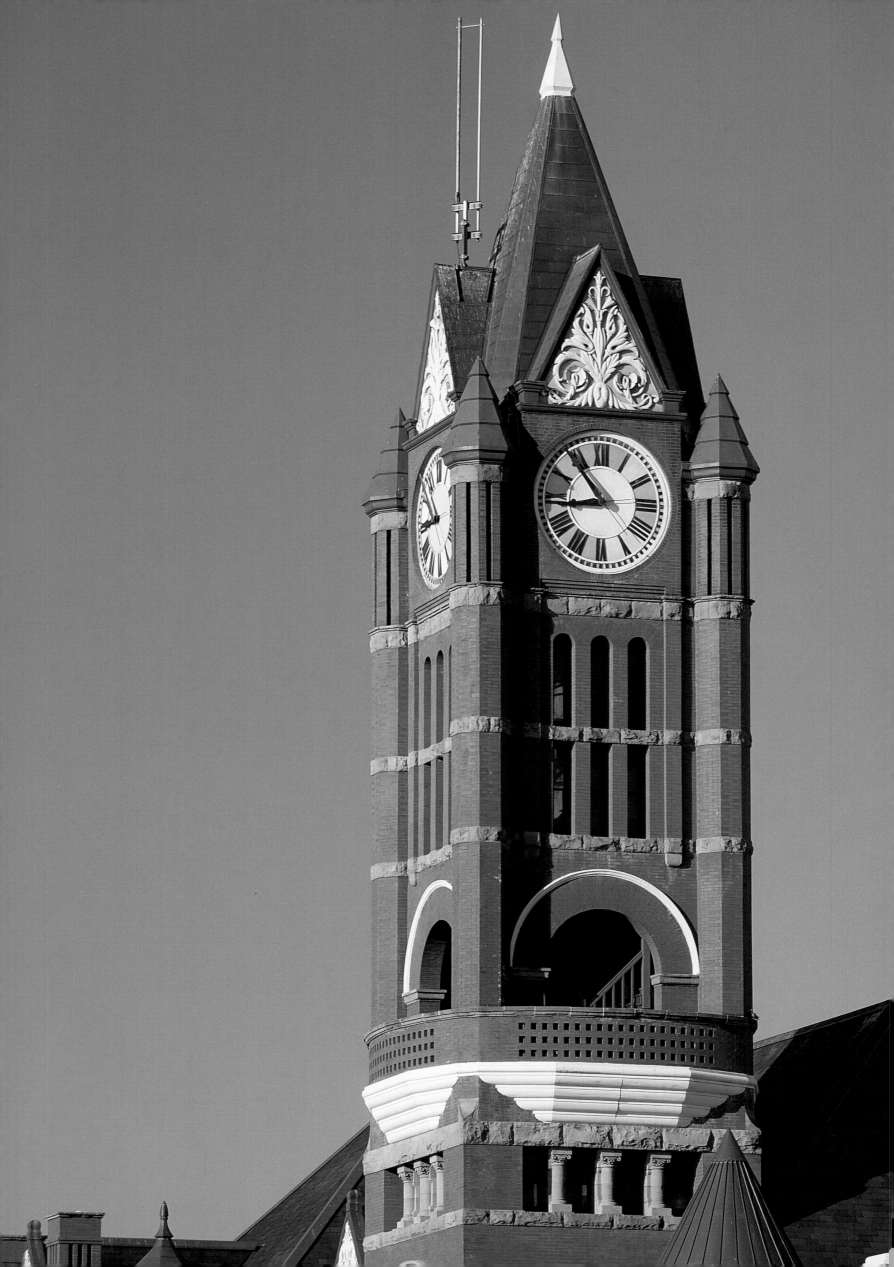

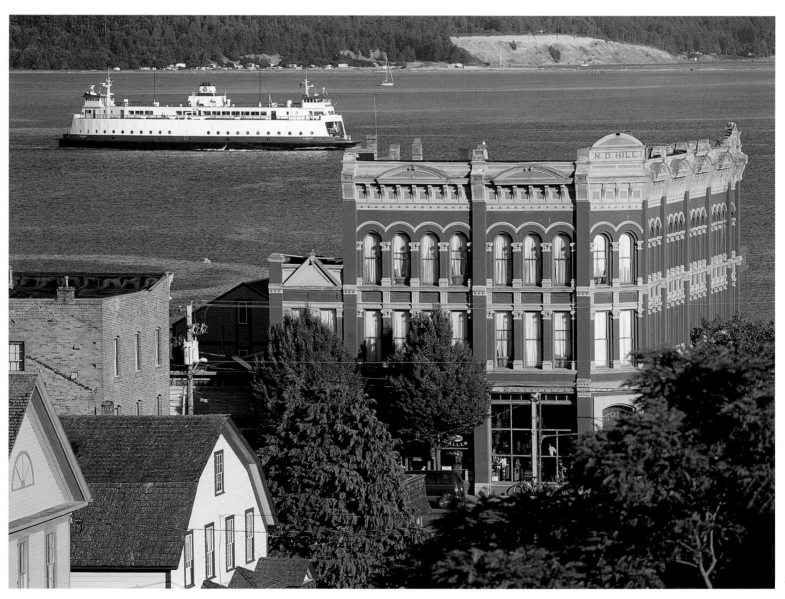

◄ The clock tower on the Romanesque-style Jefferson County Courthouse rises 124 feet above the streets of Port Townsend.
▲ A Washington state ferry slides past Port Townsend. The town became a busy port city soon after it was settled in the 1850s.
►► The cupola-topped barn near Monroe was built about 1917.

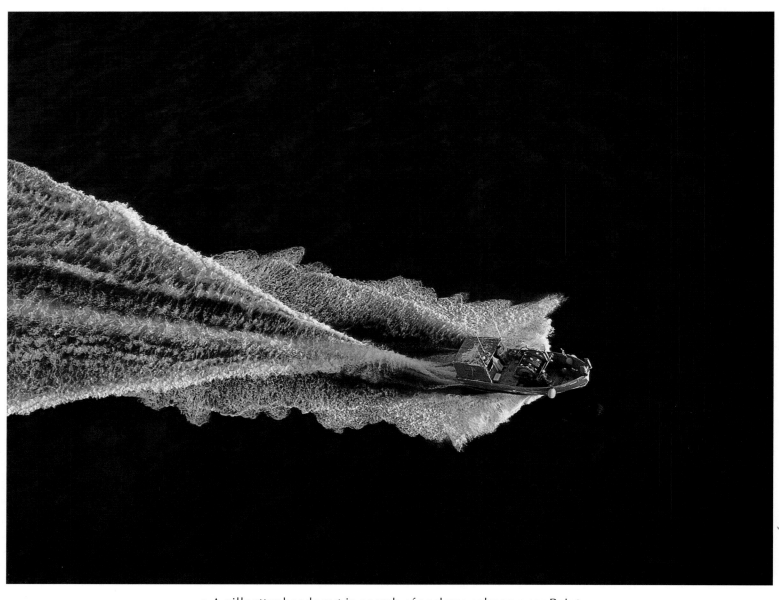

▲ A gillnetter heads out in search of sockeye salmon near Point
Roberts, in Washington waters not far from the Canadian border.
► A purse seiner sets its snare for sockeye near Point Roberts.
►► The day begins with a burst of color behind two Cascade
Mountain peaks—White Horse, on the left, and Three Fingers—
and for the farm country north of Marysville.

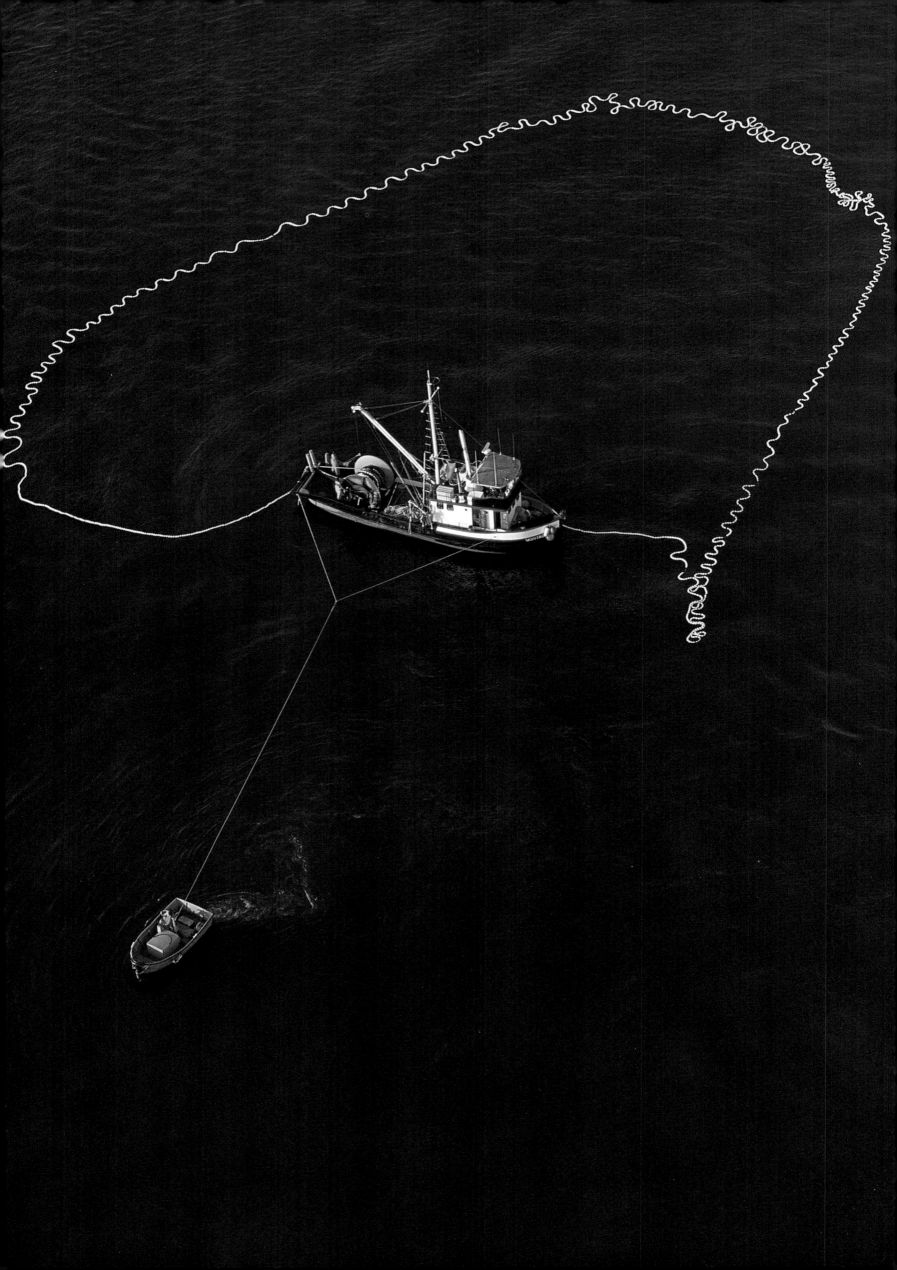

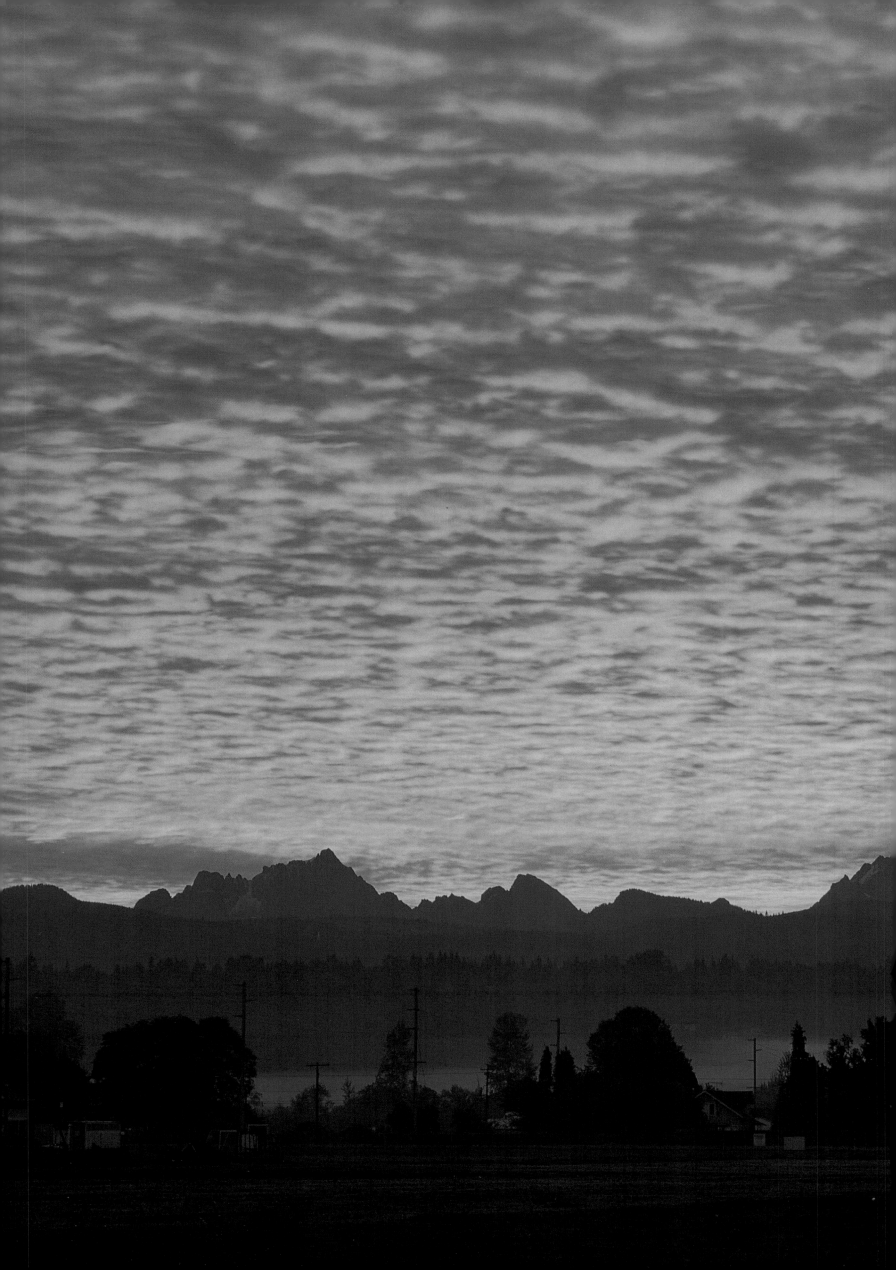

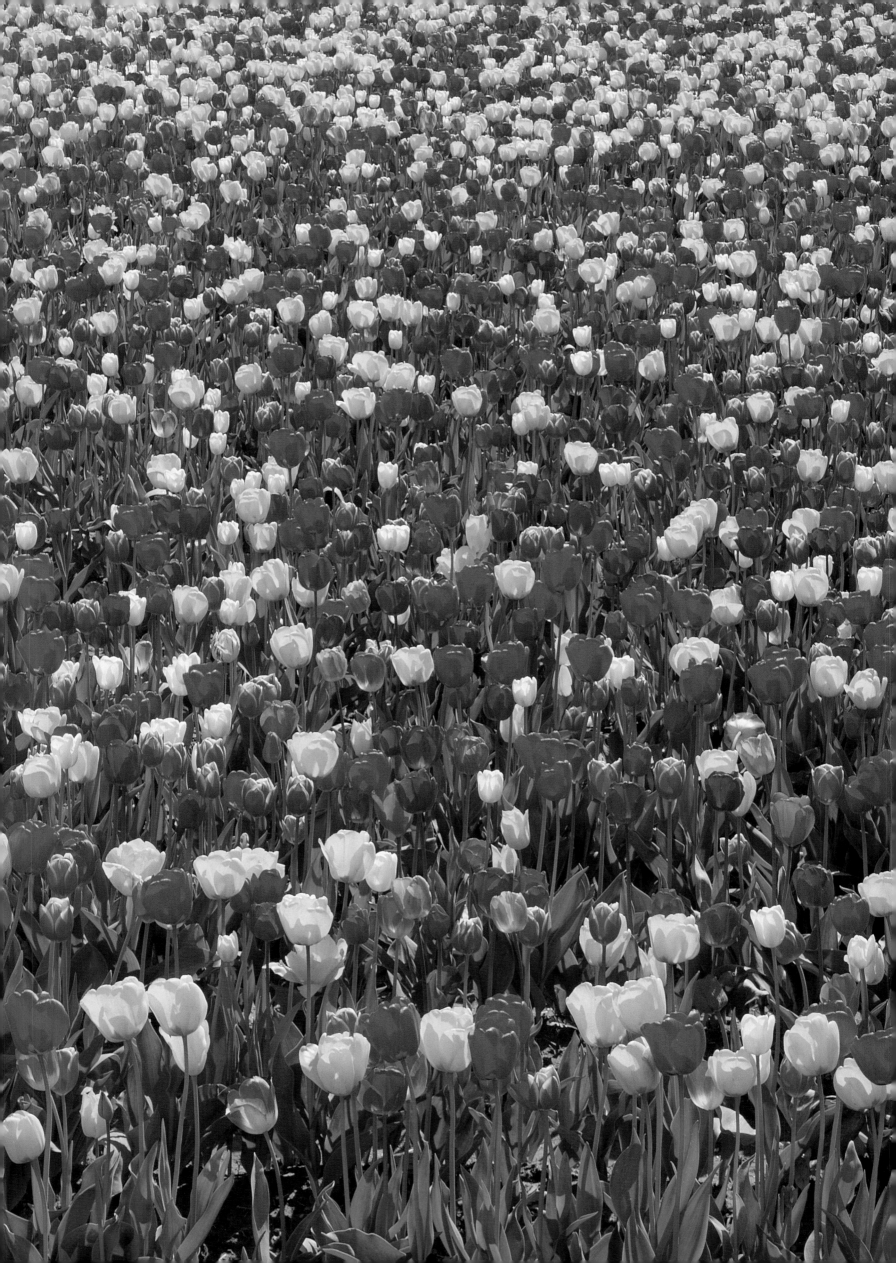

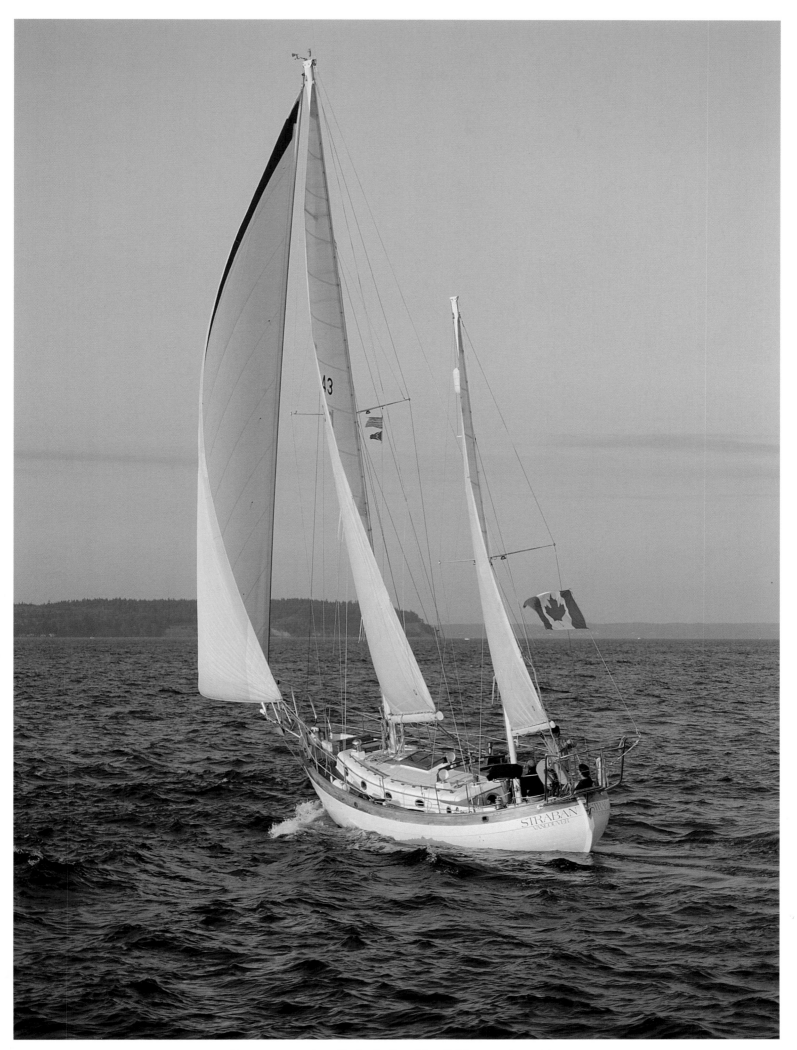

◄ Tulips, grown primarily for bulbs, fill a field near Mount Vernon.
▲ A forty-three-foot Canadian ketch enjoys brisk winds of the
Strait of Georgia as it sails toward Point Roberts, in Washington.

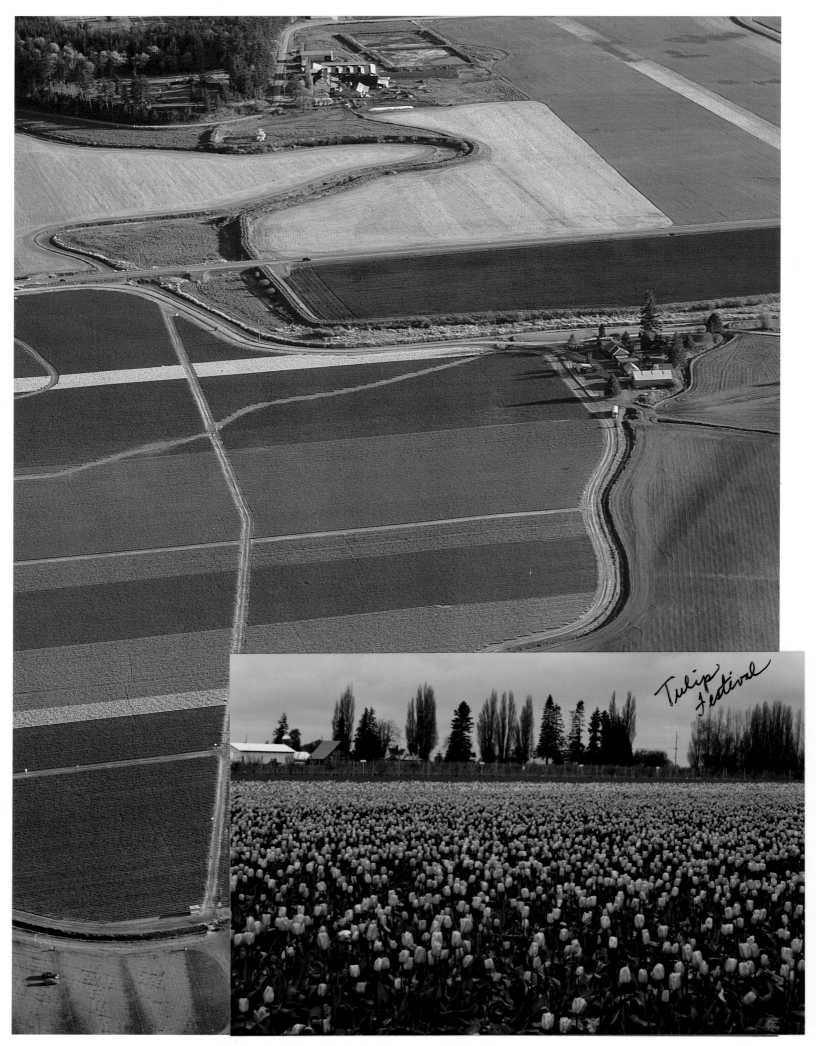

Tulip Festival

▲ Bands of cultivated tulip fields pattern the land near La Conner.
▶ Sailboats and motor yachts share a quiet place to dock below
the chapel at Roche Harbor Resort on San Juan Island.

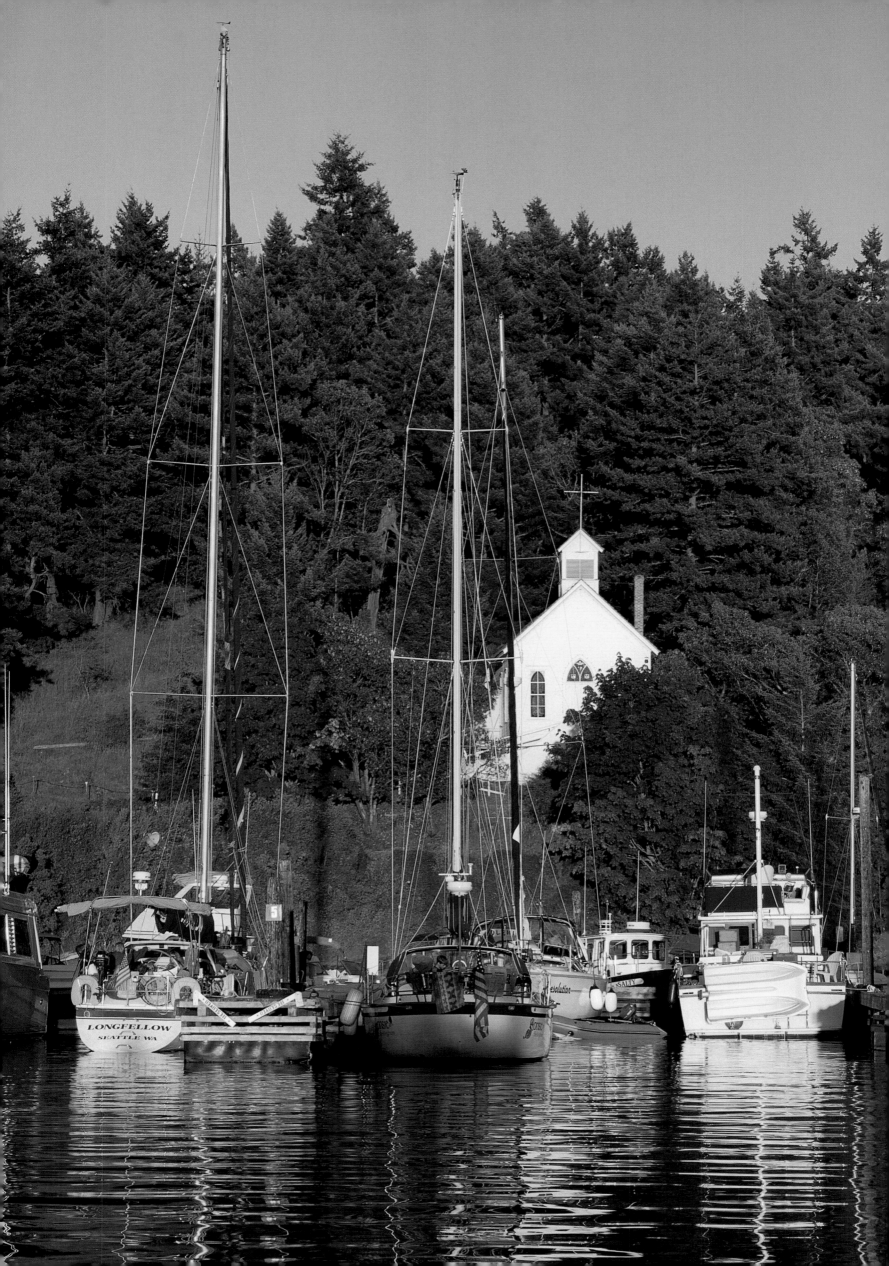

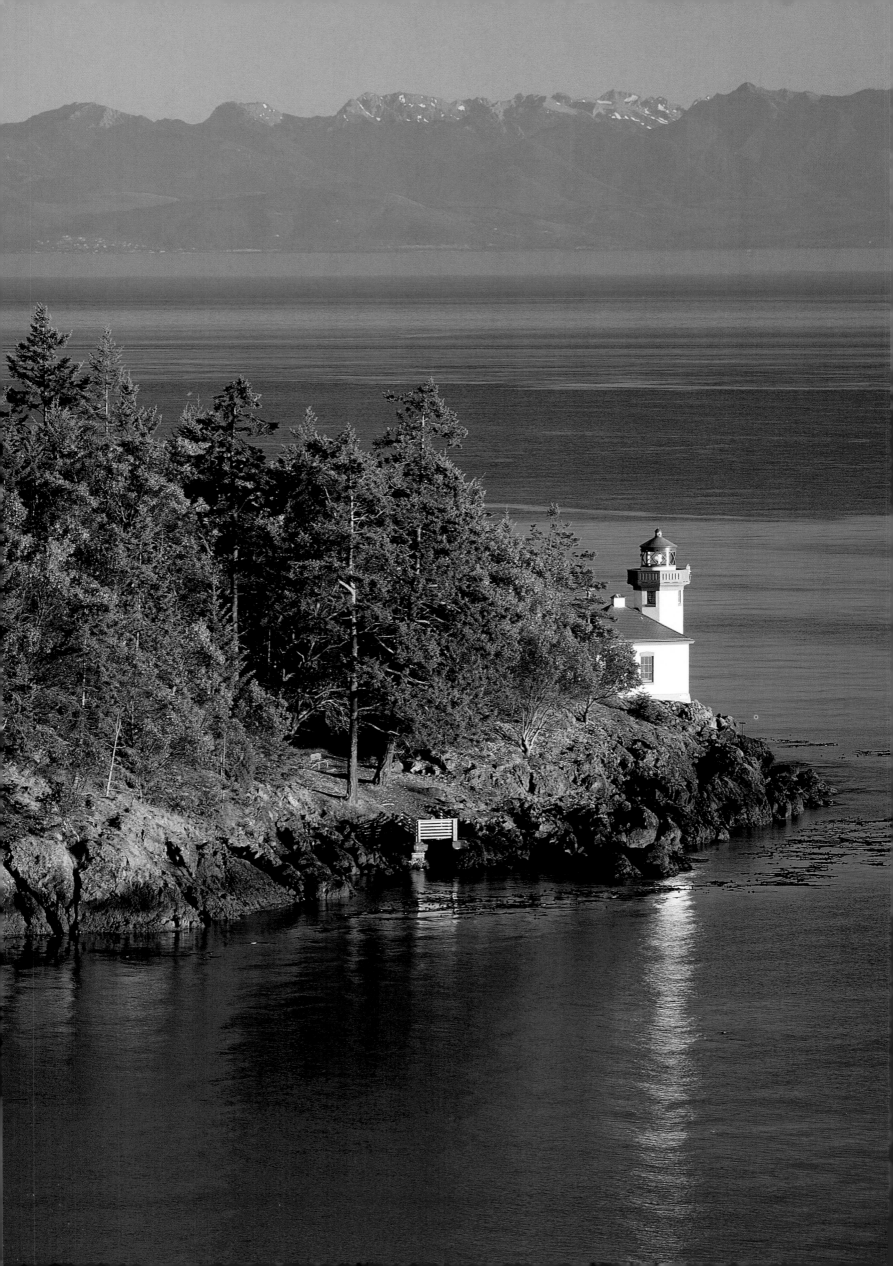

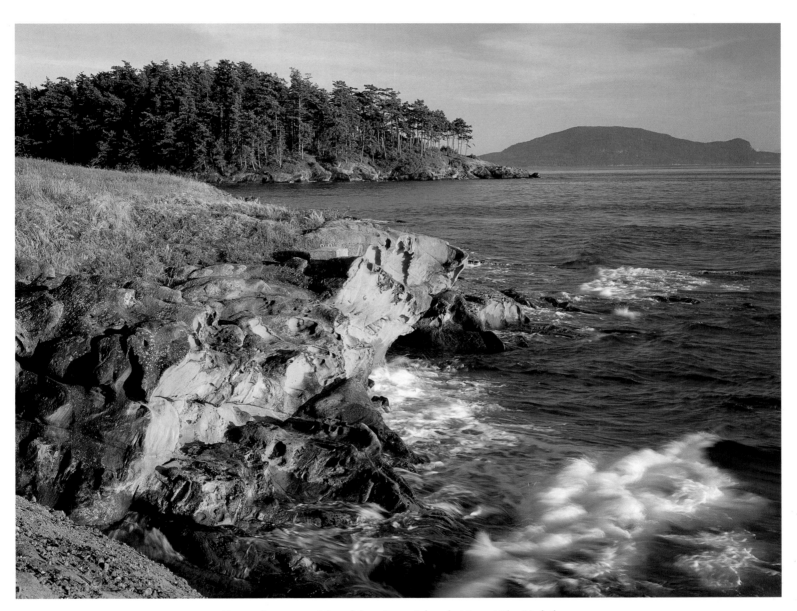

◄ From the west side of San Juan Island, Lime Kiln Lighthouse looks out on Haro Strait and, beyond, to the Olympic Mountains.
▲ A sandstone shore greets the waves on Patos Island, a marine state park within the San Juan Islands. Beyond is Orcas Island.

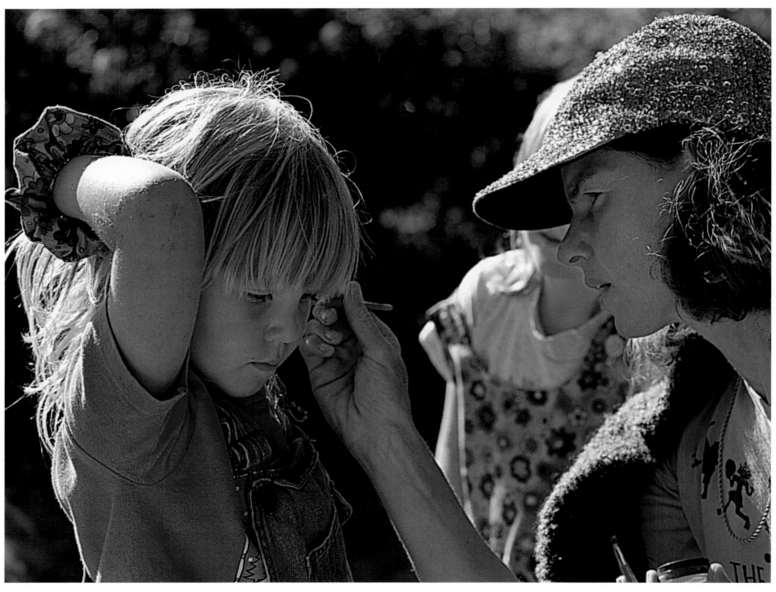

▲ Face-painting is part of the fun at a Whidbey Island festival.
▶ The industry and commerce of the port city of Bellingham are carried on just west of a Cascade Mountain region dominated by the presence of 10,775-foot Mount Baker.

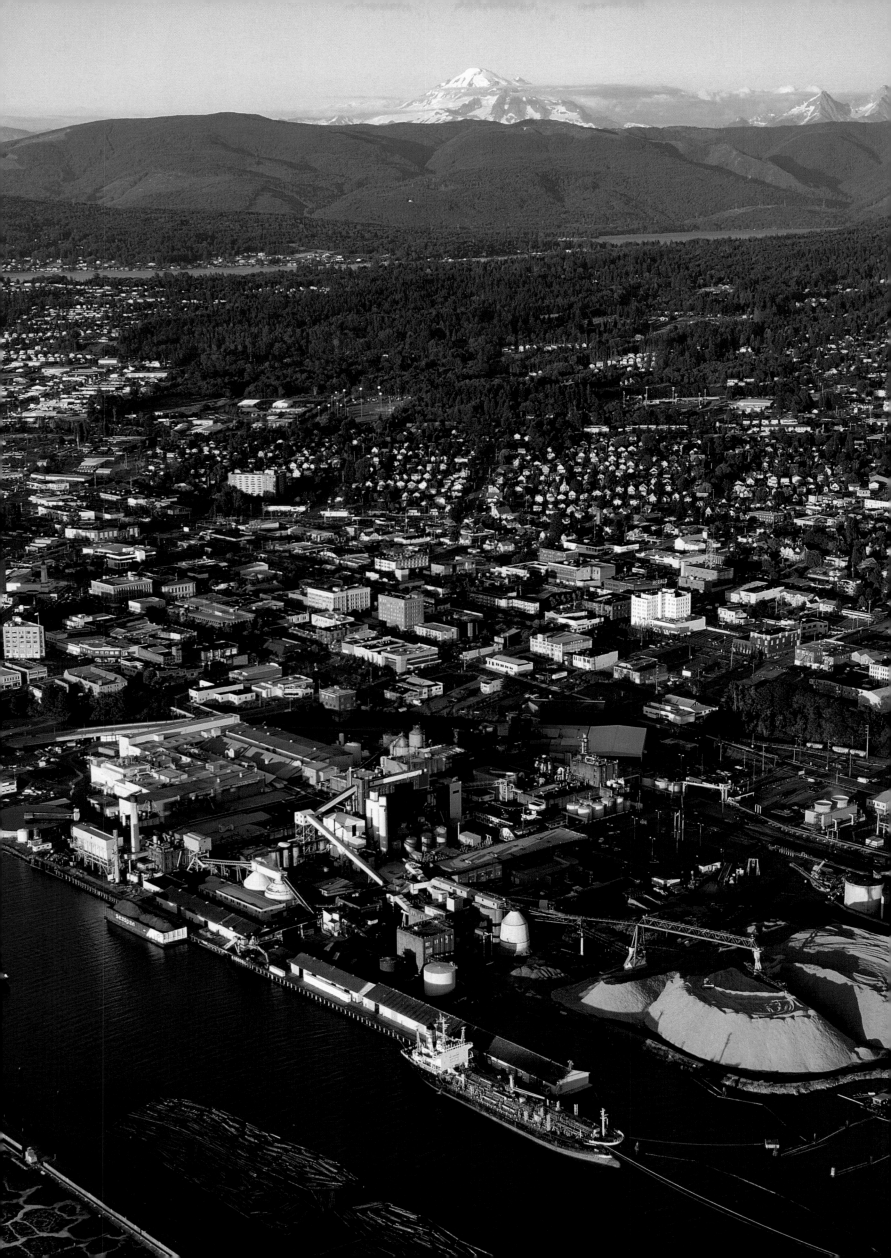

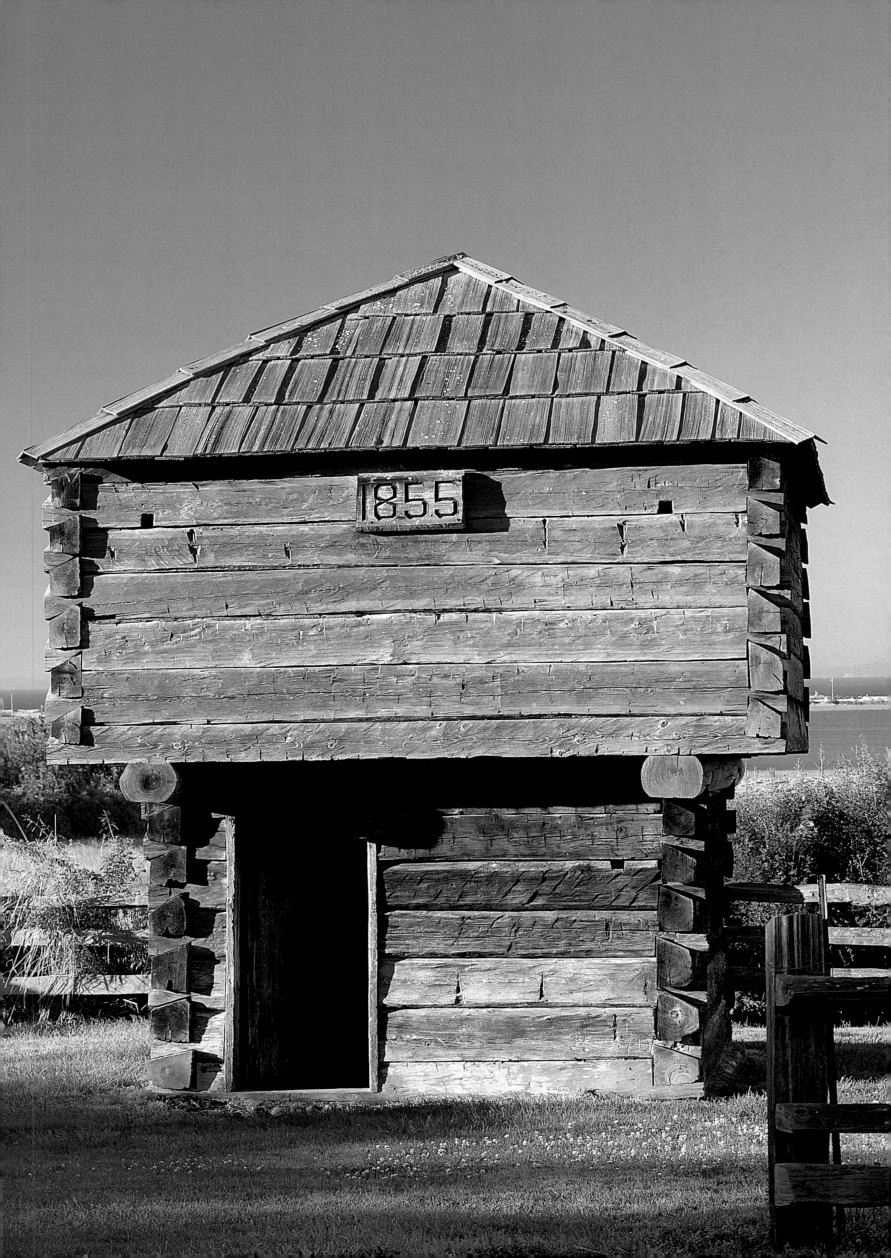

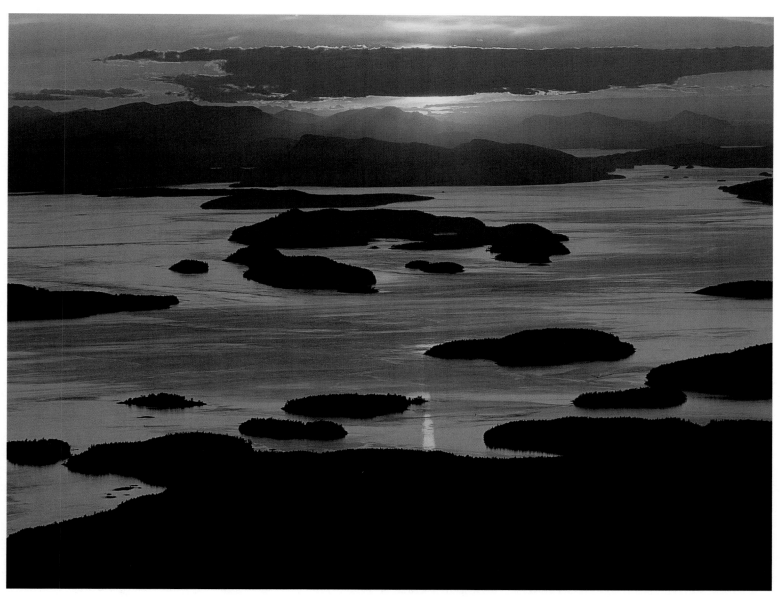

◄ Now part of Ebey's Landing National Historic Reserve, this blockhouse on Whidbey Island was built in 1857 for defense.
▲ The sun setting over Canada's Vancouver Island shines its last light of the day onto the San Juan Islands of Washington state.
►► It's white on white as fresh snow and clouds cover the northwestern side of Washington's grandest peak, Mount Rainier.

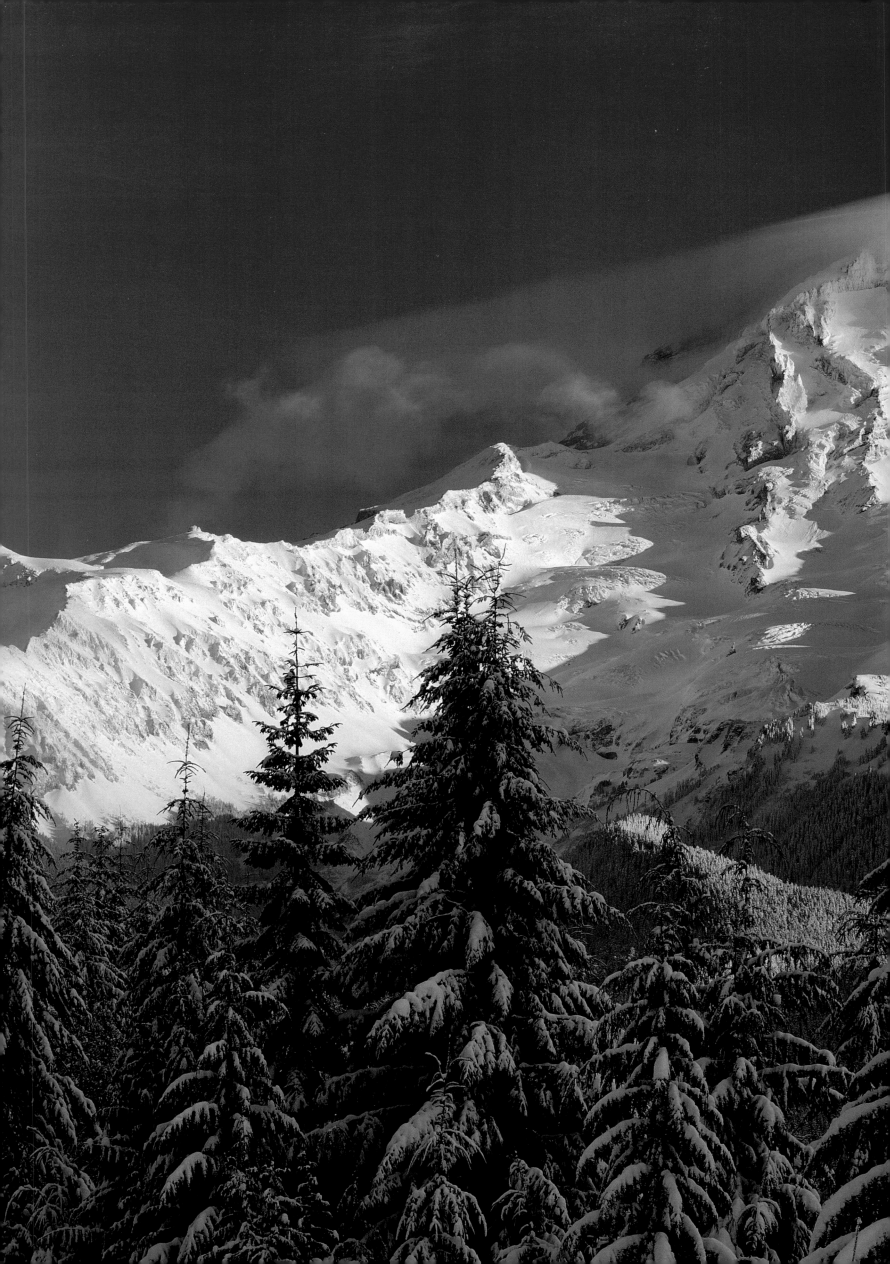

The Cascade Range

Stuart Range near Ellensburg

Range of Possibility
by Peter Potterfield

Our trail into the North Cascades follows Downey Creek for almost seven miles. Trees from the time of Charlemagne guard the way, soaring 150 feet into the forest canopy. What can one make of a living thing that has been growing, enduring *right here* for a millennium? The forest floor, thick with deer fern, is a chaos of deadfall, nurse logs, and massive trunks draped in moss and fungus. Some bridge the creek at crazy angles, felled by storms and avalanches of last year—or a century ago. It's cool in the dappled shadows of the ancient forest, but not quiet. The creek gurgles and murmurs and roars, putting a layer of white noise on the birdsong and footfalls.

Walking the river trail is conducive to stream of consciousness, but the reverie is broken when we reach Bachelor Creek, where the work begins. Here we turn to beat up alongside the small creek through hateful brush over soggy ground, tormented by devil's club and slide alder that impales us, grabs at our packs, and trips us up.

By the time we're out of the bog and onto the sunbaked switchbacks through high timber, the pack seems heavy, thigh muscles ache, breathing comes in gasps. But a perfect mountain meadow dotted with lupine and Indian fireweed leads us into a surprise storybook side valley beside a meandering brook. The little valley merges with a steep heather slope three thousand feet above Downey Creek, at a ridge that looks down on charming Cub Lake. The topography has opened up, the light of day is softening, the very air becomes different: clearer, thinner, sweeter. We move, more slowly now, up the final rocky slope of grasses and low alpine plants northeast to Itswoot Ridge.

We know we're still in Washington, but cresting the ridge affords at once transport into another dimension: Dome Peak, tomorrow's climb, stands impossibly close and high, its tower of rock draped in a low skirt of ice. The volcanic cone of Glacier Peak floats nearby like a vision over a landscape of simple majesty. Ridgelines arc away to the horizons, punctuated by snowy cones and rocky spires that rise above a sea of green forest. We have reached a deep center of the Cascade Mountains.

Though the range begins more than five hundred miles away, in California, it's here on Itswoot Ridge where the big booming bass notes of the Cascades can be seen to actually flow into the crashing crescendo of the North Cascades. It's here that the younger volcanic massifs farther to the south—Shasta, Hood, St. Helens, Adams, and Rainier—give way, reluctantly, to the jagged climax of the range. Many of the great reclusive ridges and peaks to the north—such as Mount Goode or the Northern Pickets—can't be seen from any road, but they exist there, hidden in ineffable glory from all but the most persistent pilgrim.

The journey into Dome may be the single most succinct and eloquent summation of the whole Cascade package, even a metaphor for the range. Through river valley and old-growth forest to alpine meadow and glaciated peak, these distinct zones must be experienced one at a time, and then fit into a greater whole. The component parts of the Cascades are similarly so diverse that trying to comprehend the range in a single go won't work. A better way to think about the Cascades is one place at a time, and with that perspective make the connections.

One doesn't have to be right *on* Dome Peak to feel its power, or even in the Cascades to be moved by them. Whatever power is exerted by the Cascade Range on its subjects—be it as ephemeral as an uplifting view from a distance, or as palpable as the rain shadow, or as intoxicating as days spent in their unpredictable and potentially dangerous embrace—emanates from just one thing: the mere physical presence of the range itself, the rock and snow and ice that make up its great bulk.

The range is nothing if not imposing, and so made of disparate parts that it would defy description as a single entity if not for the formidable geographic barrier it presents. Bisecting the state neatly and completely, as if engineered, from the Columbia River to the Canadian border, the Cascades have been the fulcrum of Washington's yin and yang, east and west, wet and dry, for as long as humans have lived here. The Cascades marked a defining cultural boundary long before British navigator George Vancouver sailed into Puget Sound in

Peter Potterfield

1792 and named the mountain he could see from *Discovery* for his friend Rear Admiral Peter Rainier, a man who never set foot on the continent.

The Native Americans of what is now Western Washington, known to anthropologists as Salish Peoples, after their language, were distinguished by the particular river on which they lived. "Every river has its people," one Swinomish elder is quoted by an early white settler, and there were a hundred autonomous groups living on the major and minor rivers that flowed from the slopes of the Cascades. Their attitudes toward their mountains, and the big volcanoes in particular, were similar. Rainier was viewed as a nurturing entity, invariably female, and referred to in myth as "mother" or "grandmother." The Nisqually Indians called the volcano *Ta-co-bet:* "nurturing breast" or "where the waters begin."

On the eastern side of the Cascades, the Yakimas and Okanogans had more in common with the Plains Indians than they did with the Salish. But they too had an elaborate mythology in regard to Mount Rainier that embraced the nurturing-mother icon. The Klickitats, who lived nearer to Mount St. Helens *(Loo-Wit)* and Mount Adams *(Pah-To),* passed down legends that allude to a real fear of their volatile peaks. Mountains that toss hot rocks and deadly gasses onto one's ancestors linger in memory. And for all their beauty, these mountains harbor a plenitude of lethal hazard.

The now-familiar ancient name ascribed to Mount Rainier, *Ta-ho-ma,* was probably coined by the Yakimas, and may actually have referred to any of the volcanoes or prominent peaks in the range. But the peoples living on opposite sides of those mountains blazed footpaths and routinely traded with each other. Nisquallies, in fact, sometimes married the taller and leaner Yakimas in order to improve the stature of their offspring.

Crossing the Cascades was not easy, and it still isn't. In a drafty old Yeomalt Point house I once rented on Bainbridge Island, an antique map of the state hung above the fireplace. I used to stare at that map for hours and marvel that it was pretty much right on except that the highways from both directions all stopped short of the Cascade Crest. Those eloquent gaps emphasized the difficulty of pushing usable corridors across the mountains. On modern maps, those lines now connect, but interestingly, the busiest routes today were not the busiest trails.

The first inroads into the Cascades were driven by economics. Timber and minerals were the obvious great allures. As unbridled harvesting and mining ensued, wagon road and rail had to be pushed farther into the range. Miners penetrated so deeply, and so high, into forgotten corners of the Cascades that one can hardly begrudge the damage they left behind. That was hard work. On repeated approaches into Boston Basin for climbs of Sahale or Sharkfin Tower or elegant Forbidden Peak, I've trekked through the rusting cables and machinery of the local mines, not with the distaste one feels climbing through a clear-cut, but with a grudging admiration of the pure effort applied. You can sometimes tell when you're on a trail built by miners: there are no switchbacks, only a straight track to the destination.

The first roadbeds over Stevens and Snoqualmie Passes were scouted and cleared by white settlers for neither boots nor wagons, but for railroads. The routes had tracks laid in them within fifteen years of each other around the turn of the twentieth century. Modern travelers cross the passes on paved and graded highways, and the last of these major routes across the Cascades was completed as recently as 1968. The North Cascades Highway, as it's known, is improbable in its dramatic setting. During those ragged, uncertain weeks on either side of the annual winter closure, the highway east of Ross Lake has the uneasy, way-out-there feel of roads in arctic Alaska. The decision to build that highway was hotly debated, and could have gone either way. I still wonder how the view of Liberty Bell and Early Winter Spires one gets coming around the bend at Washington Pass really compares with the same view back in the days you had to walk it.

Beating over the range on any of the highways in winter underscores the uncertain nature of Cascade travel even here at the millennium. Stim Bullitt and I were returning from an

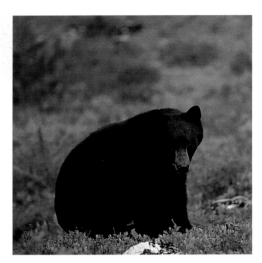
Black bear

excellent but spectacularly unsuccessful winter climbing trip when we were reminded of that. We had pulled sleds in deep snow out of Mazama for three days and didn't so much as get within a mile of our objective, much less climb it, but that's winter mountaineering in the Cascades. The snow had stopped, but cold had seriously settled over the pass by the time I steered the car across the summit at Stevens in the muted gray light and gloom of that afternoon.

Thinking we were home free, Stim began buttering up some old bread he found in the food bag as we took the long downhill grade west of the pass. But on the black ice neither of us saw, the car floated free in a dreamy, sickening way, and commenced to spin, slowly, clockwise. We did one big, lazy, heart-stopping loop after another as we hurtled down the two-way thoroughfare. Stim sat frozen, wide-eyed, the butter knife poised in midstroke. After three or four orbits I managed to get us going in the conventional way. Stim silently resumed buttering, and finally offered what there was to say: "Well, it's a good thing nobody was coming the other way."

The odds had caught up with us, but we escaped unscathed. This time, at least. After a thousand backcountry excursions, I sometimes wish I had a nickel for every time I've driven over the Cascades, or into them. But what I really want is a thousand more forays. All things being equal, my preferred route for driving over the range is via Snoqualmie Pass and then over Blewett Pass. I love the rolling meadows and subalpine forests of the high plateau between the passes, the snow-plastered summit cone of Mount Stuart sticking up rudely like a papier-mâché stage prop. Stuart's hulking form and its prominent location in the east-central Cascades make it ubiquitous from higher elevations. Climb almost any mountain from Rainier north to the Pickets, coil the rope, take a look around, and more than likely, there's Stuart. It's as big as some of the volcanoes, but is in fact an enormous batholith, an uplifted and eroded mass of exposed granite, perhaps the largest in the nation. Stuart is a range unto itself, a feudal lord with a long, orderly line of serfs in tow—Sherpa, Argonaut, Colchuck, and Dragontail.

Having climbed Stuart and many of its outriders, sometimes by multiple routes, I came to know the mountain in a different way on a midweek day in January. Steve Firebaugh and I drove eastward across Snoqualmie Pass, then left the interstate at Cle Elum River Road. The narrow blacktop was plowed free of snow far enough to get us within reasonable proximity of the Jolly Mountain Trail. The valley was still and silent, gripped in an arctic air mass when we parked the car. Our intent was a little fresh air and exercise in the depth of winter, a mere outing. By the time we had punched up the five miles to the summit ridge on snowshoes, the pale winter light already was fading and the pack-zipper thermometers were reading five below. Even for a midwinter trip in the Cascades, that's cold. To my surprise, Mount Stuart loomed, close and big. Of course it would be there; I just had not thought it through.

We brought no tent, so Steve set about digging a cave in the deep snow on the lee side of the ridge. While he dug I pretended to busy myself with the stove and other gear but was actually absorbed in the unexpectedly dramatic close to the short winter day: a crimson and purple sunset so lurid it hurt the eyes, and growing more intense by the second. I coaxed Steve out for a look. Through the unreal clarity of the frozen atmosphere, the huge flank of Stuart was *right there,* bathed in fiery alpenglow. The display was short, but unforgettable.

Back inside for dinner, the cave was a cozy cathedral. Illuminated by a single candle, it dazzled like a crystal palace, warmed by the stove. Once fed and rested and rehydrated, we squirmed out through the entrance to enjoy yet another spectacle. Standing at our threshold, we stamped our feet and talked quietly as the full moon rose higher, painting the mountain in an eerie lunar light. When the cold finally chased us back into the sanctuary of the sleeping bags, I dozed off, content and thankful. I realized how lucky I am to be wired up in a way that drives me to places where I can see what I had seen that night.

The Cascades move people. One hot August evening I drove a New York magazine editor up to Kerry Park on Queen Anne

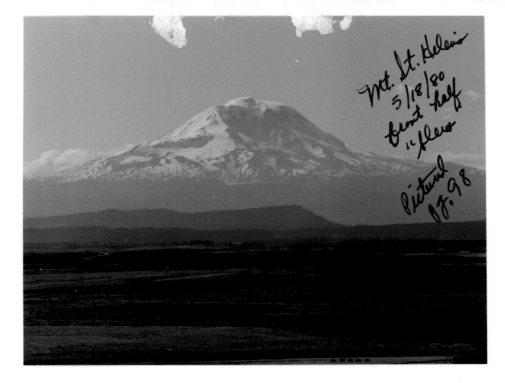

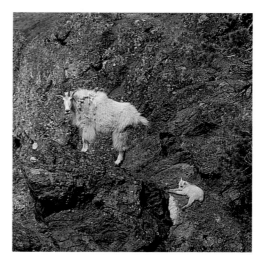

Mountain goat and kid

Hill for a sunset view of Rainier over Seattle. He stood there, his expensive suit jacket hung over his shoulder, helpless as his practiced, jaded bearing gave way to slack-jawed amazement. Clearly moved by his own "experience" with the Cascades, he said, finally: "It can't be real."

Looking at the Cascades from afar can be a complex, almost painful experience. I can't see them in a flattering light without wanting to be in them, in their gloomy forests and sheltered meadows, and on their windy ridges. When a view of Mount Baker pops up unexpectedly somewhere along Interstate 5, I find myself wondering what conditions are like up on the North Ridge, or on the rocky flanks of the Twin Sisters, those jagged-tooth consorts to Baker that are silhouetted against the volcano's white flanks. And anywhere in Washington, Rainier is liable to show itself to torment me further.

More than Dome or Stuart or the other major peaks, Rainier symbolizes the Cascades. Twenty-two years ago, the simple desire to climb to its 14,410-foot summit was the very thing that put me on an airplane and brought me within the Cascades' sphere of influence. The fact that I returned for good is proof that I was well and truly seduced. In the beginning, all I wanted to do was get to the top of this highest of the Cascade peaks, and there I was, puking on the summit with the other eager seekers who had climbed too high, too fast. In the intervening decades, I've learned to enjoy the backcountry around Rainier even more than its higher slopes. I frequently hike in the Tatoosh Range, on the south side of the mountain, just to feel the looming presence of Rainier. Scientists tell me that big mountains actually exert forces that can be measured on gravity meters, a fact that comes as no surprise to me.

On a solo backpack trip to Rainier's north side almost two decades ago, I spied from the trail what appeared to be a hidden alcove of meadow tucked between two towers of rock on an outlying ridge. It took hours of hard and sometimes dangerous work to get there, but what I found was even better than I had hoped for. A place of real solitude, if you don't count the goats, my secret meadow has a killer view into the Willis Wall, the sound of avalanches booming down from

the heights, and a snow patch into late July for water. I've since scouted a more direct route there, so choked with deadfall and unrelenting steepness that I've little worry others will find it. I've returned to that spot a dozen times, and never fail to have it to myself.

For all my trudging up and around Rainier, my understanding of it was boosted to a higher level by merely being strapped into the backseat of a supersonic airplane. Life is full of ironies, and this was one. While profiling pilot Mark DeBolt, a particularly accomplished fighter pilot at an Air Force base near Tacoma, I became a kind of Jane Goodall to his odd, closed society of squadron pilots, who were my "apes." It took six months of just being there to get beyond the fighter-pilot platitudes, to establish a bond substantial enough to evoke honest responses. Twice DeBolt took me aloft to show me the small, tight space in which he worked, and I don't mean the cockpit. On the way to the protected airspace off the coast where he and his colleagues practiced their trade, DeBolt detoured to give me the grand tour of Rainier.

The cone of Rainier filled the sky above the black globe of DeBolt's helmet. It was May, so a heavy mantle of snow still covered the upper mountain, and only the tops of the distinctive radial ridges that climbers call cleavers protruded above the snowpack. Even from fifteen miles away I had to crane my head upwards and look through the top of the canopy to see Rainier's shimmering summit. Traveling at five hundred miles per hour, DeBolt, clearly irritated, complained the airplane with its full load of fuel was "handling like a pig." So he fired the afterburner and we rocketed directly at the surreal white parabola floating in the expanse of blue.

Below the airplane, a blighted checkerboard of clear-cuts ran right up to the mountain, abruptly stopping in the plumb-line-straight border that separates towering old-growth forests from the logged-over stump fields: the national park boundary. From my perspective, Rainier looked under siege. Just as it seemed we'd fly right into the mountain, DeBolt banked his delta-winged fighter above the Mowich Face and began a midheight circuit of Rainier.

Silver Creek near Snoqualmie Pass

With the canopy canted toward the mountain, I could take in at a glance all eight miles of the Carbon Glacier, flowing from the base of the chaotic Willis Wall to its terminus at timberline, where melting water from its snout formed both forks of the Carbon River. Yawning crevasses on the upper slopes marked the point where Liberty Ridge rises out of the glacier for five thousand vertical feet to join the summit plateau at Liberty Cap. Despite the fact we were screaming around Rainier at nearly the speed of sound, Rainier is so big I had ample time to pick out landmarks. The experience was exquisite proof of the massive scale of the mountain's impressive architecture.

The last time I climbed Rainier was with Scott Fischer, a friend and climber who loved mountains without reserve. He was one of those enviable people who had figured a way to spend almost all his time in the mountains by guiding all over the world. We ascended the Emmons route, and moved fast. One of our party broke through a snow bridge at twelve thousand feet, moments after I had crossed it, and fell into a deep crevasse. It was a worried moment, but we had the guy out before he could go hypothermic, and we were on the summit by 10 A.M. Scott laughed and laughed, and pulled cans of Rainier Ale out of his pack to pass around in celebration.

When Scott Fischer died on Mount Everest in 1996, it brought home the fact that mountains have a dangerous side, and a life spent in them can come with some sadness, even tragedy. Along with the joy I've felt in the Cascades has also come a measure of naked fear, distasteful to me and at odds with my self-image. The mountains also bring predictable discomfort and pain, and even outright misery in the unrelenting drizzle and gloom that can hang close for days. Sometimes it's too hot, or too cold, or too much hard work, but mostly, for me, it's just fun—honest moments of pleasure spent with interesting people in pretty places.

At the self-possessed age of thirty-eight, when I thought my judgment and experience would see me through a lifetime of fulfillment in the Cascades without serious consequence, I was surprised once again at where these mountains would take me. On the last climb of a weeklong outing deep in the Alpine Lakes Wilderness, I found myself on a small ledge on Chimney Rock, the prominent peak on that section of the Cascade Crest. The mountain is made of metamorphic rock, rotten in places, but it's high and bold and striking, a peak that would be more at home in the North Cascades than here in the central part of the range. From my high perch above seven thousand feet I could look far down into deep Cooper River Valley. The pretty Pete Lake was far below, in the trees; the larger Cooper Lake, farther yet down the valley where it doglegged east.

It was a magnificent view, and likely the last I would have. I had taken a deadly leader fall that morning, bounced and flailed and crashed down the steep rock wall, and now lay, broken and marooned, on the tiny ledge. The splintered ends of fractured bone protruded through my skin, and though by then I had stopped most of the bleeding, my death seemed to me a certainty. My companion, assuming he had figured a way down the problematic technical sections of the upper mountain alone, was going for help. But it was nearly twenty miles to the trailhead, so it could be days before rescuers arrived. Damaged, in shock and bled out, time is what I didn't have.

The late afternoon light had softened the valley aspect, and from high on the mountain I watched the trees below me go from green to black, just black, as the light of day left them. A raptor soared effortlessly on the thermals. I was surprised to find that even in my wretched condition, the beauty of this place was not lost on me. I had learned something that day: when death comes close, and stays close, panic departs. One is left to ponder one's demise without self-pity, or even fear, but with clarity. I didn't want to die, but I found myself thinking that if this were to be my fate, what a place to enter the hereafter.

My rescue was magnificent and unlikely, and though I lived, I did so in a very different way. It was years before I had healed well enough to venture again into the Cascades. But I returned as soon as I could, albeit in a transformed way, a far less able climber, a less arrogant human being, knowing my recovery would be forever incomplete without the palpable peace I always feel among those mountains. ■

Wild flowers
along the N. Cascades
Hwy — took a great
3 day Harley trip — mom
wonderful

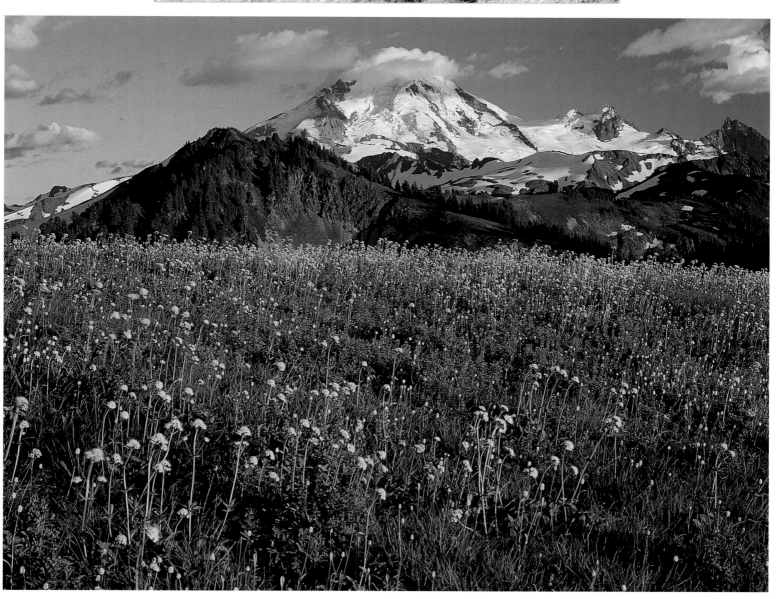

▲ Valerian, lupine, and American bistort share a summer day
along the Skyline Divide Trail on the north side of Mount Baker.

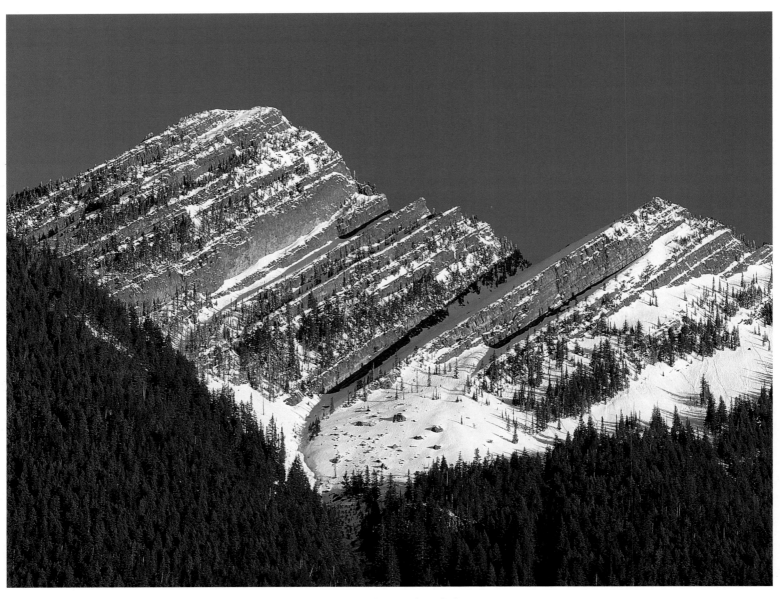

▲ Mount Higgins displays its layered rock face near Darrington.
▶ From Artist Point, sun, moon, and shadow conspire to create a
sunrise view of Mount Baker and a silhouetted mountain hemlock.

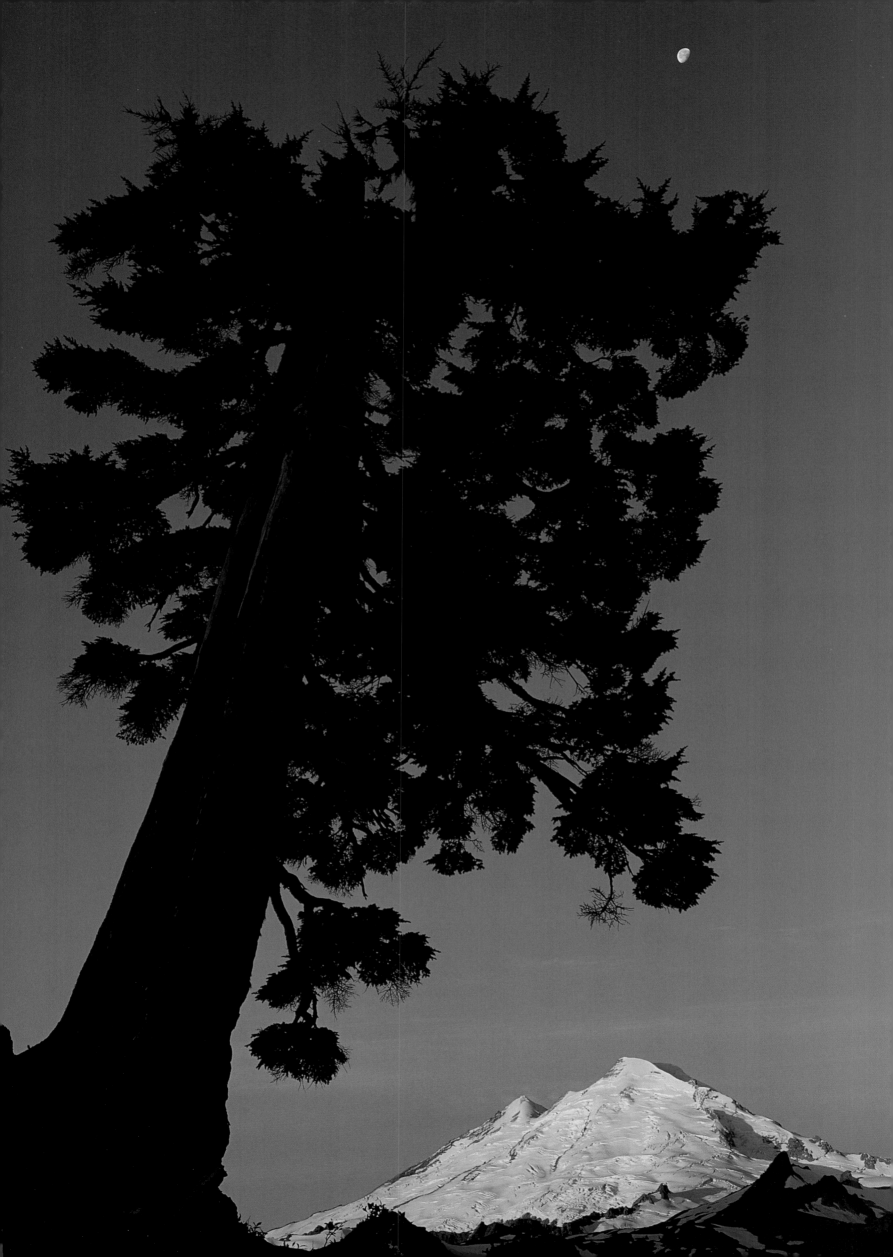

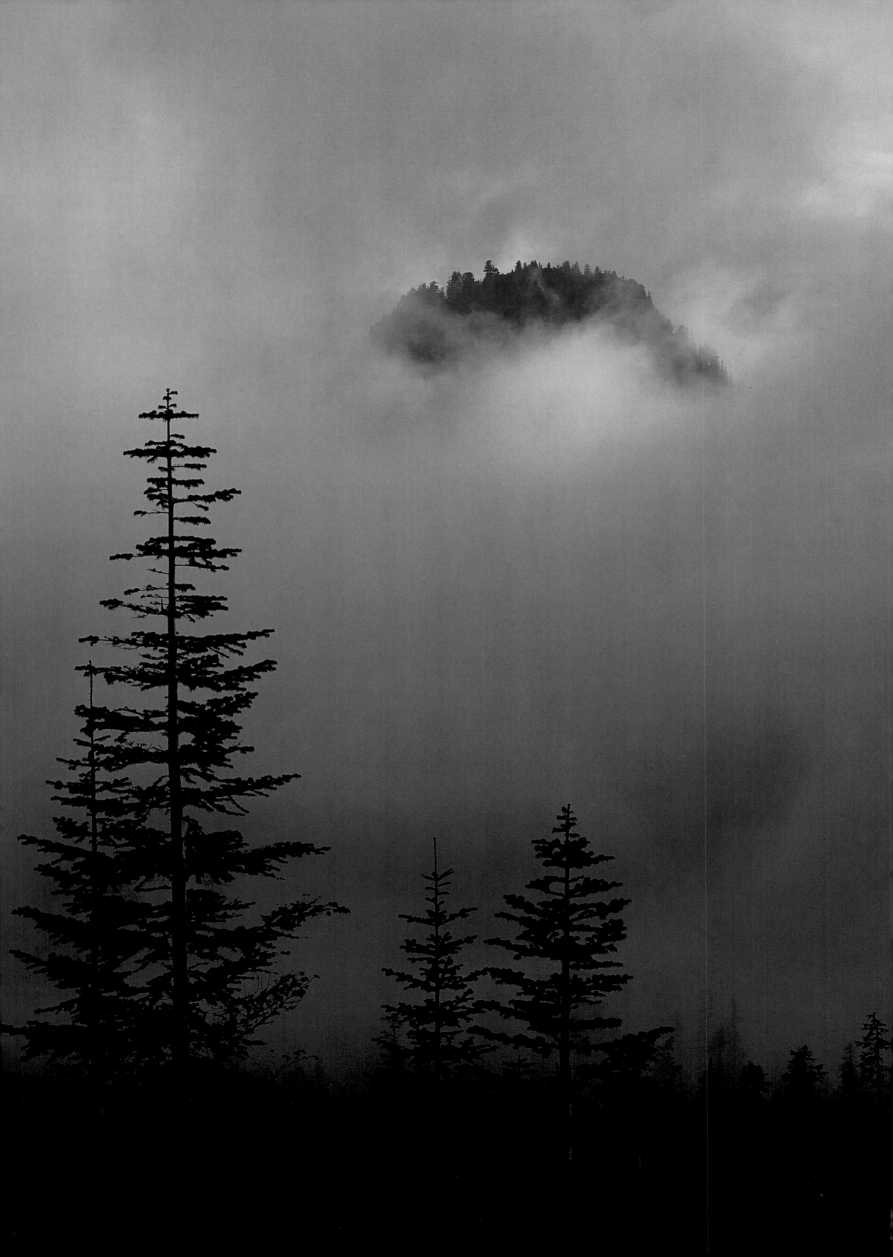

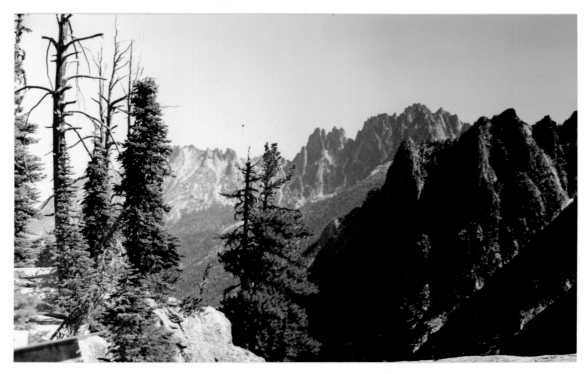

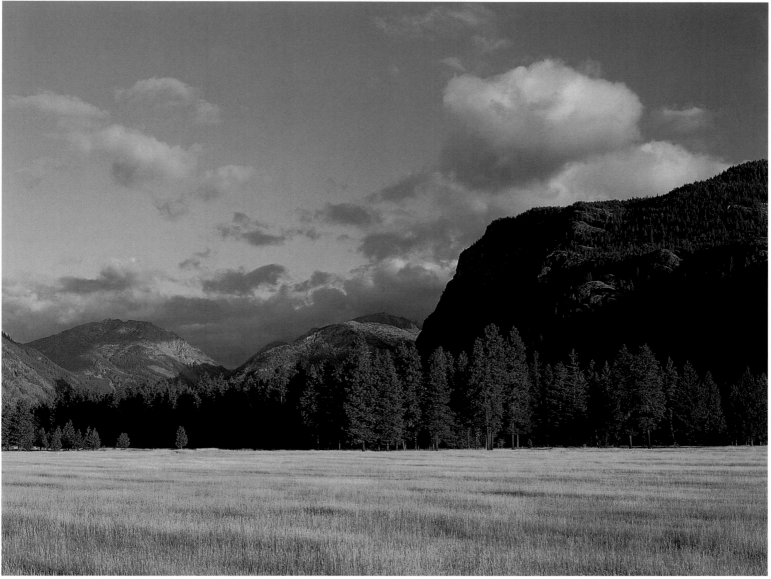

◄ Shifting fog grants a glimpse of Grouse Butte, by Mount Baker.
▲ Goat Wall rises from a Methow Valley meadow, near Mazama.
► ► A grand outcropping of granite confronts travelers along
the North Cascades Highway at Washington Pass. Liberty Bell is
the peak to the right; the two Early Winter Spires are to the left.

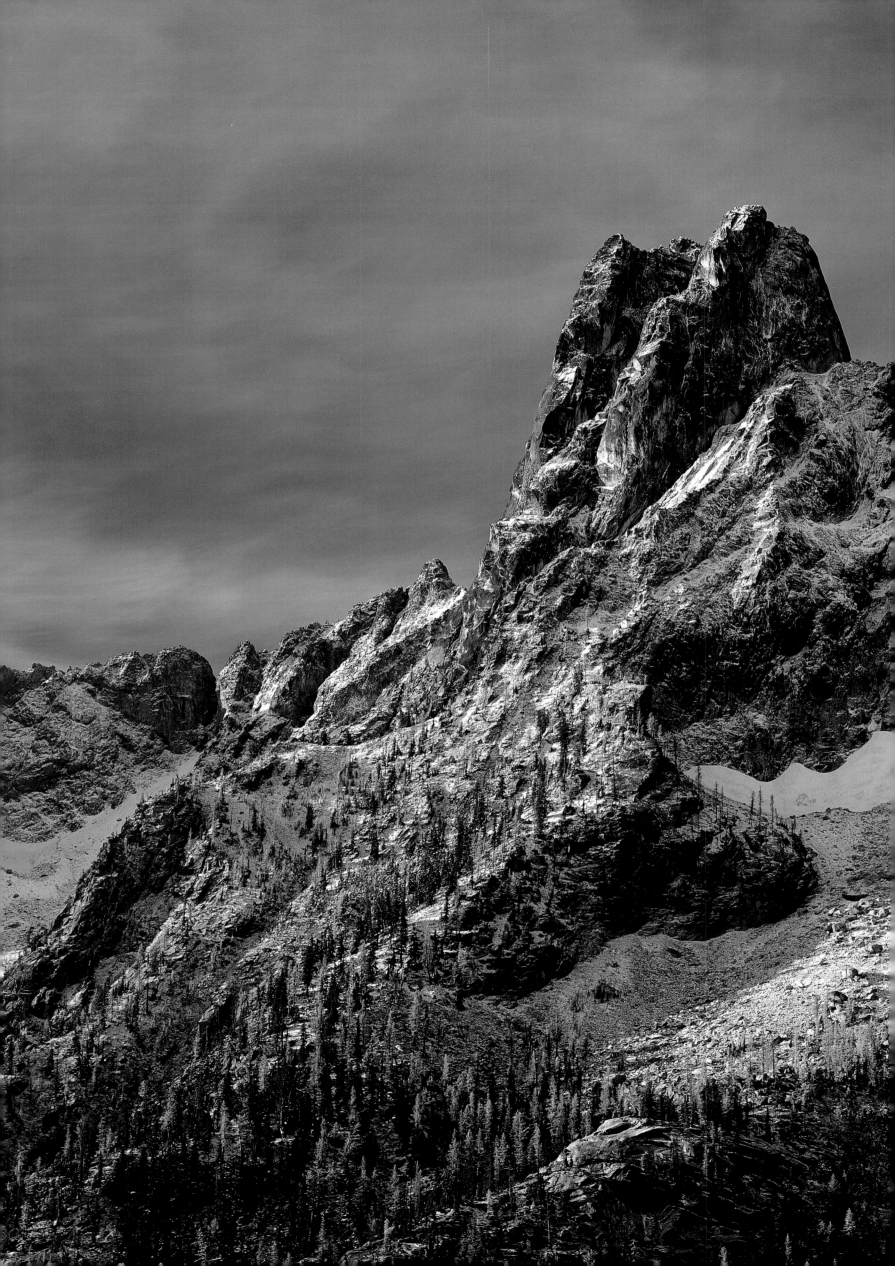

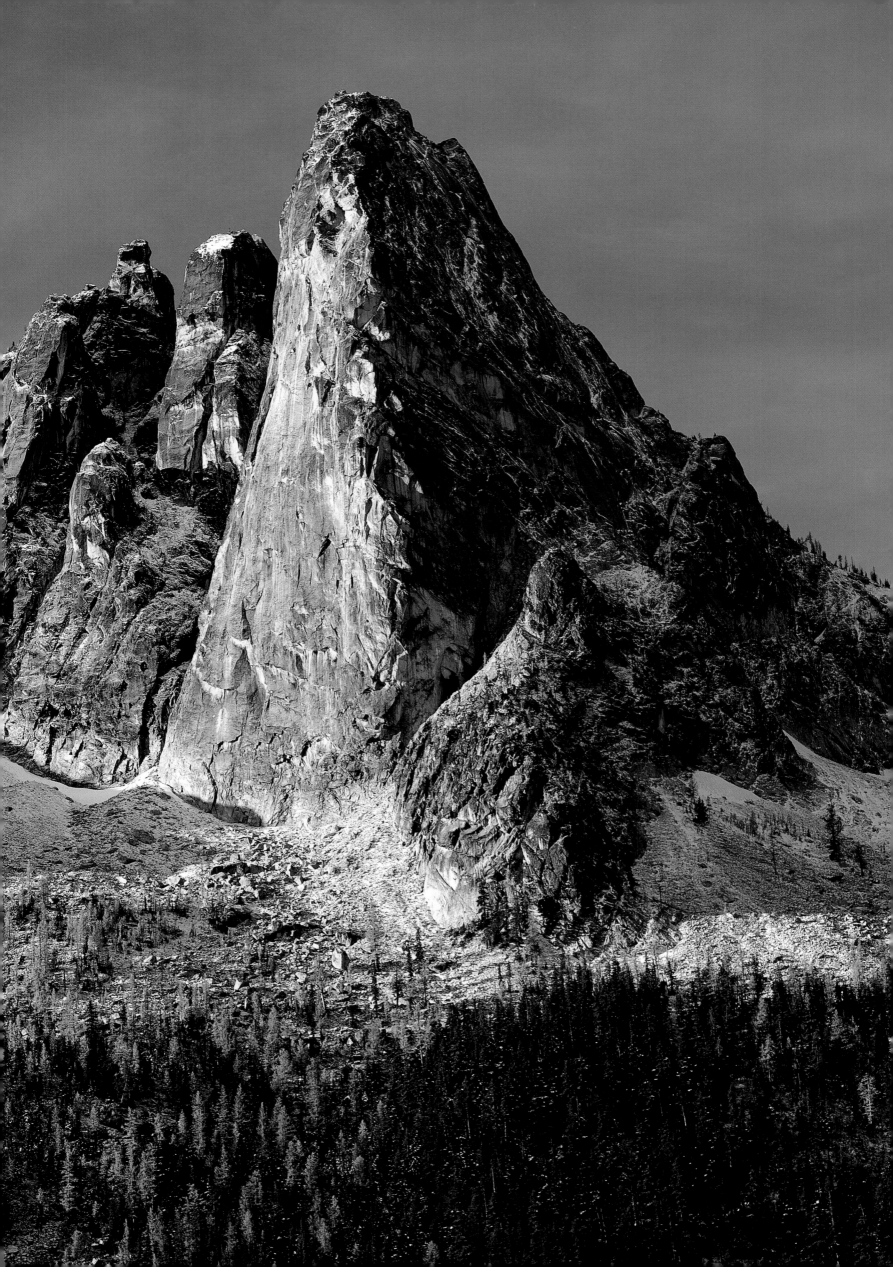

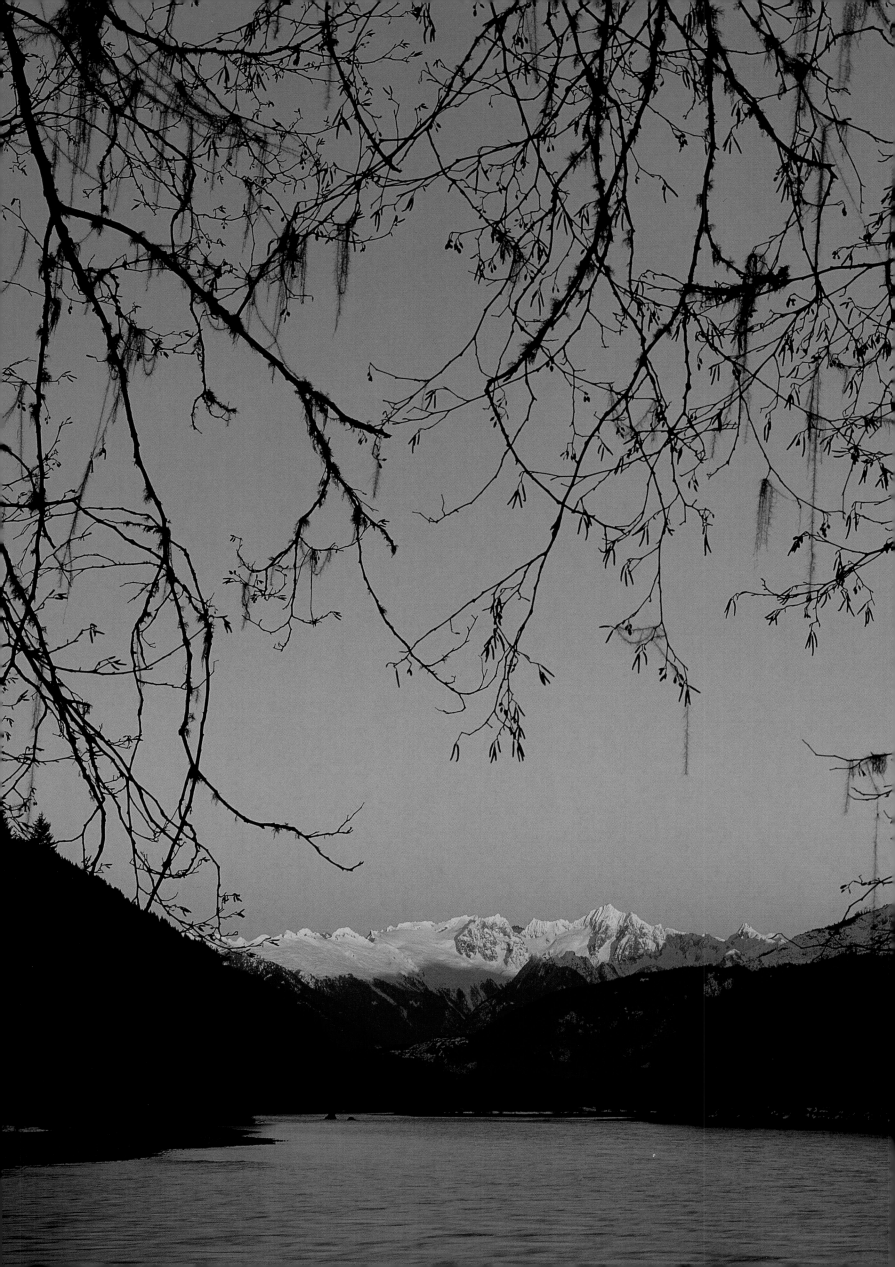

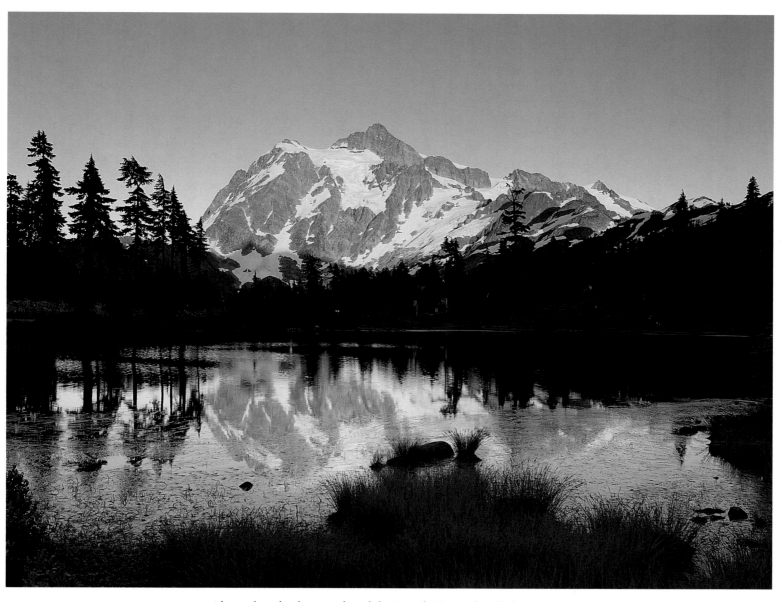

◄ Alpenglow bathes peaks of the North Cascades, lighting up an evening view from the Skagit River, near the town of Concrete.
▲ Picture Lake mirrors Mount Shuksan in the North Cascades.
►► A grove of big-leaf maples etched in autumn light stands beside Sauk Valley Road in Western Washington.

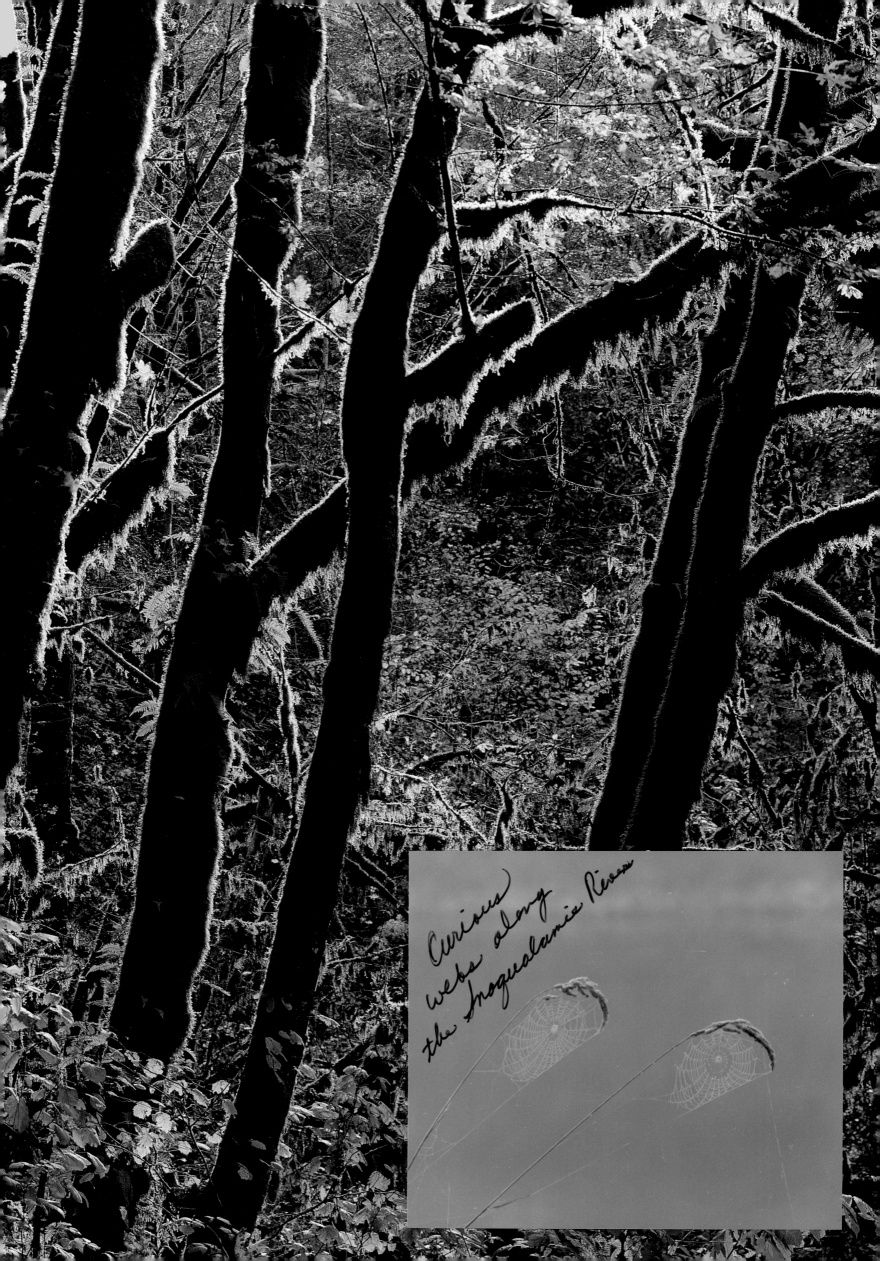

Curious webs along the Snoqualmie River

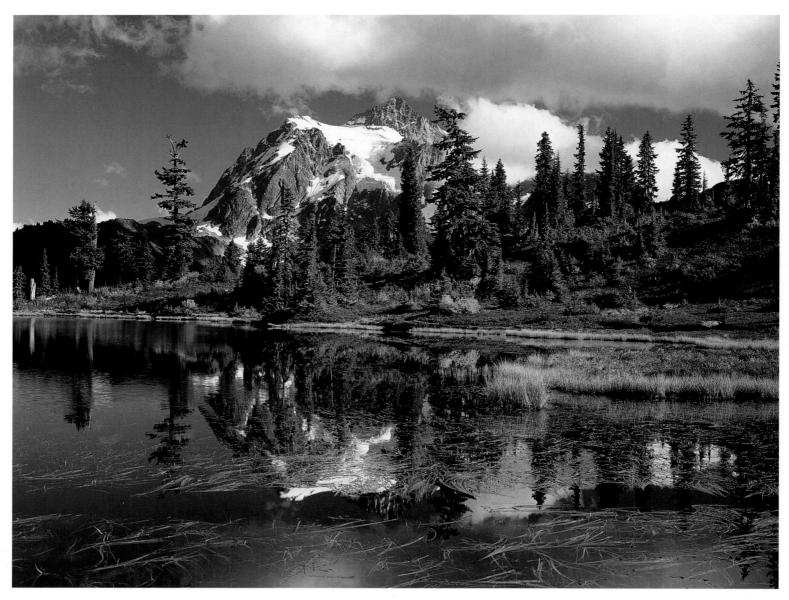

▲ Picture Lake, west of Mount Shuksan, lives up to its name as huckleberry, blueberry, and mountain ash contribute fall color.
► Hikers head to the hills in fall to discover the alpine larches in their autumn glory. These larches are in Glacier Peak Wilderness.

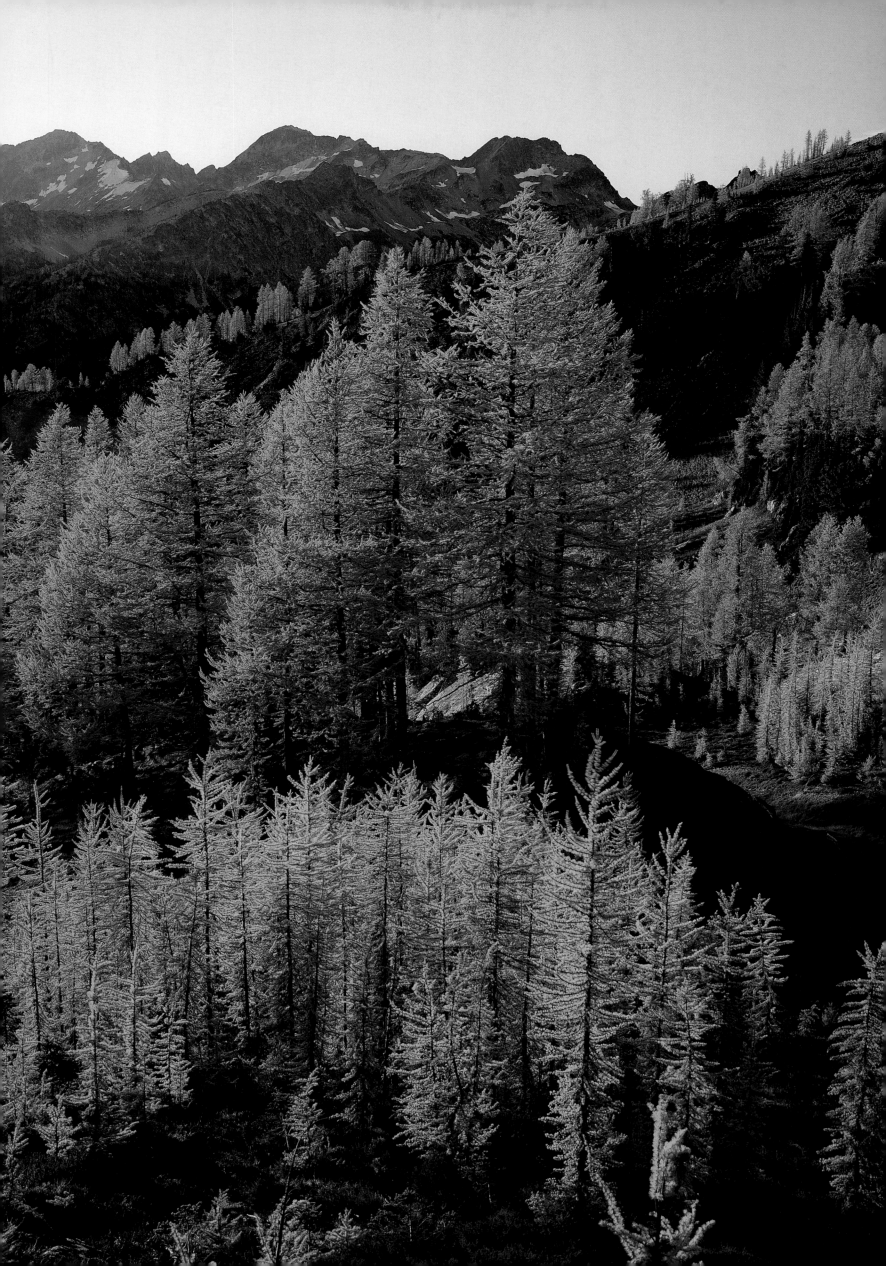

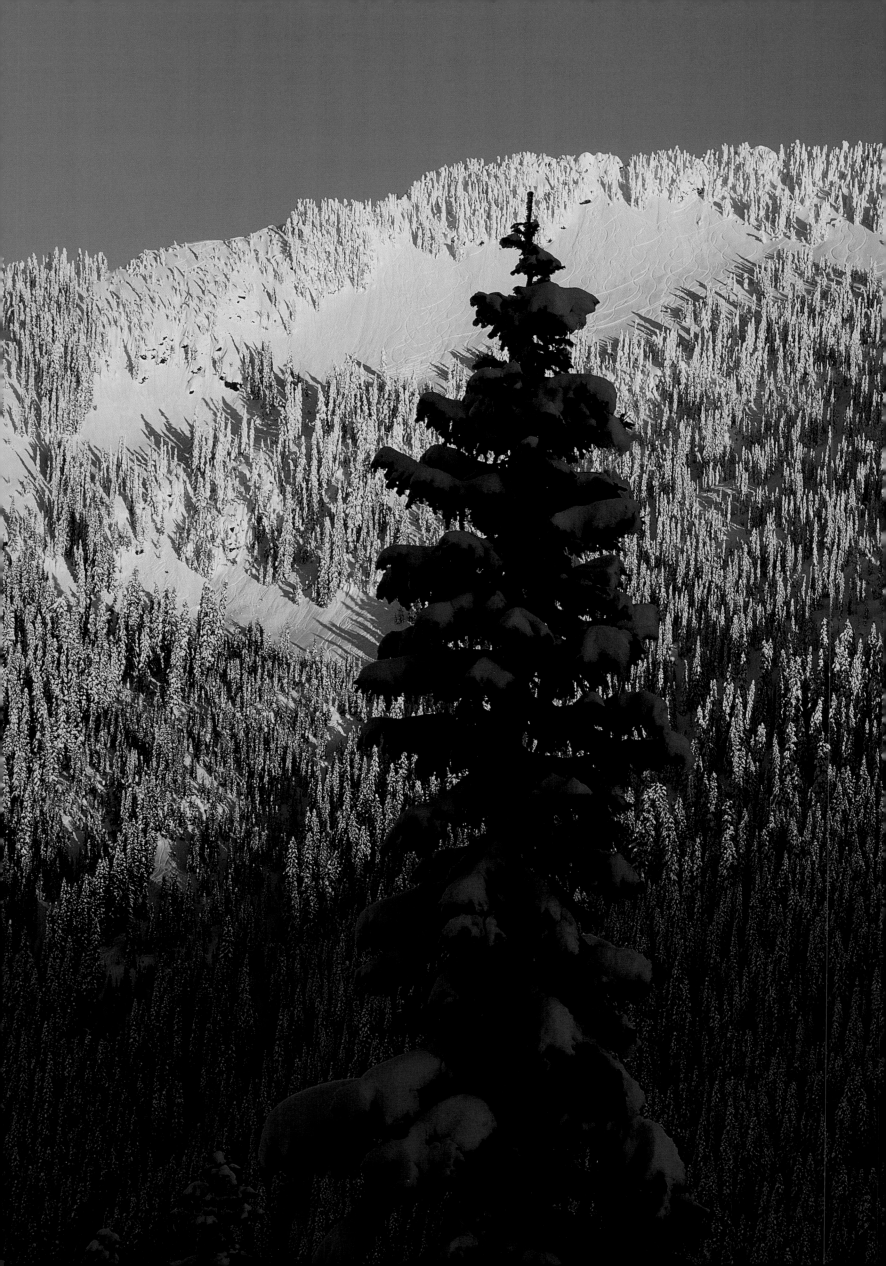

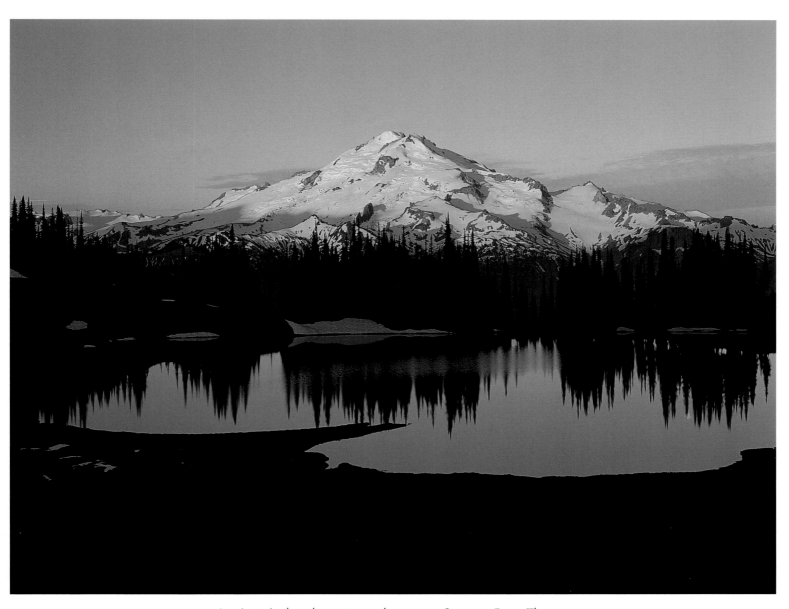

◄ A winter's day draws to a close near Stevens Pass. The open area below the ridge is known to skiers as Wenatchee Bowl.
▲ Glacier Peak beats Image Lake to the first sunshine of the day.

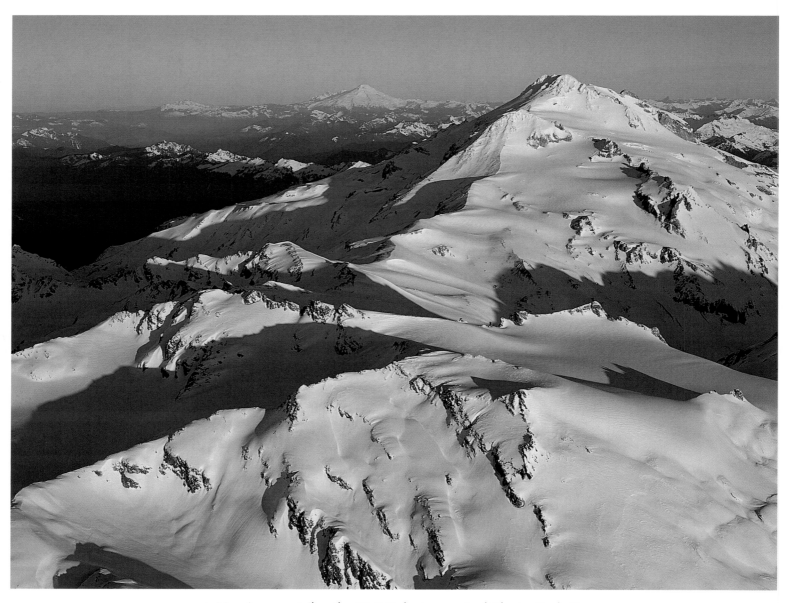

▲ Morning sun strikes the 10,541-foot summit of Glacier Peak. To the north, Mount Baker is lord of its own region of the Cascades.
▶ Sven Jonassen races past mountain hemlocks at Stevens Pass, in the Mount Baker–Snoqualmie and Wenatchee National Forests.

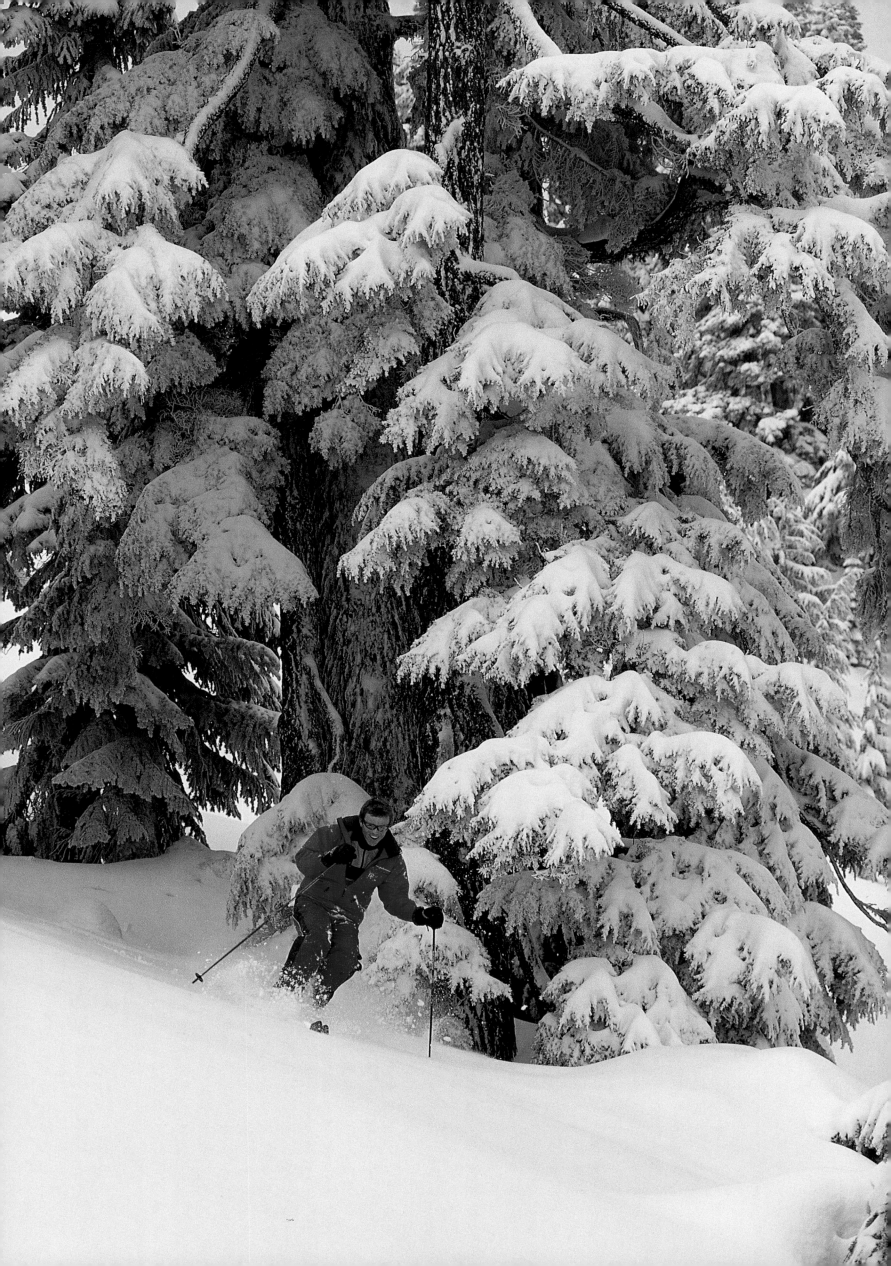

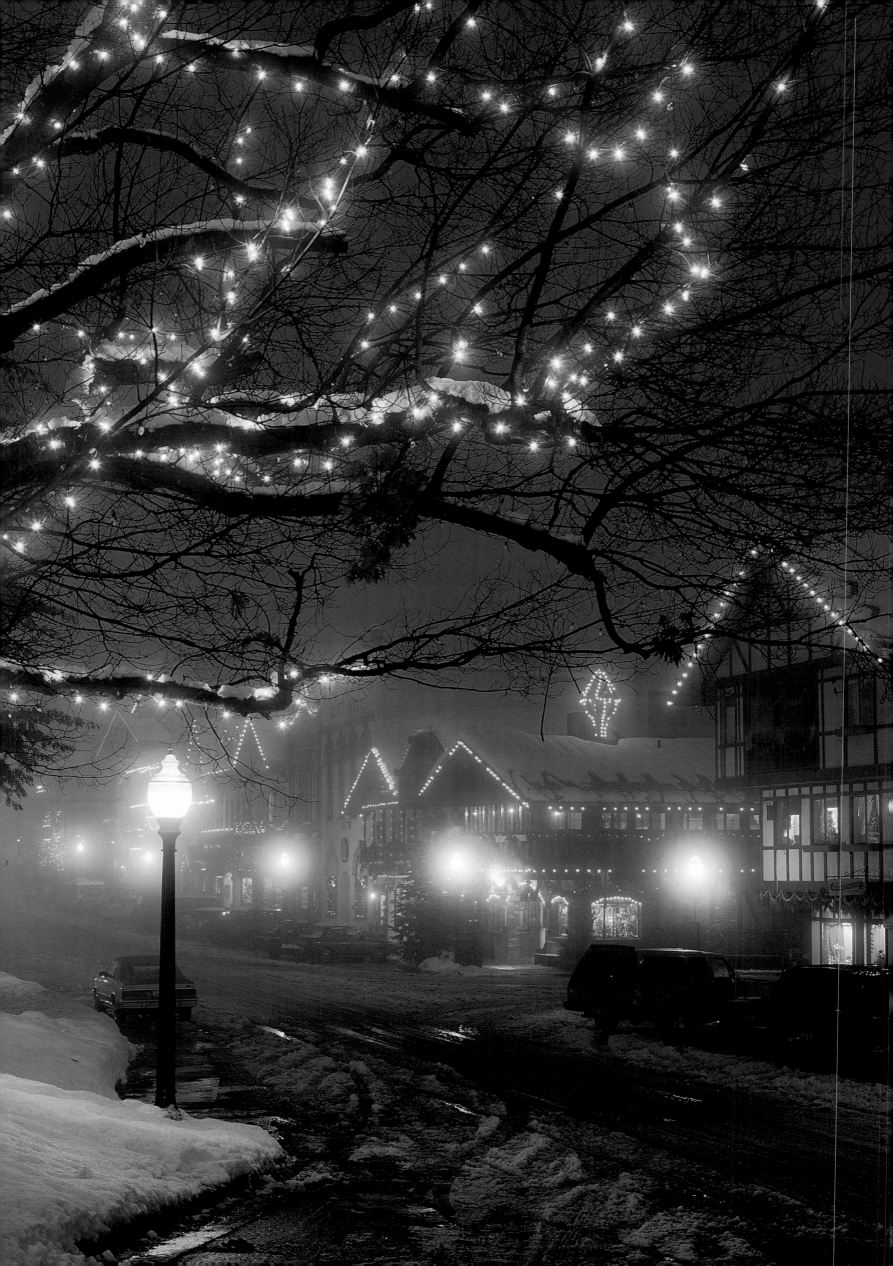

Spring thaw
around Leavenworth
brings out the
mushrooms — many
edible, some not.

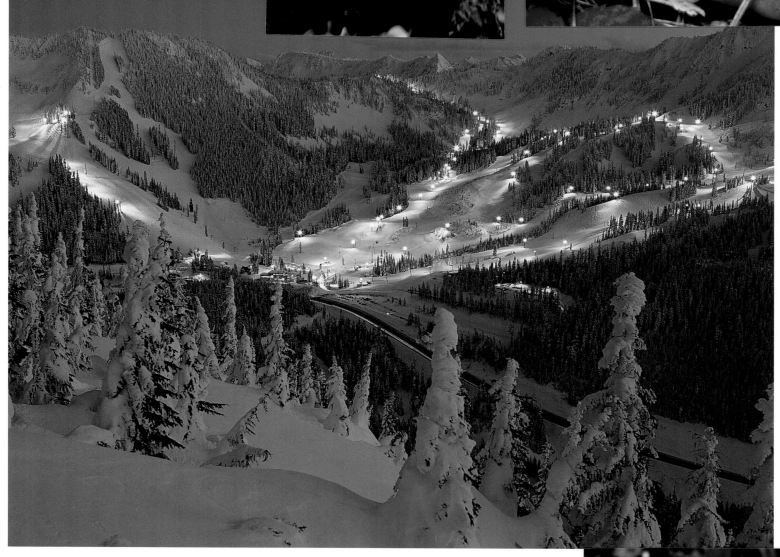

◄ Leavenworth, permanently gussied up as a Bavarian village, brightens the winter night with street lamps and Christmas lights.
▲ Rows of lights outline the slopes at Stevens Pass as day begins to fade and the area prepares for several hours of night skiing.

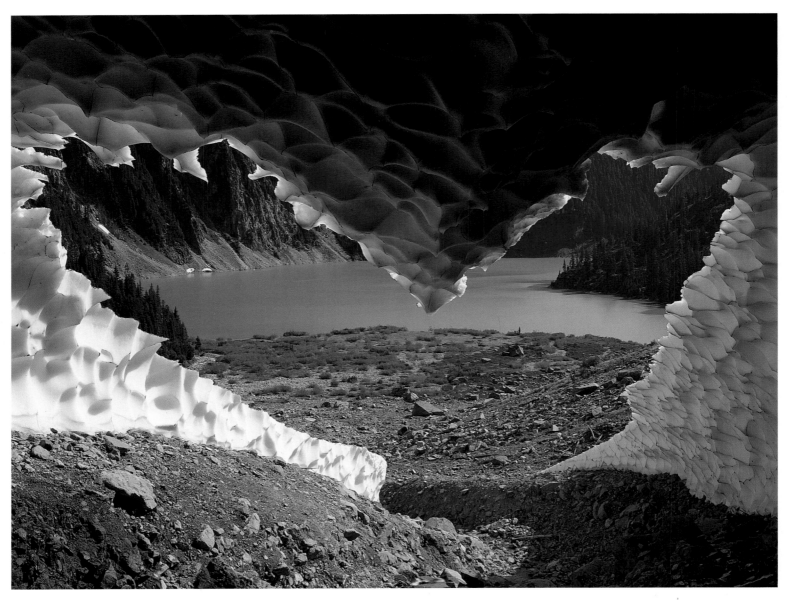

▲ Blanca Lake, viewed from the mouth of a snow cave, beckons
to hikers. Water flowing beneath a field of snow created the cave.
▶ The spires of Johannesburg Mountain stab the sky above the
Cascade Pass area of North Cascades National Park.

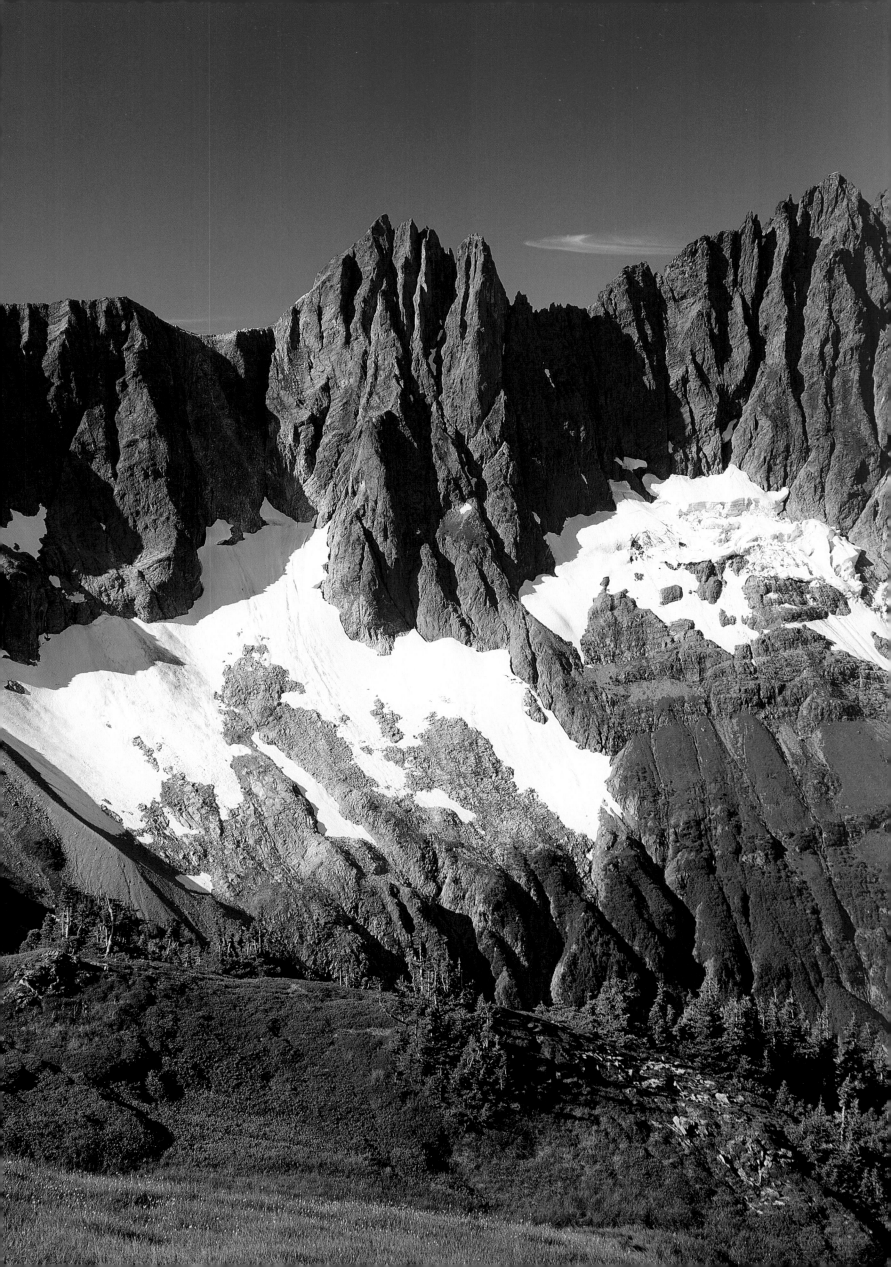

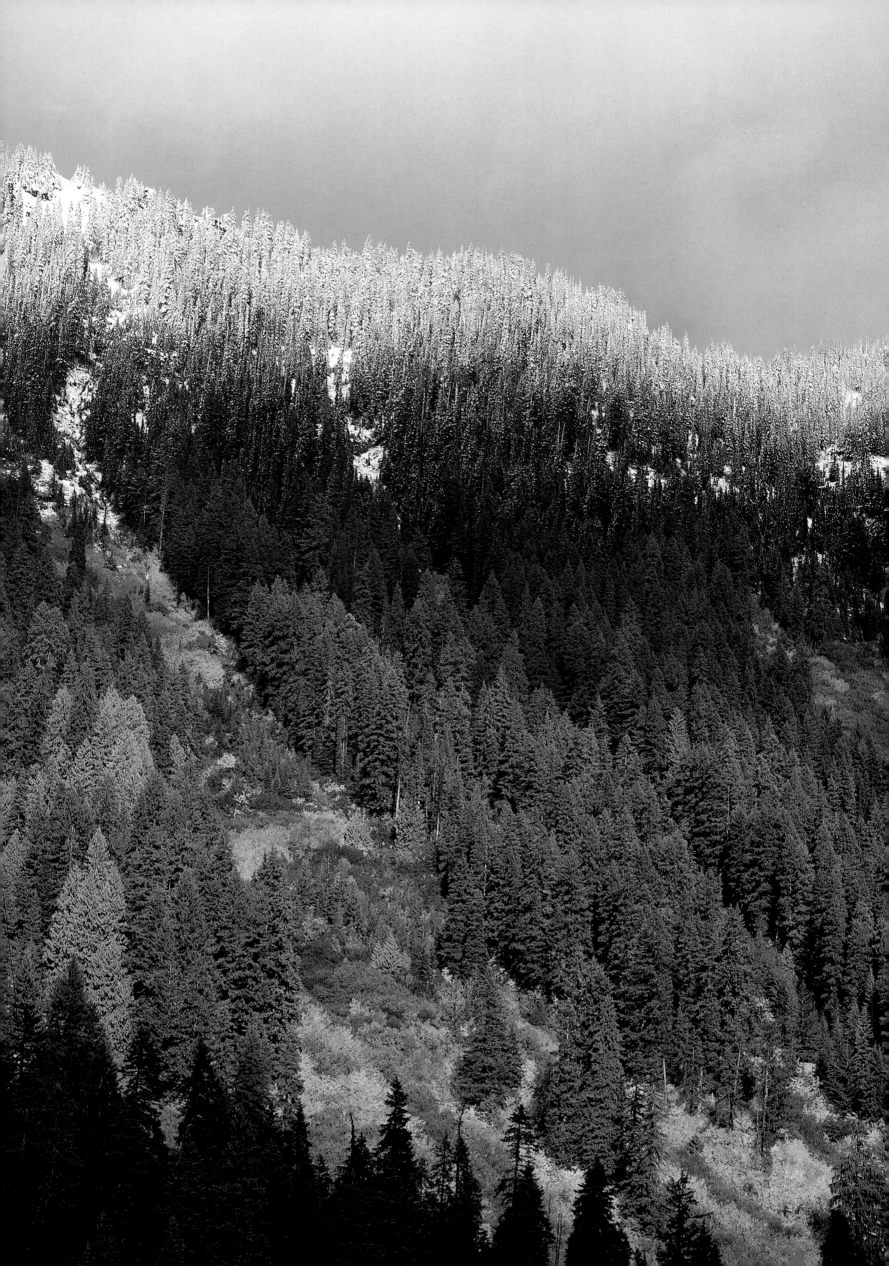

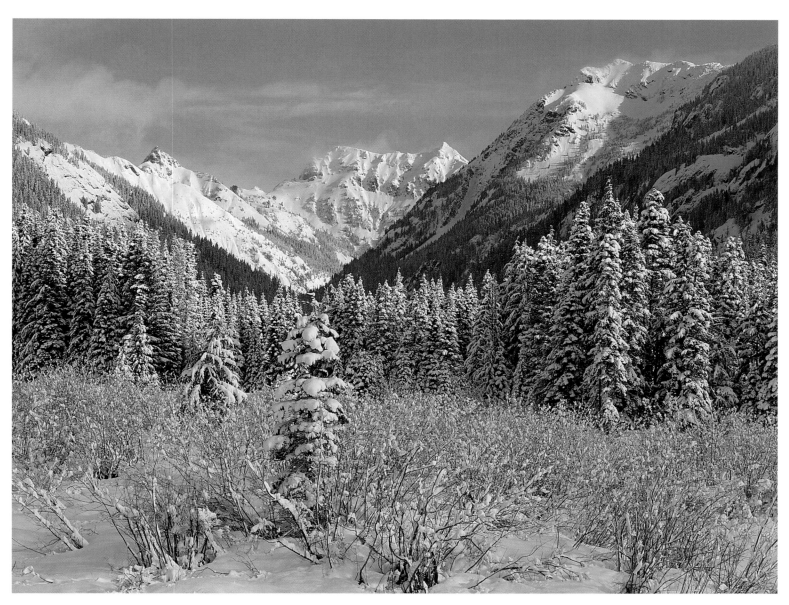

◄ Early snows whiten Nason Ridge near Stevens Pass, even as an avalanche chute through the forest remains ablaze with fall color.
▲ The Gold Creek basin east of Snoqualmie Pass is popular for cross-country skiing. At the head of the basin is Chikamin Peak.

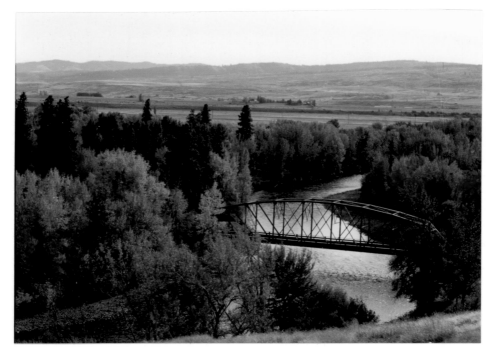

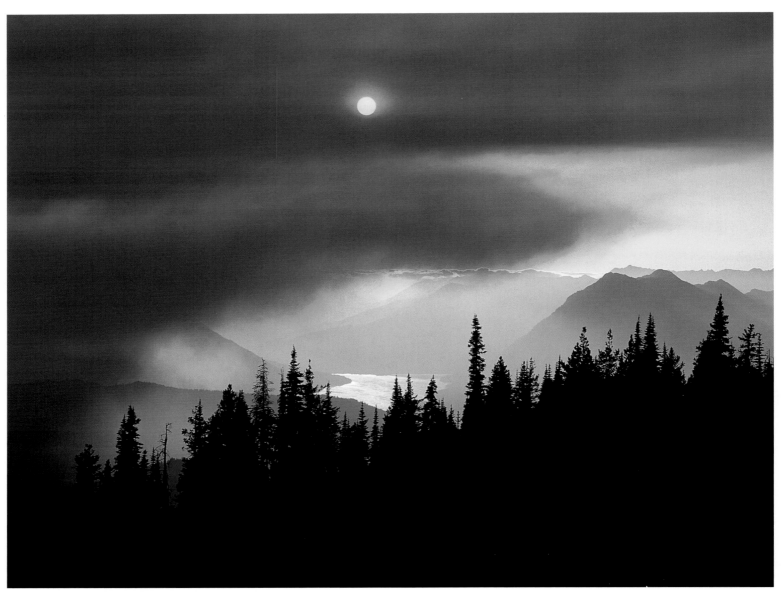

▲ Smoke rising from a fire in the Wenatchee National Forest turns day to dusk near Lake Wenatchee in the Central Cascades.
▶ The price is four and a half miles of hiking; the payoff, an awe-inspiring view from Lake Stuart of the north face of 9,415-foot Mount Stuart. The lake lies within the Alpine Lakes Wilderness.
▶▶ Clouds move in on Ives Peak in the Goat Rocks Wilderness.

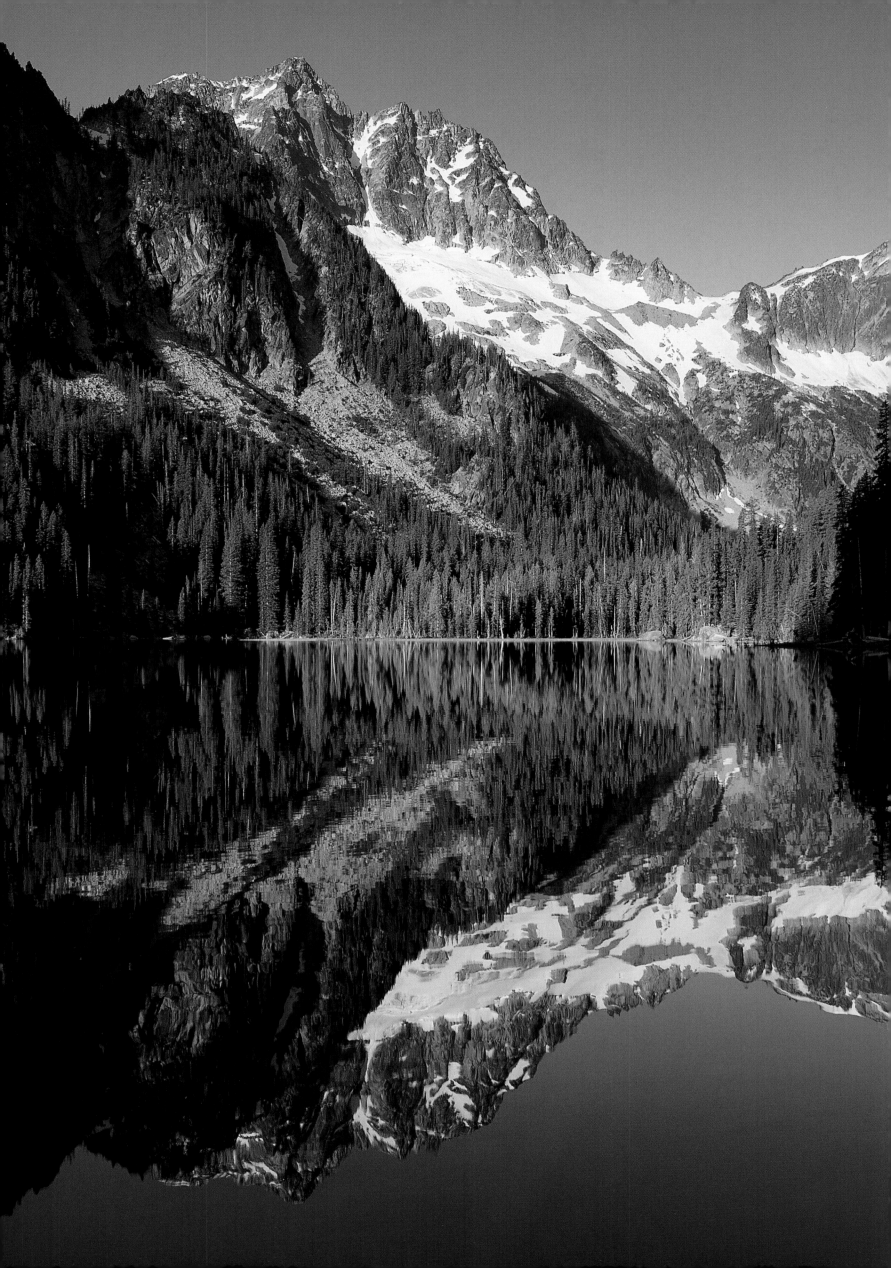

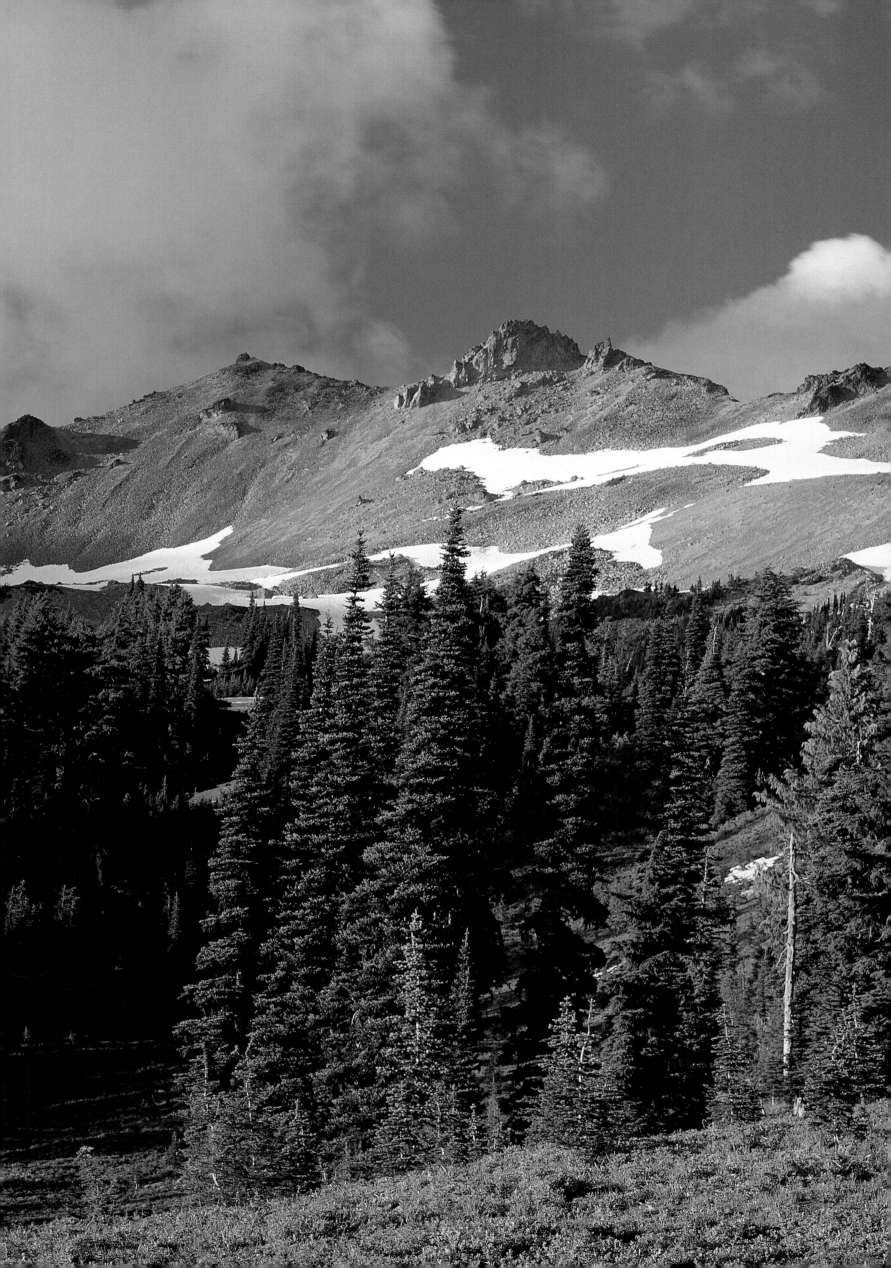

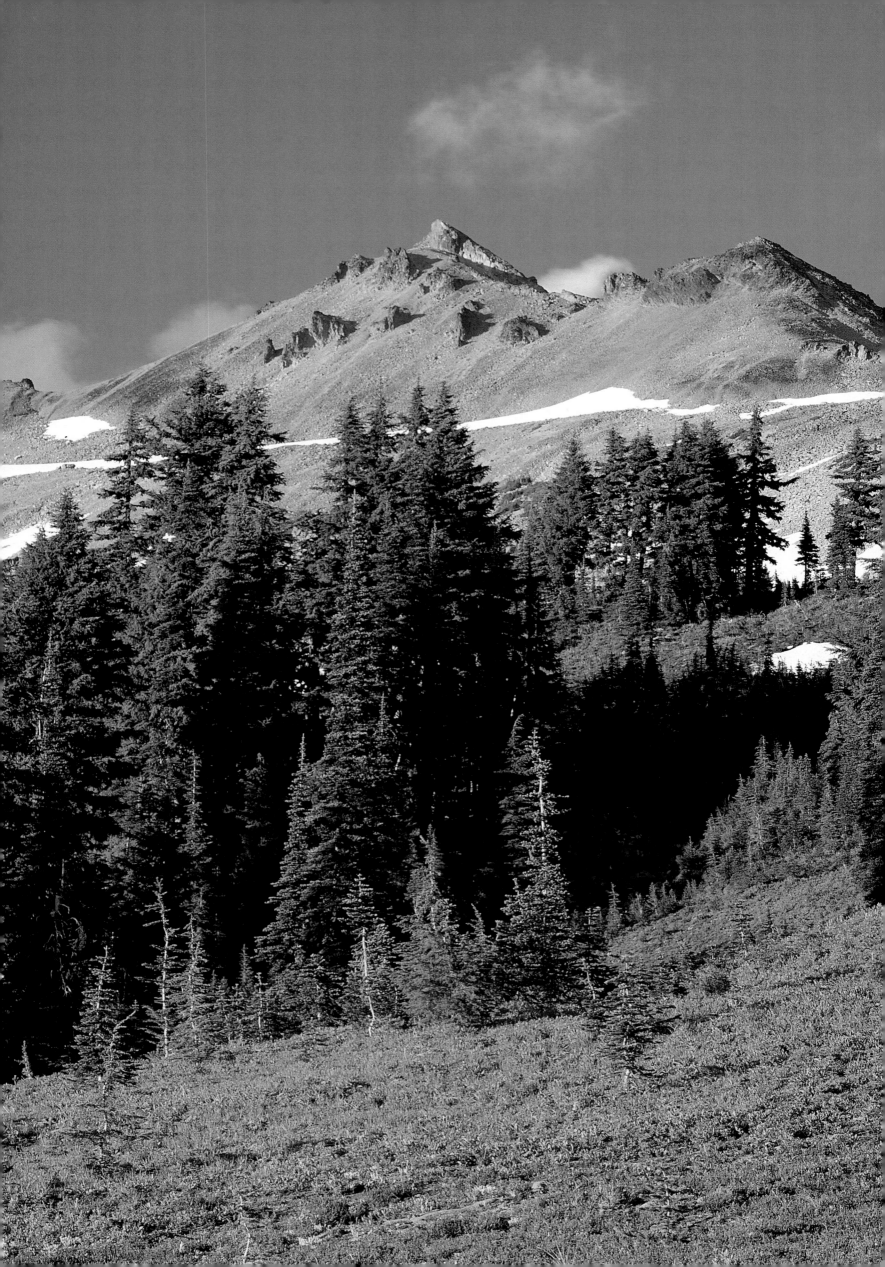

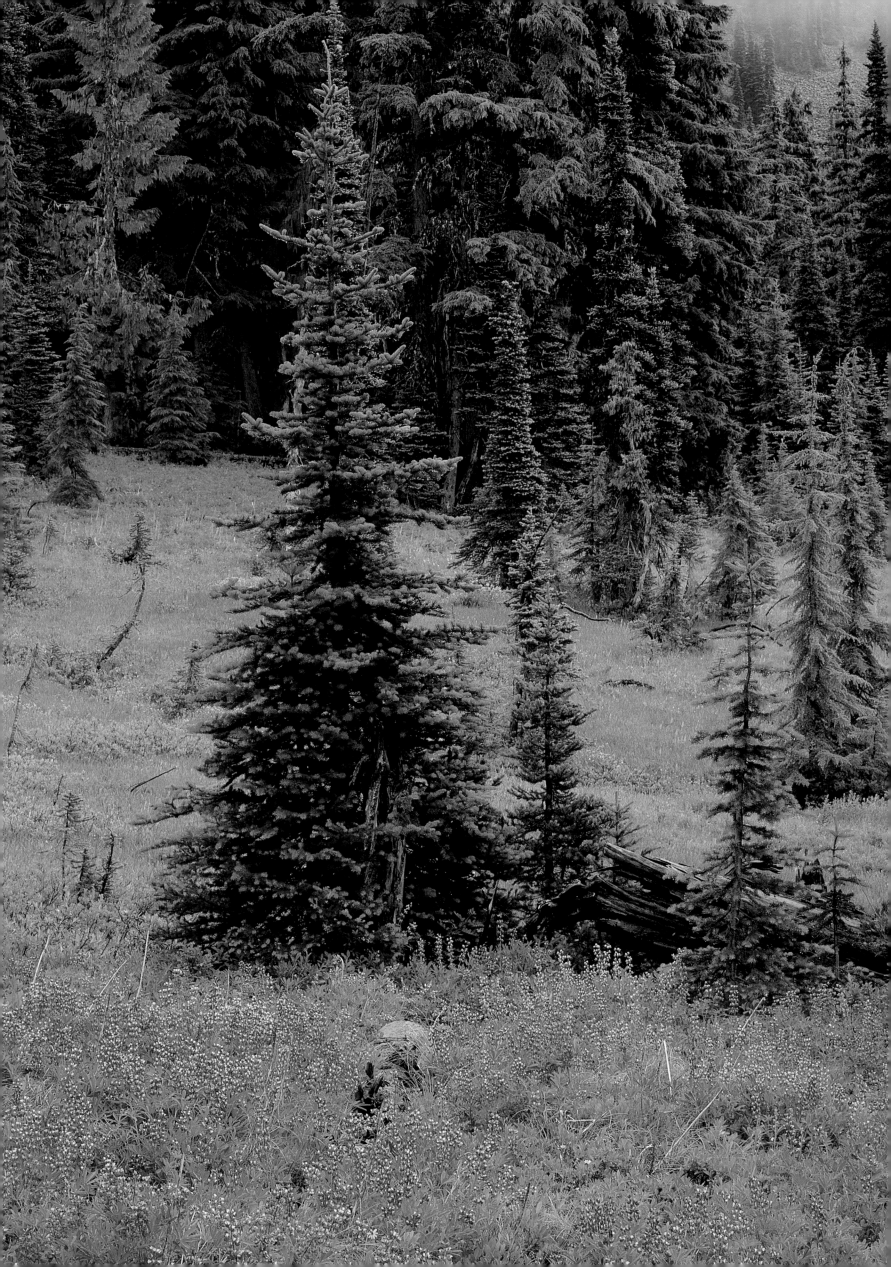

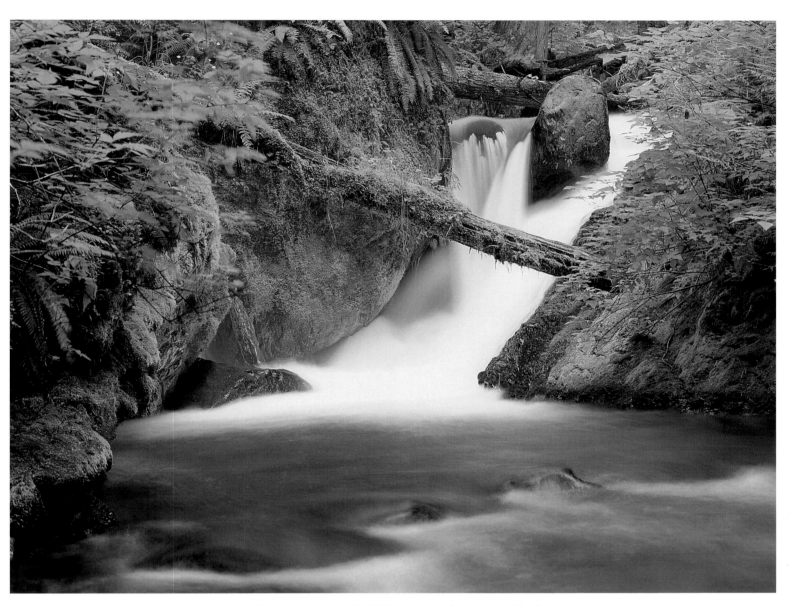

◄ A meadow in Goat Rocks Wilderness is brightened by lupines.
▲ South of Packwood, Glacier Creek cascades mightily on its way.

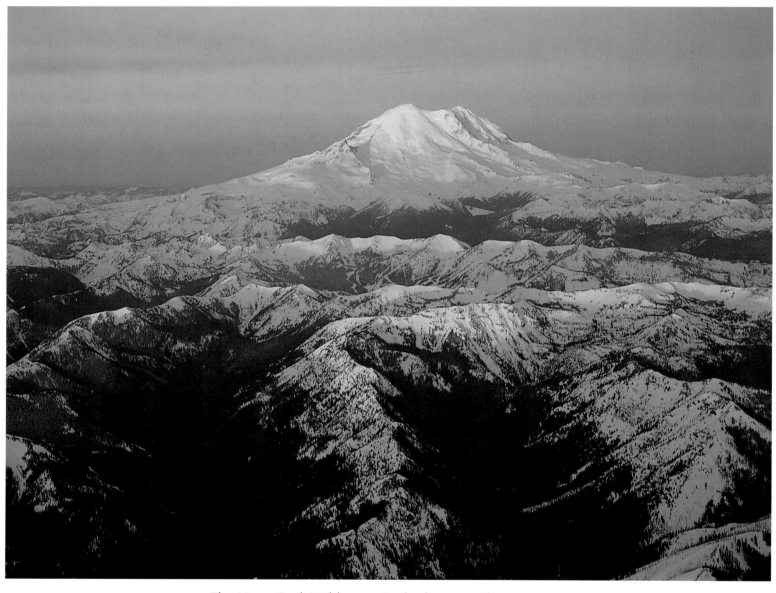

▲ The Norse Peak Wilderness in the foreground serves as pre-
lude to Mount Rainier, whose volcanic dome rises 14,410 feet.
▶ Stalks of lupine bloom in the Cascades foothills near Peshastin.

92

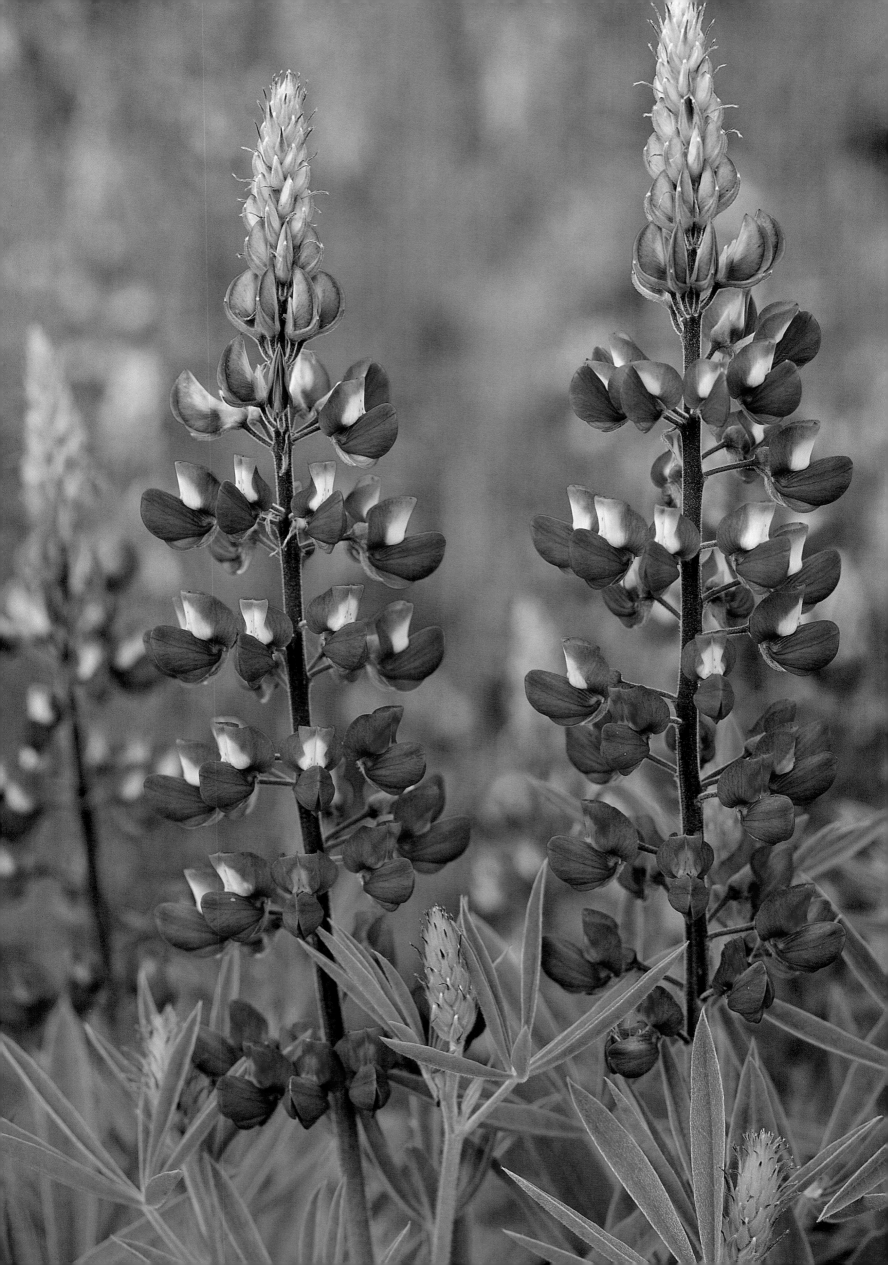

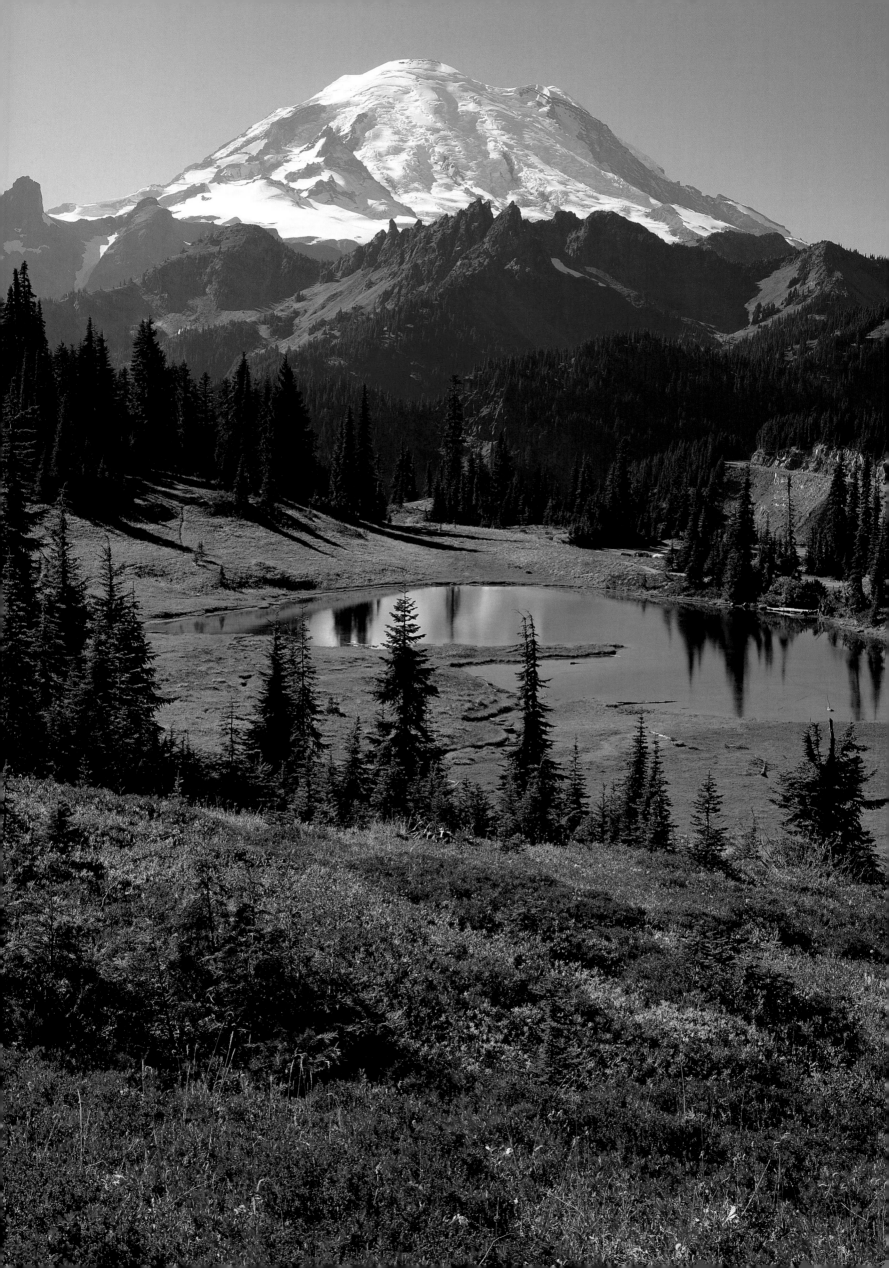

◄ At Chinook Pass, blueberry bushes and the waters of a high mountain tarn are witness to an eastside vista of Mount Rainier.
▲ Autumn vine maple leaves mingle with fronds of bracken fern.

Chinook Pass is where I picked the Huckleberries for your jam. The next day a bear ran off my berry picking friend.

95

▲ Needles from western hemlocks whirl about a pool in Box
Canyon Creek in Alpine Lakes Wilderness, near Snoqualmie Pass.
▶ A waterfall along the Wonderland Trail drops into Devil's
Dream Creek, southwest corner of Mount Rainier National Park.

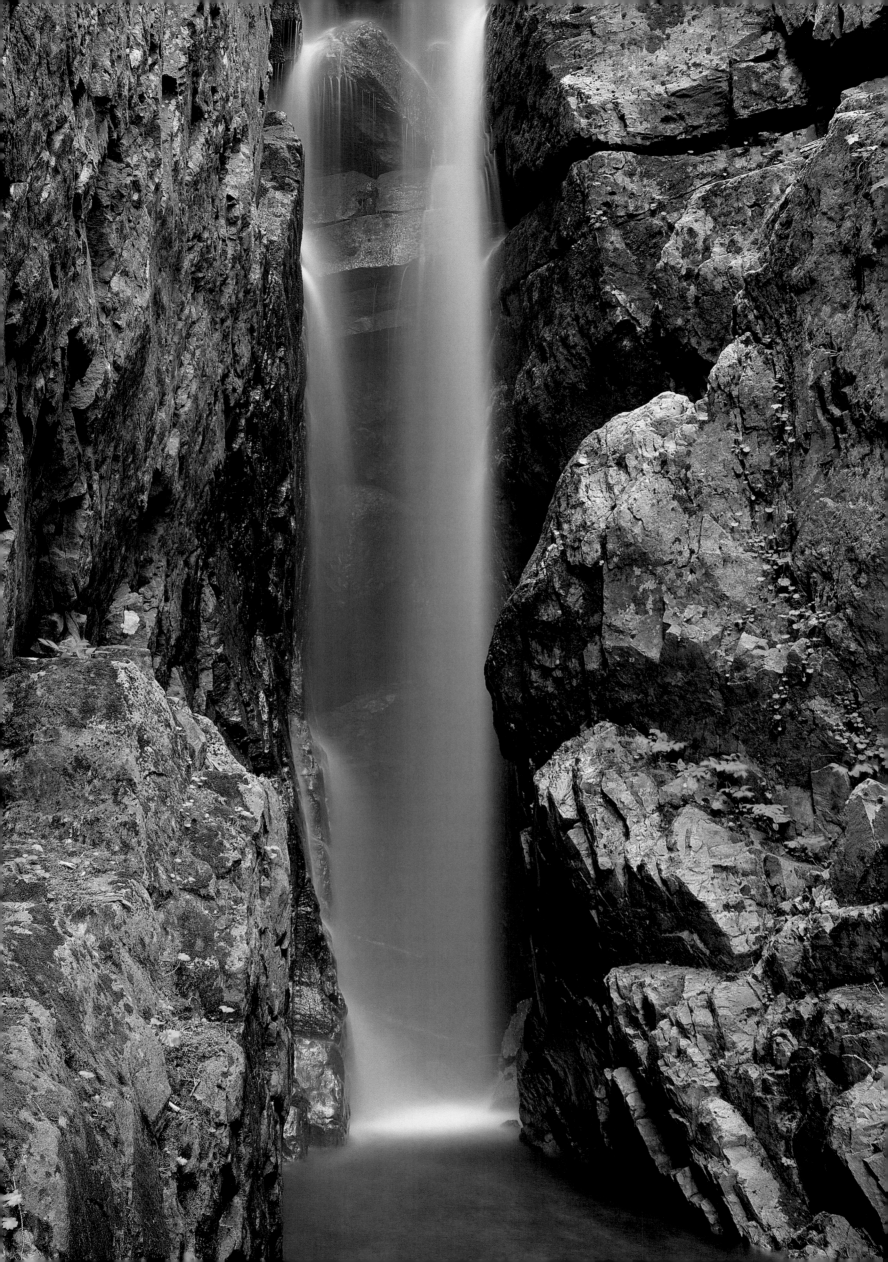

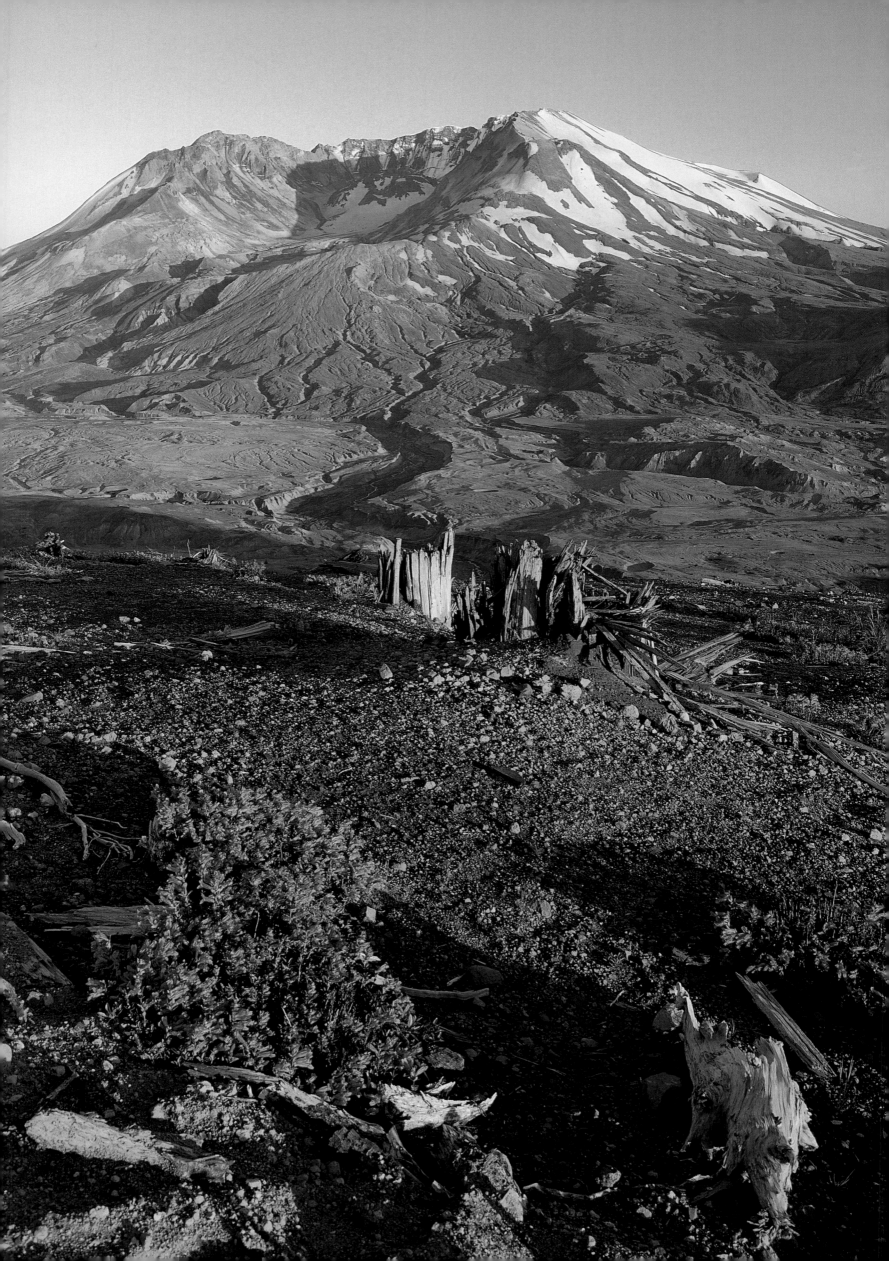

◄ The northwest side of Mount St. Helens gapes open, result of a huge eruption that destroyed forests and killed fifty-seven people.
▲ Fall brings out the color in vine maples along a mountain road.
► ► Sun-bleached snags from trees destroyed in the May 18, 1980, eruption of Mount St. Helens now look out over a recovering landscape of grasses, wildflowers, and young fir trees.

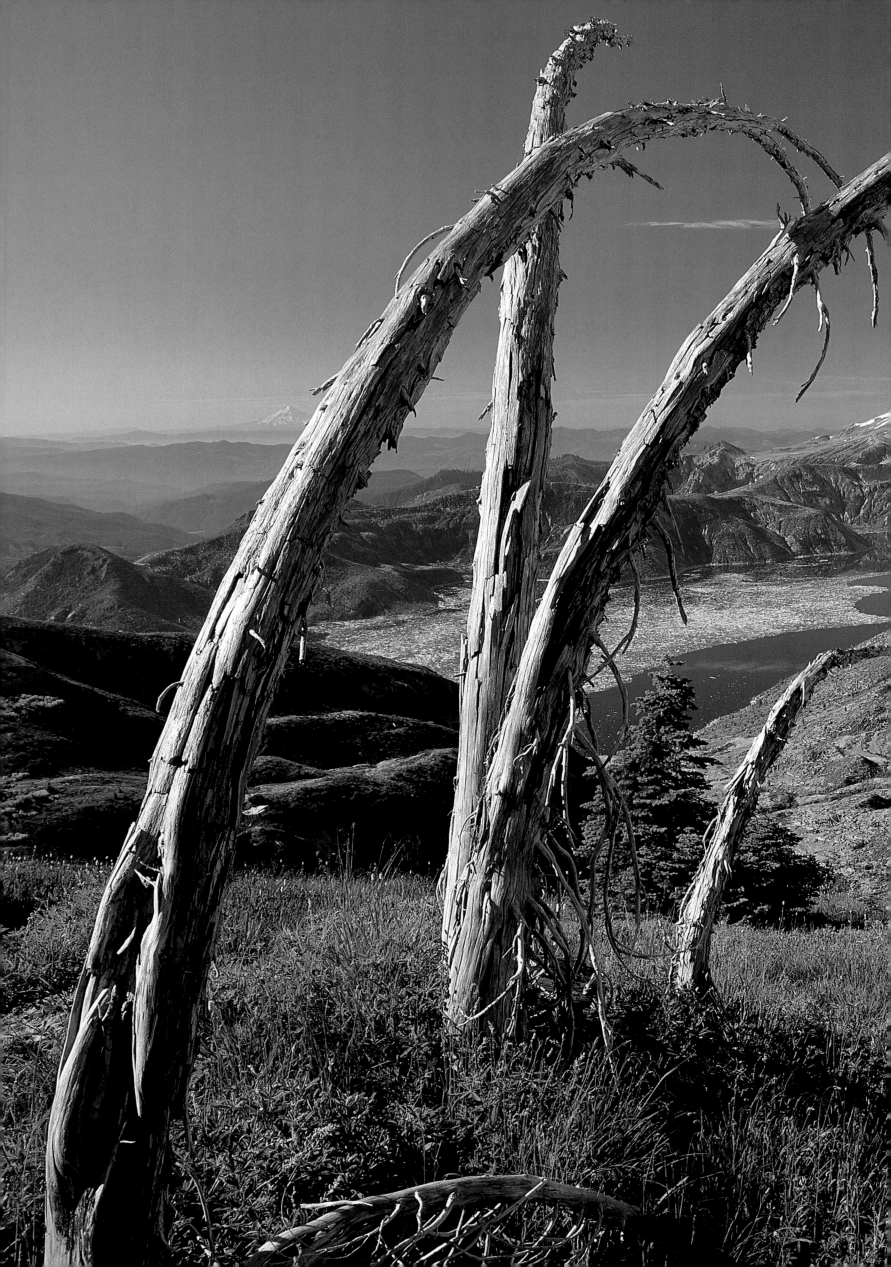

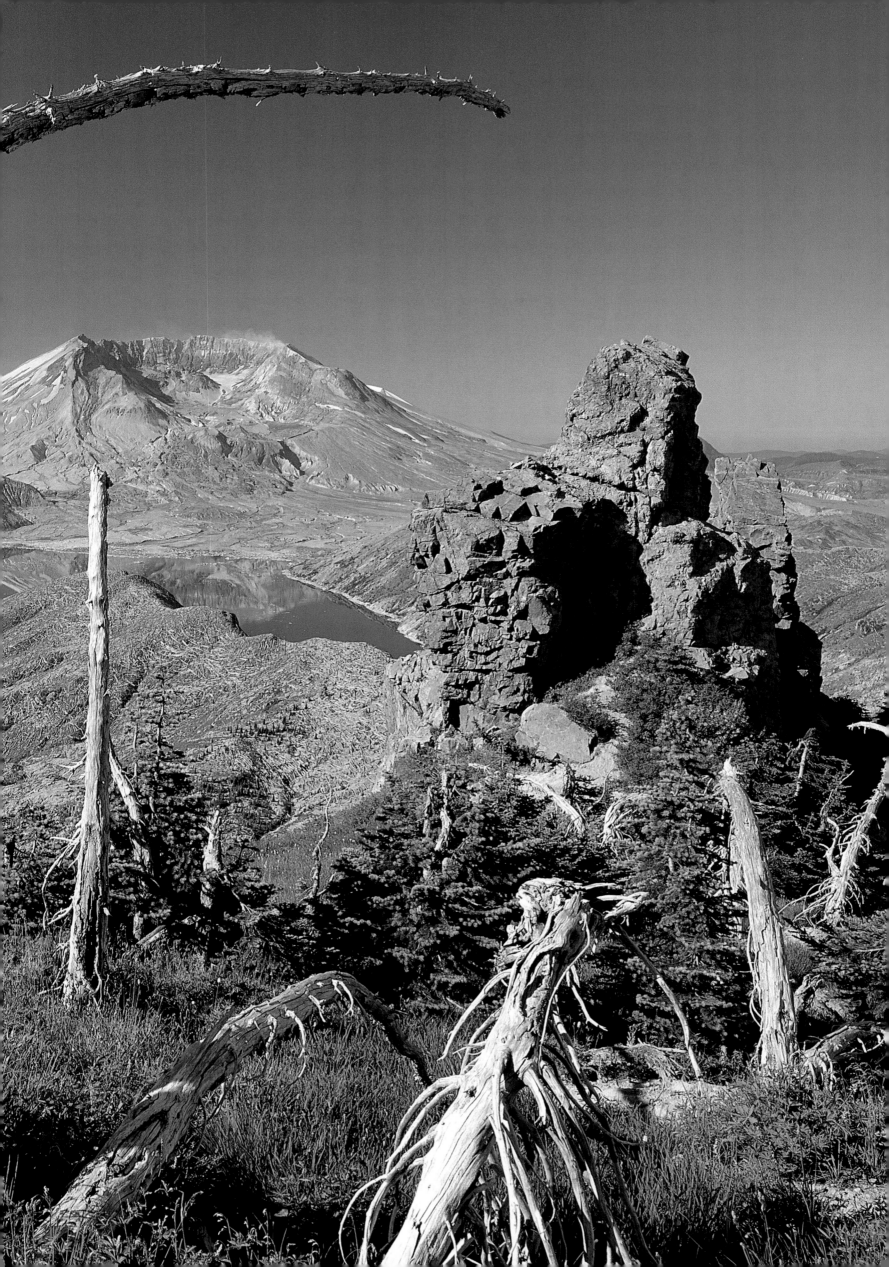

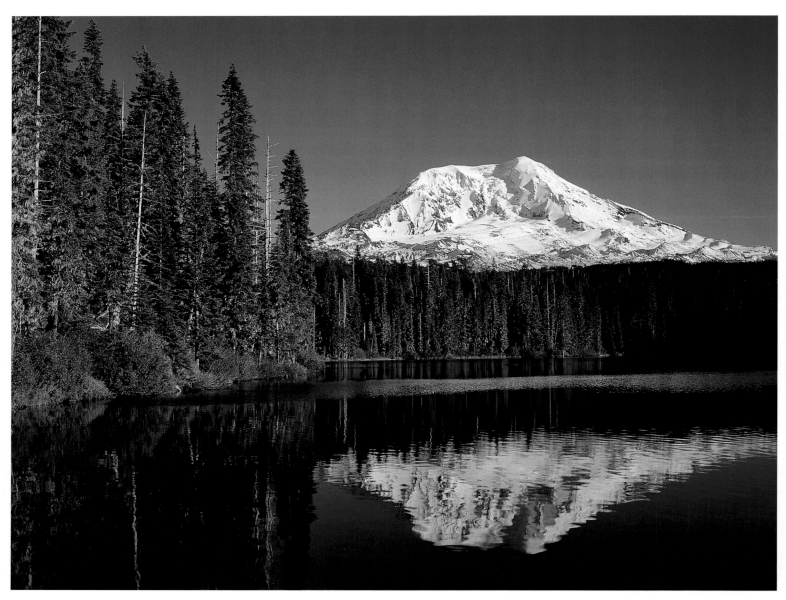

▲ Mount Adams, 12,276 feet high, rises beyond Takhlakh Lake.
► Brothers Luke and Max Tiffany rest at the base of a forest giant along the Eastside Trail in Mount Rainier National Park.

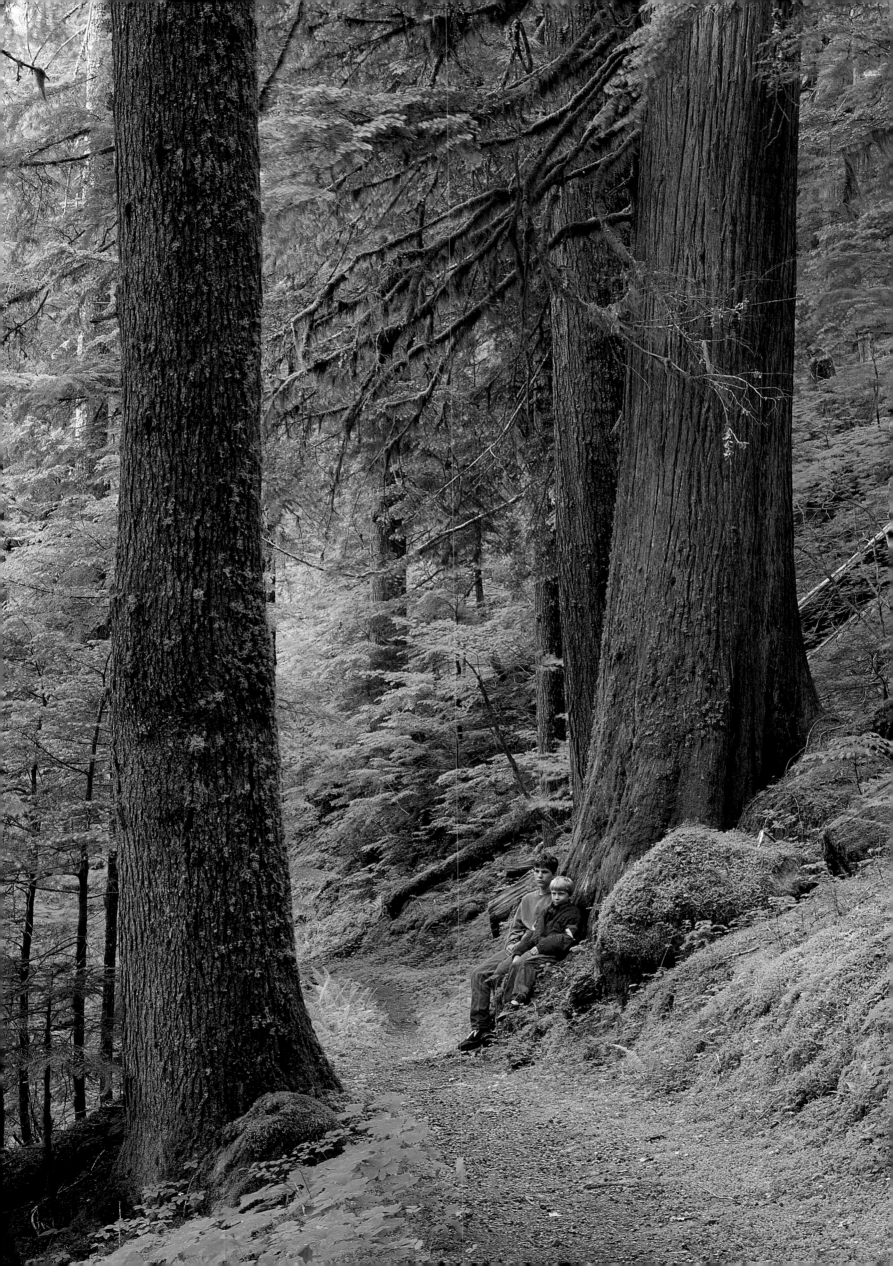

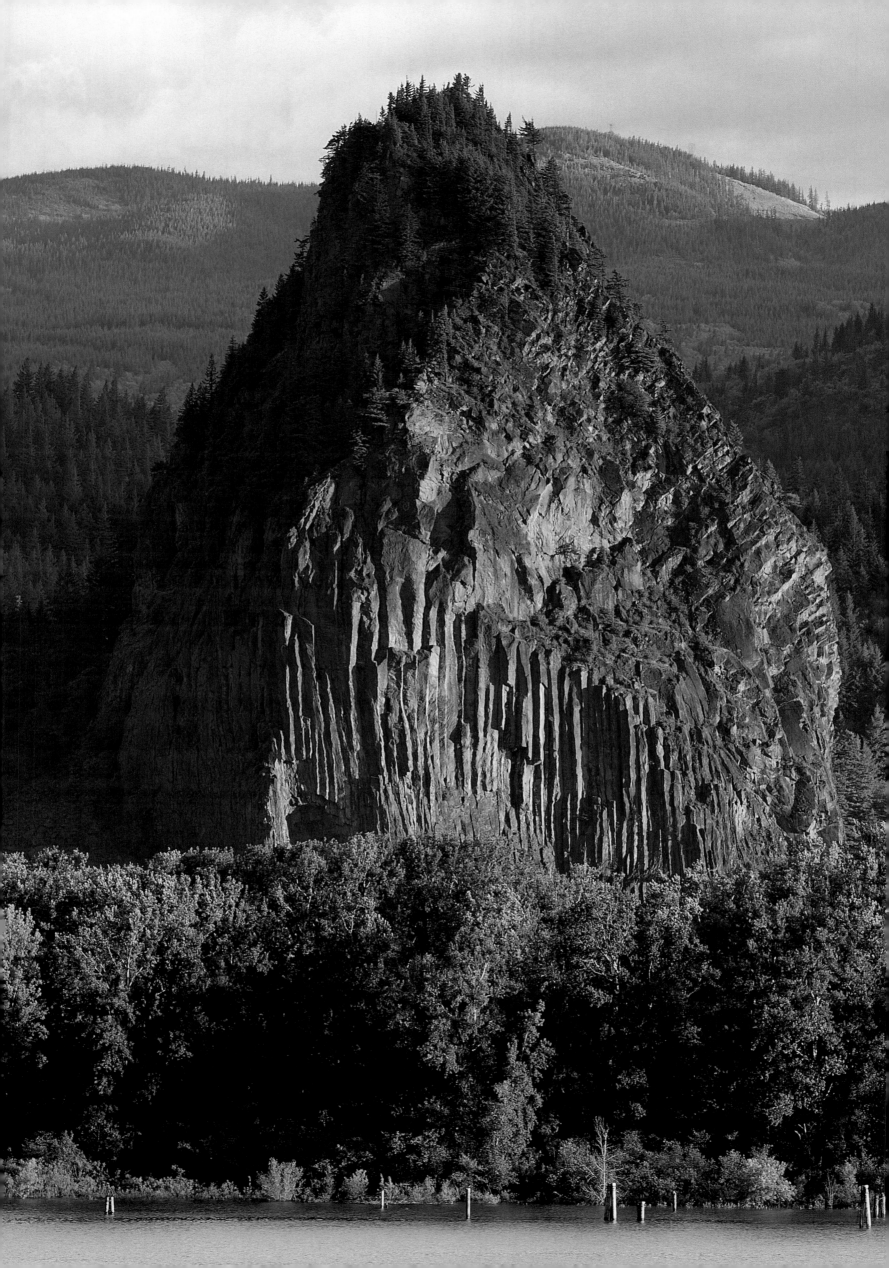

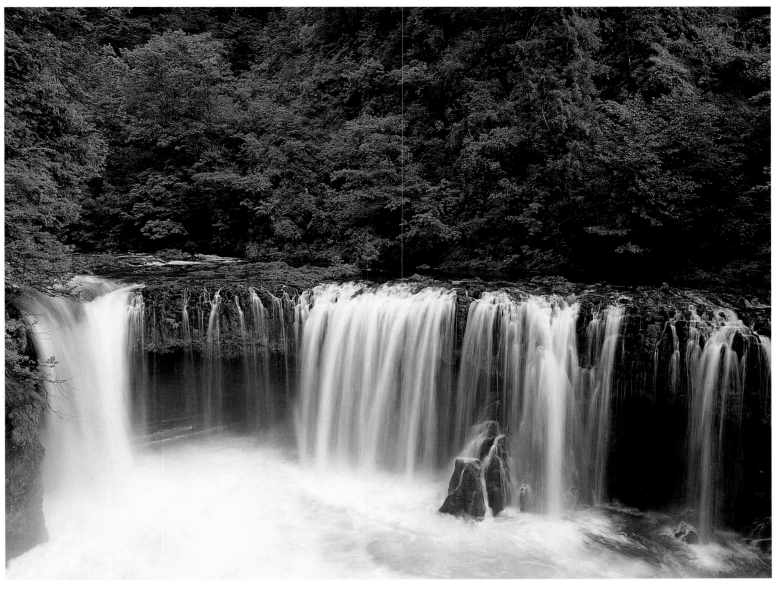

◄ Morning sun highlights the basalt columns of Beacon Rock, on the Washington side of the Columbia River, across from Oregon.
▲ The Little White Salmon River streams over a rock shelf in the Columbia River National Scenic Area.

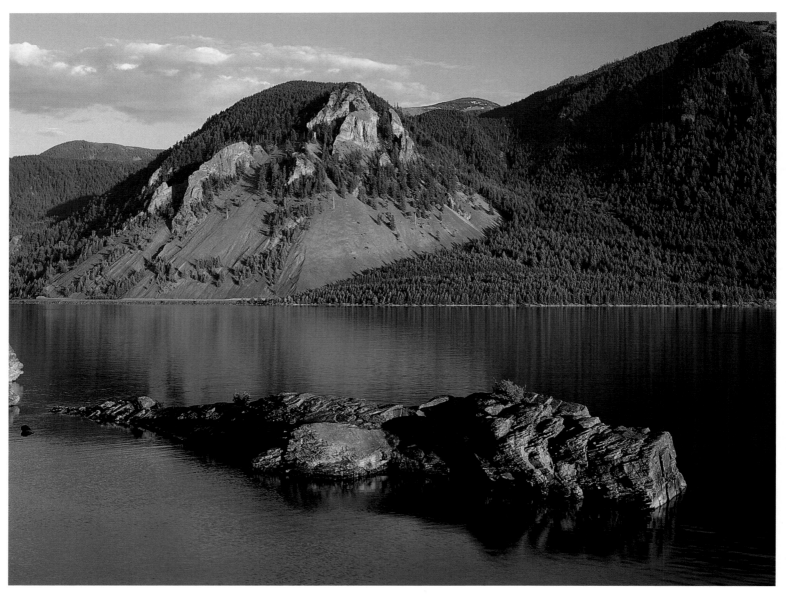

▲ A windless evening lets the Columbia River east of Carson flow
calm and flat. Across the river in Oregon is Shellrock Mountain.
► Chris Wyman windsurfs the Columbia near White Salmon. The
river is a mecca for fans of the high-speed sport of board sailing.
►► Steptoe Butte rises above wheat fields, in Whitman County.

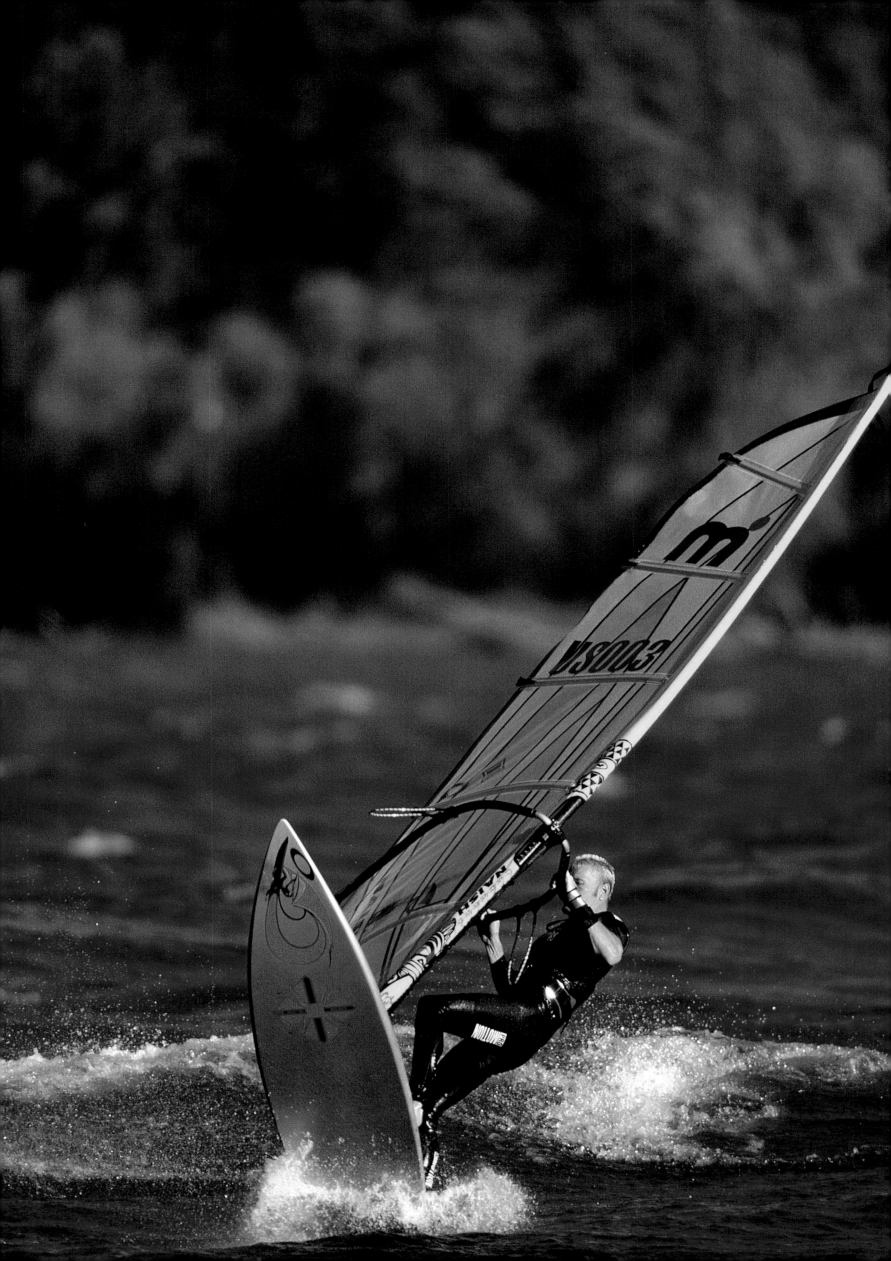

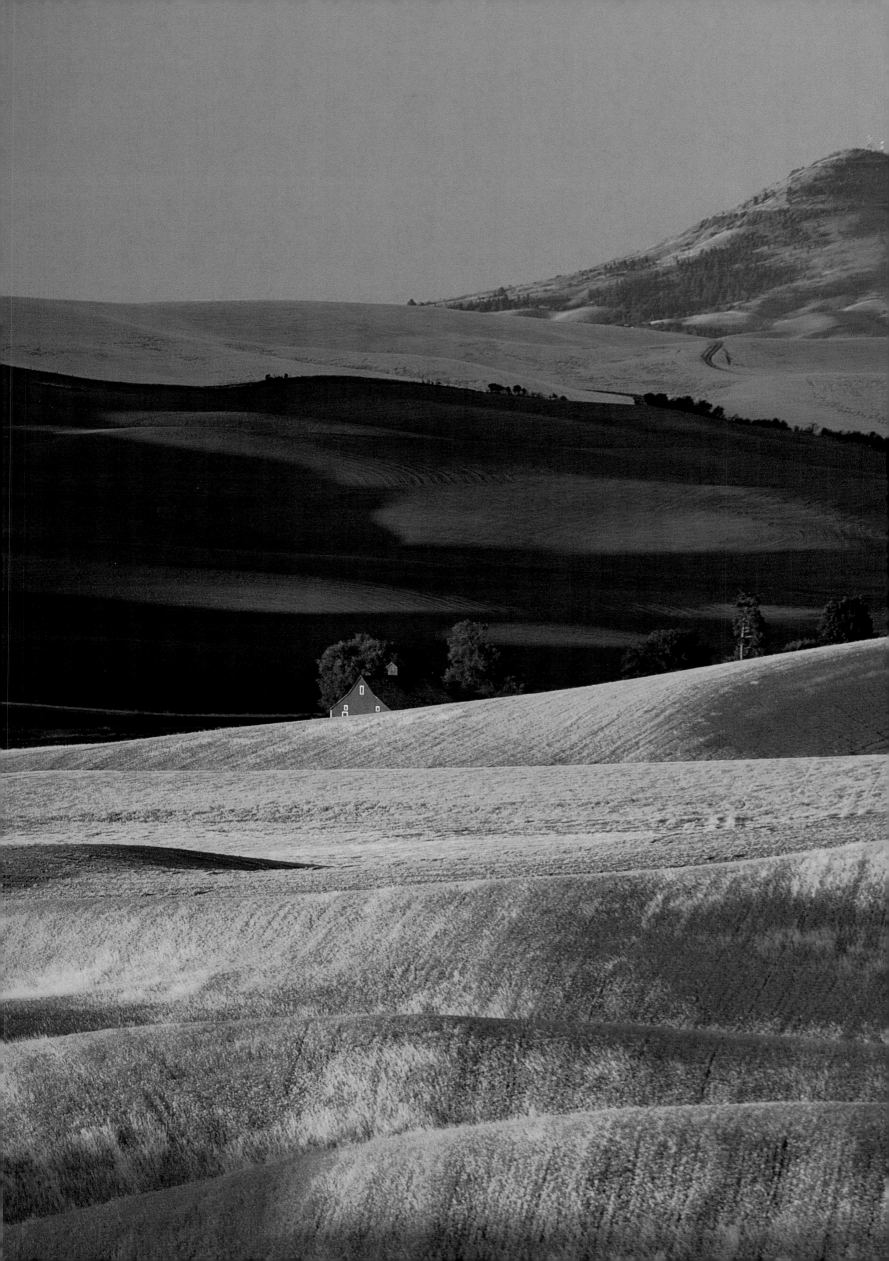

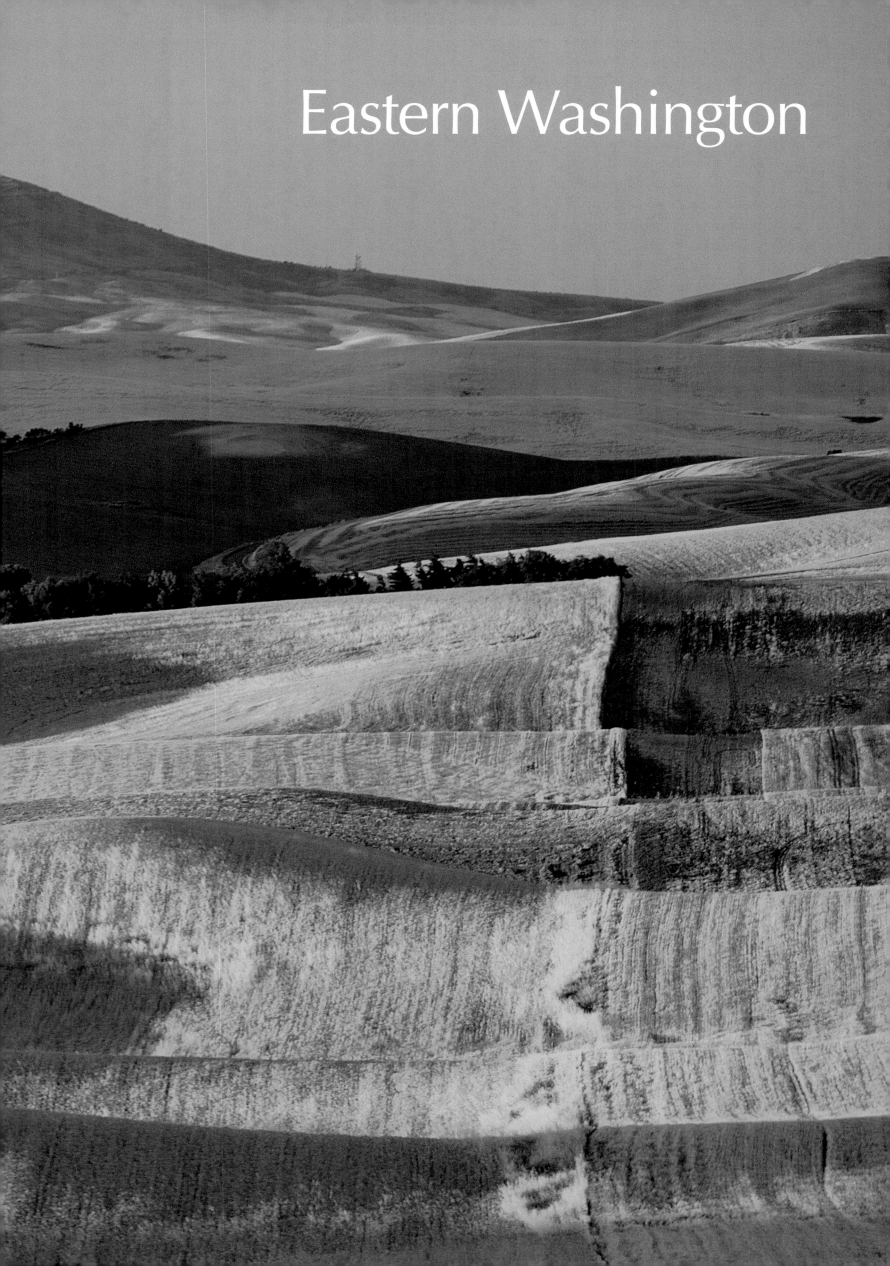

Eastern Washington

Into the Open
by Jeanette Marantos

milk weed blossom

You can see forever here. But in this kind of country, forever is a big sky, an arrow-straight road, and plowed curving fields on either side, as plain and sensuous as a stomach or a thigh. "Eastern Washington," I think, "haven for claustrophobics."

We're driving west along Highway 2, between Wilbur and Coulee City, my seven-year-old son, Dimitri, and I. We're at the end of a long weekend jaunt to learn more about this region, and, lost in thought, neither of us has spoken for miles.

This is crop country, where farm implements are often the only things that stand out on the furrowed land. Nothing changes much as we drive except the flavor of the air. Yesterday, near Quincy, it was the sharp smell of onions, then faint whiffs of manure. Now it's the pungent odor of wet ground. The plowed patterns are hypnotic, weaving along the contours of the hills, sometimes in blond stubble, sometimes moist and dark like chocolate, and sometimes with a faint glaze of green as winter wheat emerges.

Trees are a rarity, something to stare at, and several stand out like an oasis heralding a homestead or town. We rarely see any people, except the few who pass in their pickups or cars, the men invariably wearing a baseball cap or cowboy hat.

Everything is a blur at interstate speeds, and we discover that to really see this region, we must go slower, along its winding back roads. It's there you begin to understand why the Indians could not comprehend the idea of land ownership when the settlers flooded their world in the 1800s. If all you knew was this open, undulating land with the endless sky, the idea of owning just a piece of it would seem as strange and impossible as fencing the sea.

This thought runs through my head as Dimitri and I drive toward our home in Wenatchee, on the western edge of Eastern Washington. It's the end of the day in early October, and before us, the sun is melting like a nova into the horizon, a spectacular rosy haze gradually fading into purples and grays.

Behind us, the sky is already dark, and a fat harvest moon hangs in my side-view mirror, shining pale orange in the sunset's glow. "It's like we're driving to the end of the earth," I think to myself, and then start at the sound of my son's voice.

"The sky looks like the ocean," he says, "and it looks like we're going to run into the ocean."

* * *

Eastern Washington is often thought of as that vast barren area east of the Cascade Mountains, made up mostly of arid plateaus and weedy flatlands. There are forests in the northern counties, but they are drier and less dense than the moist forests to the west. Although the region is the nation's top hydroelectric producer and a big food grower, it seems largely invisible to the rest of the world.

Maybe that's because it's so different from the west side of the state. The twenty counties of Eastern Washington encompass nearly two-thirds of the state, an area as big as Tennessee, but hold less than a quarter of the state's six million people. The region does have the state's second largest city, Spokane, but unlike Western Washington where one city seems to blend into another, our urban edges are more abrupt. Once you leave Spokane, you can drive for hours without seeing anyone except other motorists.

Our weather is different, too: drier. Moist-landers tend to pity our lack of green, as if lush forest is the true form of natural beauty. But in Wenatchee, I've satisfied my craving for seasons and sky. I find dense forests claustrophobic, and a little boring, because their colors are so muted, and, well, green. I've come to love this area's intense colors, its ever-changing hills, and the knots of sagebrush that stand like ruins among the wispy grass.

Our flatlands and hills don't always stay brown. They're really a canvas for the sun and the seasons. They look quilted in the winter's snow, and in the spring they turn a hopeful green that slowly fades as the days grow warmer. Sometimes in summer, when the sun is straight up, the hills seem so parched they make you thirsty just to look at them. Then later in the day, the shadows get purple and the creases of the hills look like folds in a gown that someone let slide to the floor.

We have lots of trees in the Wenatchee Valley, but only because of the persistence of settlers who found a way to tap the indifferent rivers that flow through this arid land. This is a community of orchards now, pears, cherries, peaches,

Jeanette Marantos

nectarines, 'cots, and, of course, apples, so many apples that in the fall you can step outside just about anywhere in the valley and breathe in their sweet smell.

You needn't go far, though, to reach the unirrigated lands east of Wenatchee, a desolate landscape the settlers faced more than a century ago. Othello pioneer Laura Tice Lage described the "barren alkali soil which would scarcely support a weed" and the aching belief of homesteaders that, "If we only had water, this soil would grow anything."

They were right. Settlers around Wenatchee and the Okanogan region to the northeast built small irrigation canals to support their orchards, but the water that really transformed the Columbia Basin came from the mother of all irrigation projects, the Grand Coulee Dam. Today the Basin grows everything from wine grapes, apples, and soft fruits to all the ingredients for a thick vegetable stew—potatoes, onions, legumes, grains, carrots, squash, and corn.

Grand Coulee Dam was made possible in large part because of the region's geologic history. Ice Age glaciers and ice dams rerouted the Columbia River about two million years ago, carving deep channels—coulees—into the basalt plateau. Then, about eighteen thousand years ago, floods deluged Eastern Washington as ice dams broke at Lake Missoula in Western Montana, strewing giant boulders as far as Western Oregon. The Grand Coulee was one of the channels left behind, and it became a perfect reservoir for irrigation water diverted from Grand Coulee Dam.

One of the best places to experience that geologic history is on Highway 155, between Coulee City and Grand Coulee. Cracked basalt cliffs tower above the highway and the reservoir named Banks Lake. I get the best sense of how massive these floods must have been by standing at the brink of Dry Falls, just west of Coulee City. This immense, sculpted ravine is the remains of one of history's great waterfalls—three and a half miles wide and 400 feet high. Niagara Falls is just a mile wide and 165 feet high.

* * *

The Grand Coulee Dam greened the Basin—and the state's economy. It also obliterated a way of life for the Native

peoples. The dam created Franklin D. Roosevelt Lake, which extends upstream almost to the Canadian border. The lake flooded several communities on and off the Colville Indian Reservation and immersed Kettle Falls, where the nomadic people of the arid Northwest had been coming to trade and to fish for salmon for more than nine thousand years.

Grand Coulee also became one of eleven dams that "harnessed" the Columbia, transforming a tempestuous river whose rocky rapids defied navigation into a long series of placid-looking lakes. Tamed or not, the Columbia is still omnipresent in Eastern Washington. We cross it in Wenatchee, and it seems no matter where we go, south, east, or north, we run into one of its twists. Dimitri and I cross it again north of Wilbur, where the Keller ferry takes vehicles across Roosevelt Lake.

During the mile-and-a-quarter crossing on the *Martha S.*, our attendant, John Rivera, predicts we'll see a lot of wildlife throughout the northern part of the region. He's had two bears in his RV park this fall, he says—then gives a whoop as he spots a bear swimming the other way across the lake. "I've seen moose swim across here, but never a bear," Rivera says, staring at the bobbing black shoulders and head.

We find the wildlife Rivera promised as we drive into the brushy forests of the Colville Reservation, heading north toward Republic. We see mule deer, and a huge osprey nest solidly built atop a telephone pole. Farther along, we spot two bear cubs rolling in the weeds just off the road. And then a flock of big birds casually struts out of the brush onto the road. I stop and back up, unable to believe what I see. These are turkeys, wild turkeys, magnificent birds with glossy brown and black feathers. I thought wild turkeys were limited to the Eastern United States, and we drive on feeling privileged.

I'm less appreciative the next day in Summit Valley, when a flock of these turkeys explodes from the brush in front of my van. The straight, open road before me is suddenly obscured by feathers and bodies. When it's over, my van has a dented hood and a broken headlight, and an enormous bird is sitting with a strange dignity by the side of the road.

111

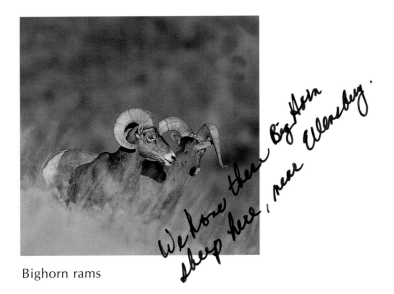

Bighorn rams

I run back to the bird, hoping it's merely stunned. It flops away from me, hissing and rocking. As I approach again, it extends its wings and neck, and for several terrible, majestic moments, it tries to fly. I am five feet away, and I can feel an enormous displacement of air as its wings beat futilely against the ground. Then suddenly the turkey throws its neck back, closes its eyes, and becomes still.

Dimitri is back at the van, shouting, "Will he be OK?" I stand there, feeling miserable. A woman stops to help and says if I can get the bird into my van, I can take it to her home. There, she says, her husband can put the poor animal out of its misery.

So I wrap the bulky bird in a blanket, and carry it to my van, its head and feet dangling, a small pulse still beating in its neck. By the time we reach the home of Amy Balmores, ten miles up the road, there is no pulse at all. But she and her husband, Tracy, permit us to leave the dead animal. A taxidermist friend was coming over today anyway, Tracy says, and he'll be happy to have this bird. As we drive away, Dimitri gives me a severe look and wonders whether the turkey had any children.

We made only a couple of rules for our trip—stick to the back roads, and stop whenever something looks good. So when we reach Republic, a town just a bit more than thirty miles from Canada, we spend a few hours digging for fossils at the Stonerose Eocene Fossil Site. During the Eocene epoch, fifty million years ago, the land that is now Republic was at the bottom of a lake. Layers of sediment, mostly volcanic ash, entombed the fish, insects, and plants that settled on the bottom.

For just a few dollars, Dimitri and I rent some chiseling tools and get a permit to join about twenty other people at the narrow, rocky site. The work is tricky. You have to hammer just right to split the shale neatly, like pages in a book. But it's addictive, like a treasure hunt, and after a couple of hours we have two sides of a beautifully preserved elm leaf, and pieces of alder and birch leaves, too.

* * *

A few weekends later, I go exploring the southeast part of the state with my other son, nine-year-old Sascha. We have another cloudless autumn weekend. The fruit stands of the Yakima Valley are in full swing, loaded with pumpkins, apples, pears, and other produce.

Our favorite stand is a lovingly restored 1911 general store called Donald Fruit and Mercantile, in the burg of Donald, just east of Wapato. This place is special because it has a maze built from bales of straw. After several trips through the maze, we cross the road and enter the store's pumpkin patch. We stagger out carrying two pumpkins, with a combined weight of seventy-four pounds, then buy a pop and browse in the store, sampling sweet, round Asian pears and trying out the collection of old-fashioned toys.

The straw maze is the main thing Sascha talks about for days, even though our trip also involves a hair-raising hike down the sheer cliffs at Palouse Falls, a spectacular waterfall in the middle of dryland wheat country about sixty miles north of Walla Walla. To reach the base of the falls, nearly two hundred feet below, Sascha and I ease down a narrow crack in the basalt cliff, then mince along a narrow, sloping path. In many places, the edge of the cliff is less than a foot away from the path, and Sascha grows very quiet as we pick our way along.

When we reach the bottom unscathed, I am jubilant and relieved. Sascha runs ahead while I follow, feeling smug about our accomplishment, until I notice a man ahead of us with a baby on his back and a woman beside him carrying a back pack and a small ice chest. Ahead of them are four boys, ages 9 to 16, each carrying a fishing pole and tackle box.

By the time I reach Maria Mendoza and her husband, Romer Gutierrez, she has started a driftwood fire and begun frying chicken thighs in an aluminum pan. It's dusk, but this family from Moses Lake is obviously just settling in, unconcerned about returning up that precarious path in the dark. I, on the other hand, am very concerned. Sascha and I hurry back up the cliff, reaching the top breathless but safe, and when we last see the family they are all fishing, their fire burning merrily in the thickening night.

* * *

I am in love with the Palouse country—the fertile, rolling farmland that extends south of Spokane to the Blue Mountains along the eastern edge of the state. Before the settlers came,

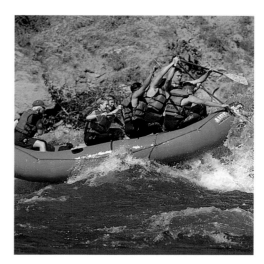

Rafting on the Wenatchee

the fat, fluid hills were covered in bunchgrass, and the area was named Le Pelouse, "grassland country," by French-Canadian fur traders. Today the hills are either newly plowed and coffee-colored or woven with wheat stubble that in the morning sun possesses an ethereal quality, as though it's lit from within.

We haven't seen any wildlife this trip, but that's probably because just about every vehicle we pass is bristling with men and boys dressed in orange vests. Deer hunters. I quickly abandon any off-road explorations. Instead, we concentrate on admiring the lovely old homes and mansions in even the smallest towns of the Palouse, and exploring the many museums and monuments. One of the most moving is the site of the Whitman Mission outside Walla Walla.

Missionaries Marcus Whitman and his bride, Narcissa, spent their honeymoon on the Oregon Trail in 1836, on their way to open a mission and bring Christianity to the Cayuse Indians. They worked nonstop, building the mission, running a school, and trying to teach the nomadic people about farming. During their eleven-year tenure, they never converted the Cayuse to Christianity or farming, and their only child drowned. Because they lived alongside the Oregon Trail, much of their time went to assisting the weary waves of settlers who stopped at their door.

It was settlers who led to their death, by bringing a measles epidemic in 1847. The disease quickly killed more than half the Cayuse tribe. Whitman worked night and day to help the sick, but the Indians had no resistance to the disease—so while his medicines seemed to heal the whites, they did nothing to help the Cayuse. Some Indians feared they were being poisoned. On November 29, a band of Cayuse attacked the mission, killing the Whitmans and eleven others.

The mission has beautiful walks and somber exhibits that teach us as much about the Cayuse point of view as about that of the missionaries and settlers. The heartrending stories unfold like a Greek tragedy.

It is on the last day of our trip that Sascha and I really learn something about the people of the Palouse. It starts at the top of Steptoe Butte, a 3,612-foot prominence that provides a humbling, panoramic view of patchwork plains and the faraway haze of mountains. On our way down, a loud grinding noise from the van makes us pull off the road. Antifreeze is pouring from under the hood. Two hours later, after a tow to Colfax, we learn that the water pump has died, and there's no way to get a new one until the next day.

Colfax, we soon discover, has about half a dozen garages and body shops, but only one grocery store. You can always drive somewhere else to buy food, says Kevin Cloninger, our tow truck driver, but if you don't have a rig in this country, you're sunk.

It's supper time on Sunday and all the garages are closed, but Lonnie Brown agrees to meet us at his shop to check the van. After it's clear we can't leave, he calls the only motel in town and gets us a comfortable room for $26, then drives us there in his pickup.

On the way, Brown, a solid, serious man in coveralls and a flannel shirt, explains how hard this country can be on vehicles. He has twenty rigs behind his shop right now, he says, waiting to be fixed. I gasp a little, and he assures me mine will be ready in the morning. And sure enough, the repairs are completed by 10:45 A.M. the next day, and the bill is $167, a more-than-fair price, my home mechanic tells me later, especially considering that Brown came out to help me on a Sunday. With such friendly efficiency, I can easily understand why people drive from Pullman, fifteen miles away, to have Brown work on their vehicles.

In some small towns, life seems so narrow that even a stranger can feel suffocated just driving through. But I never get that sense in Colfax, or most of the other towns of the Palouse. The people we meet are upbeat, articulate, and proud of their home—people like Cloninger, our tow-truck driver, who has lived in Colfax all his life.

"When we graduated from high school, all my friends said, 'How can you stand to stay in Colfax?'" he told us on our trip into town, while the sunset gave the hills a violet glow. "I just told them, 'You wait. You'll be back.' And I was right. Most of them have come back. They just couldn't stand living anyplace else. We're an hour from Spokane, five hours from Seattle. We've got skiing, hunting, boating, and fishing, and this is a beautiful place to raise kids. Why would I want to leave?" ■

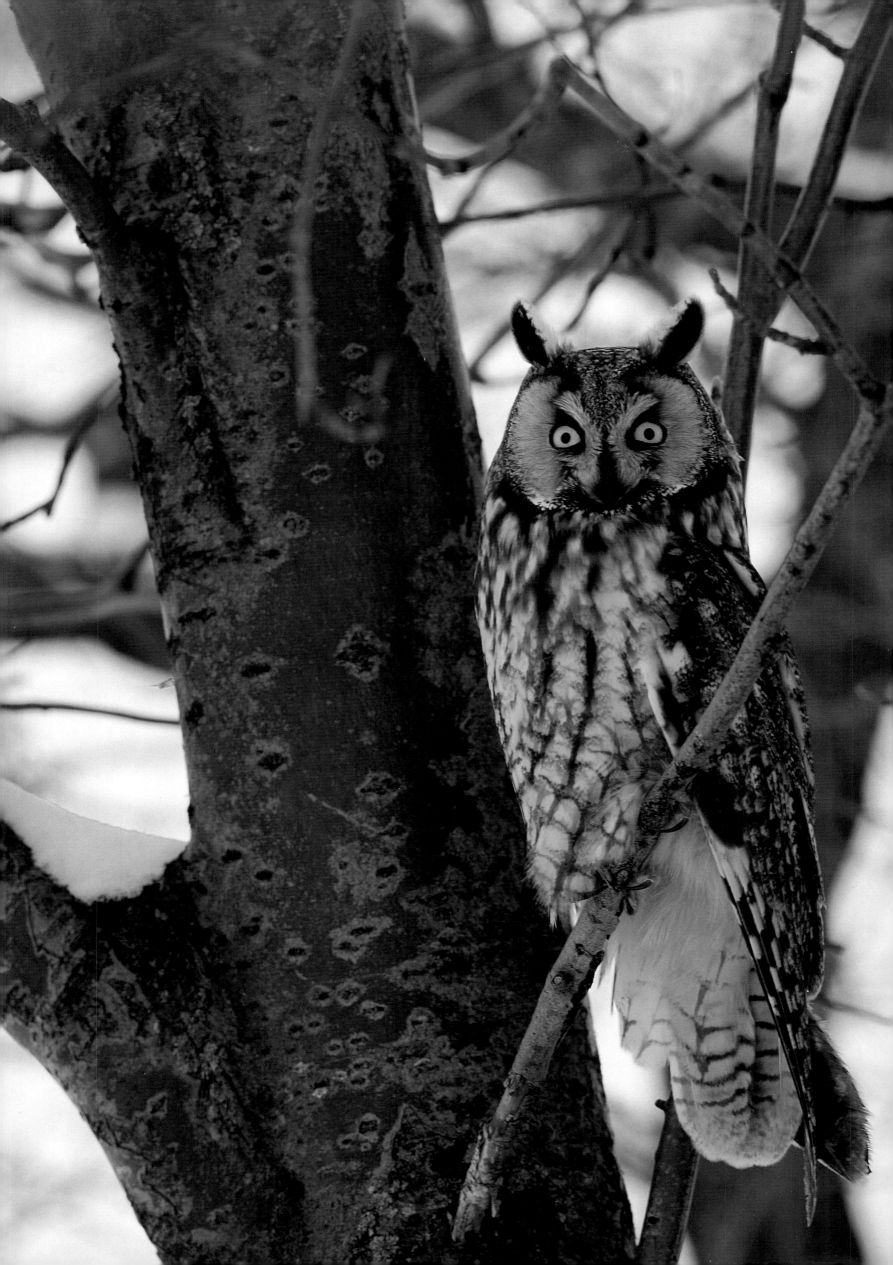

◄ A long-eared owl peers from a wintertime perch near Thornton.
▲ An opening in the wall of a barn at Cherry Cove, in Whitman County, frames the scene of an old shed returning to the earth.

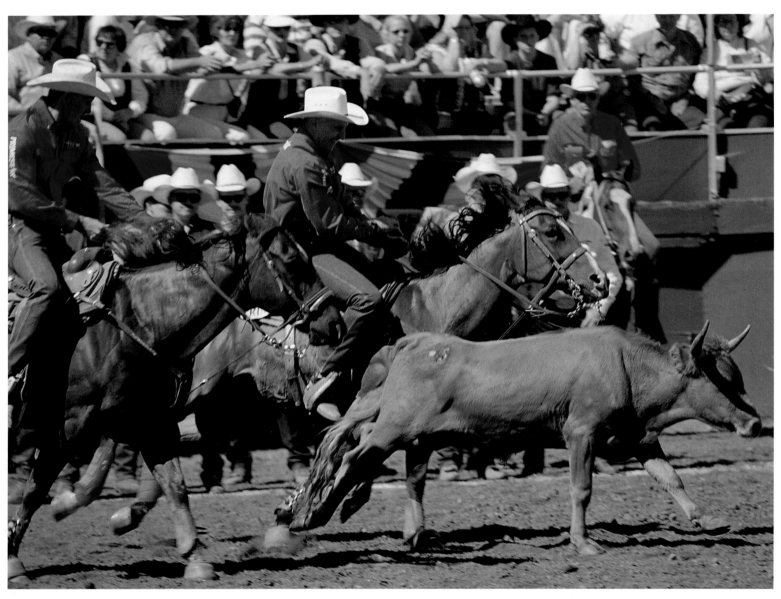

▲ Steer wrestling is on the bill at the yearly Ellensburg Stampede.
▶ Jody Hunt, a Yakima Indian, uses a dip net to fish for salmon
in the Klickitat River in southern Washington.

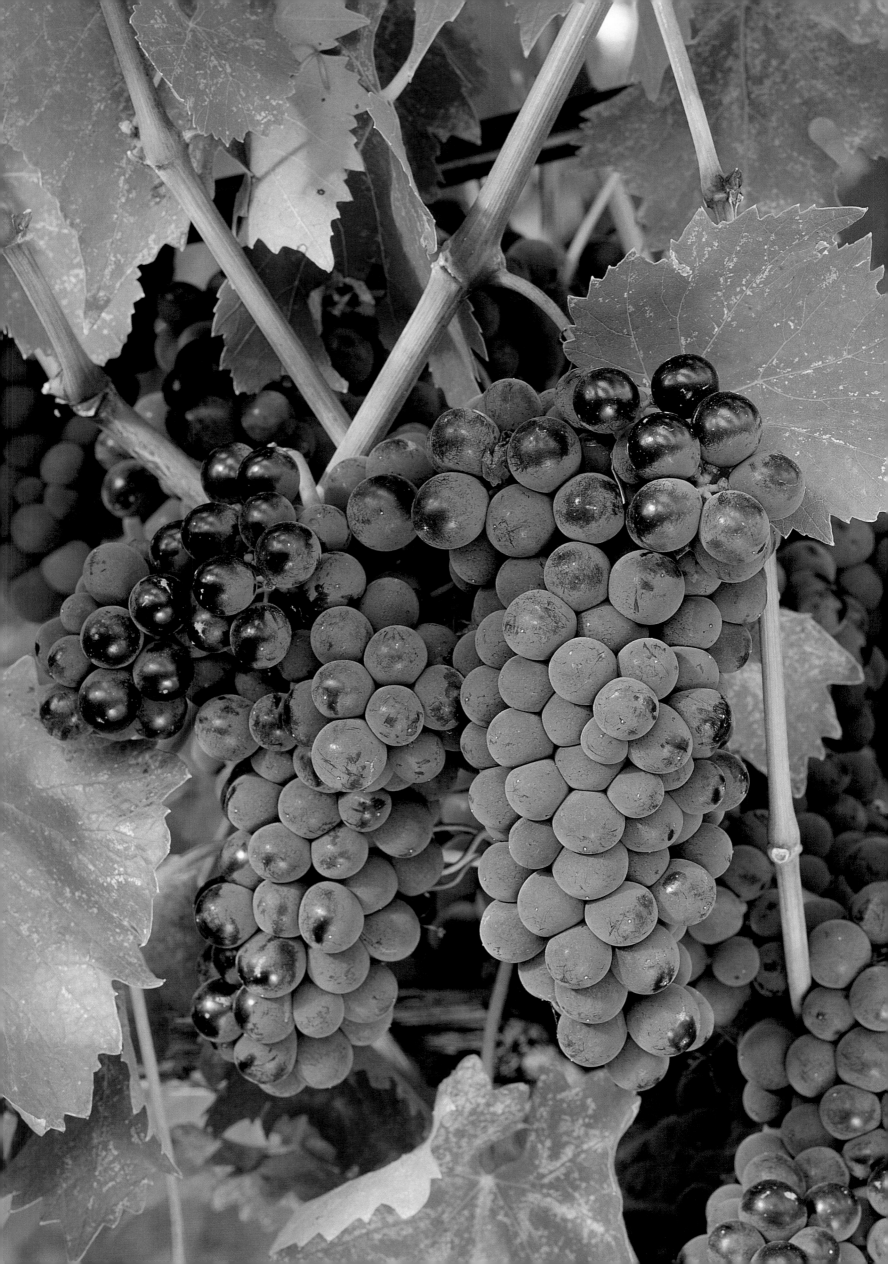

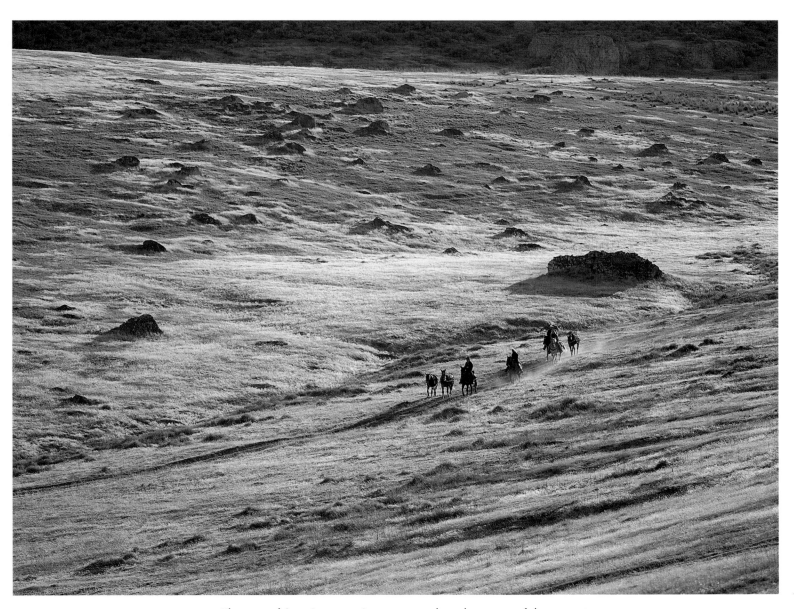

◄ Clusters of Sangiovese wine grapes take advantage of the sun at Red Willow Vineyard, west of Wapato in the Yakima River Valley.
▲ Horses and riders cross an open expanse west of Ancient Lake, near Quincy. Ice Age floods carved the plain out of basalt cliffs.
►► Colors of autumn mix with winter white in a cherry orchard.

near Soap Lake

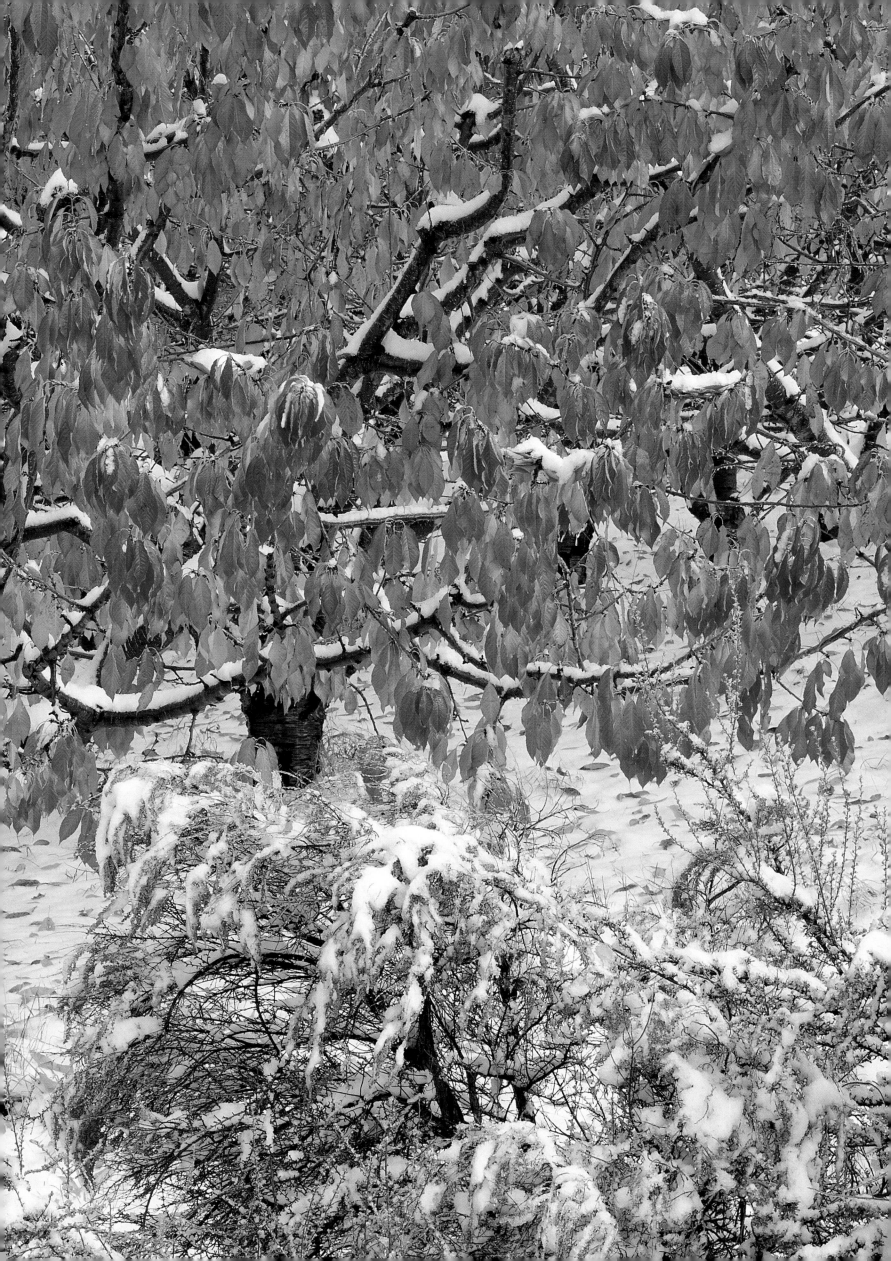

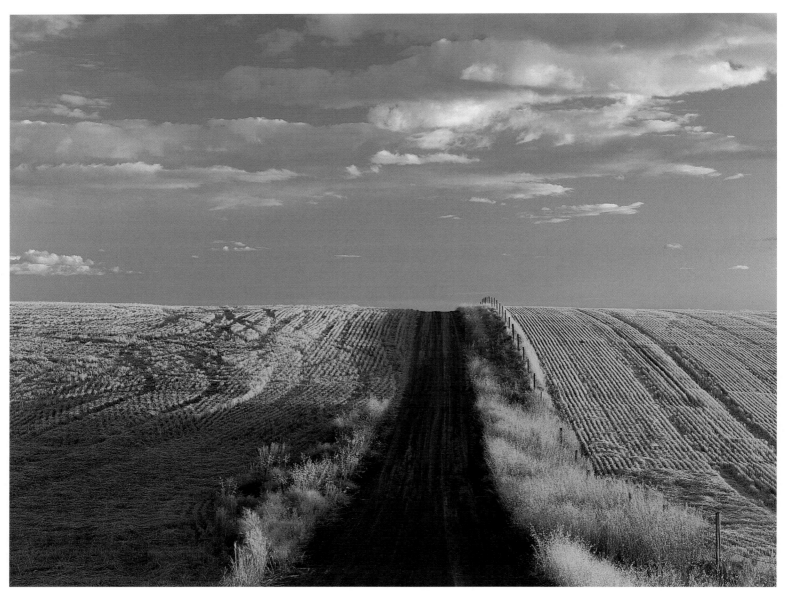

▲ Day draws to a close in the wheat country of Lincoln County.
► The art of harvesting alfalfa creates bands of semicircles on the
land. This field displays its perfect form near the town of Quincy.
►► Apple orchards rise into the hills near Yakima. ―(next page)
These are
the Hills south of
our valley.

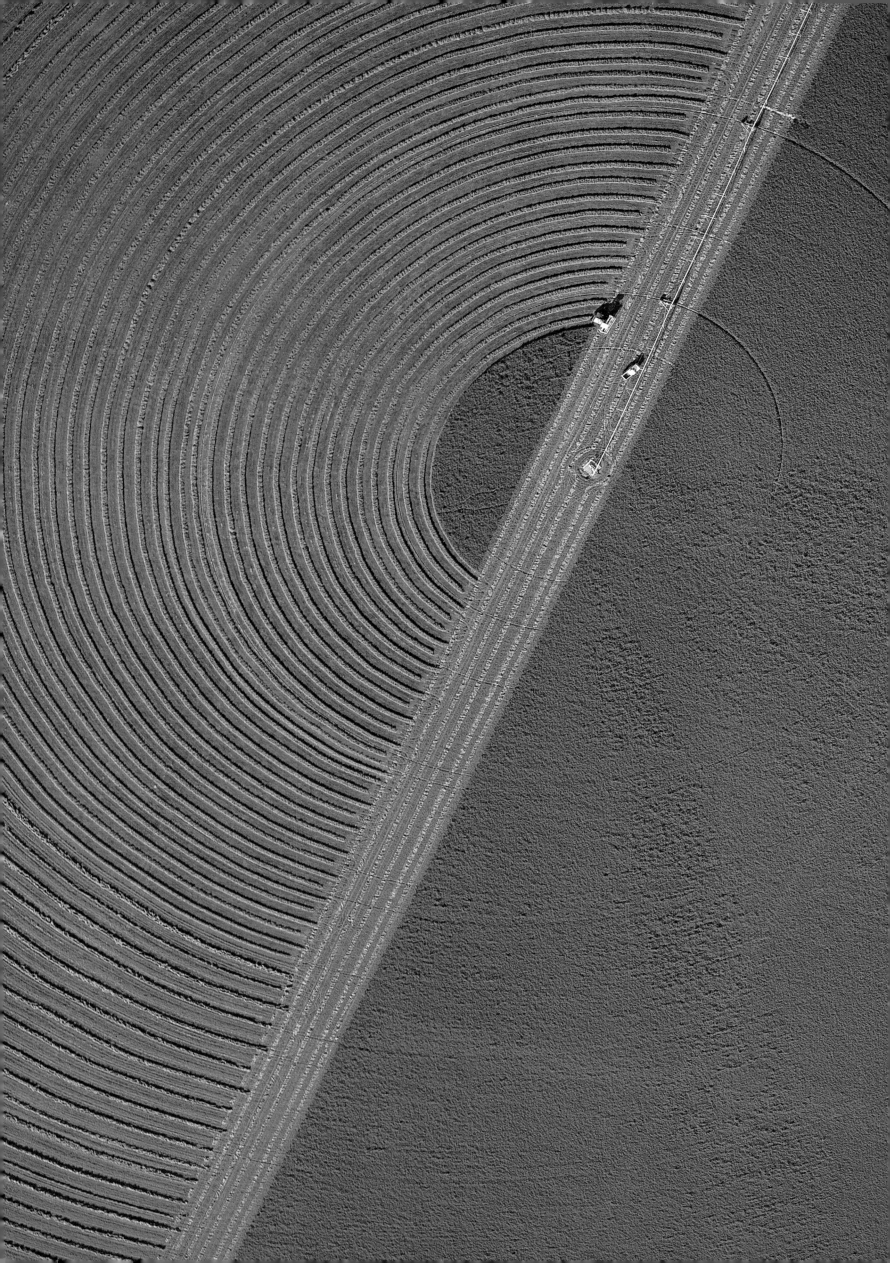

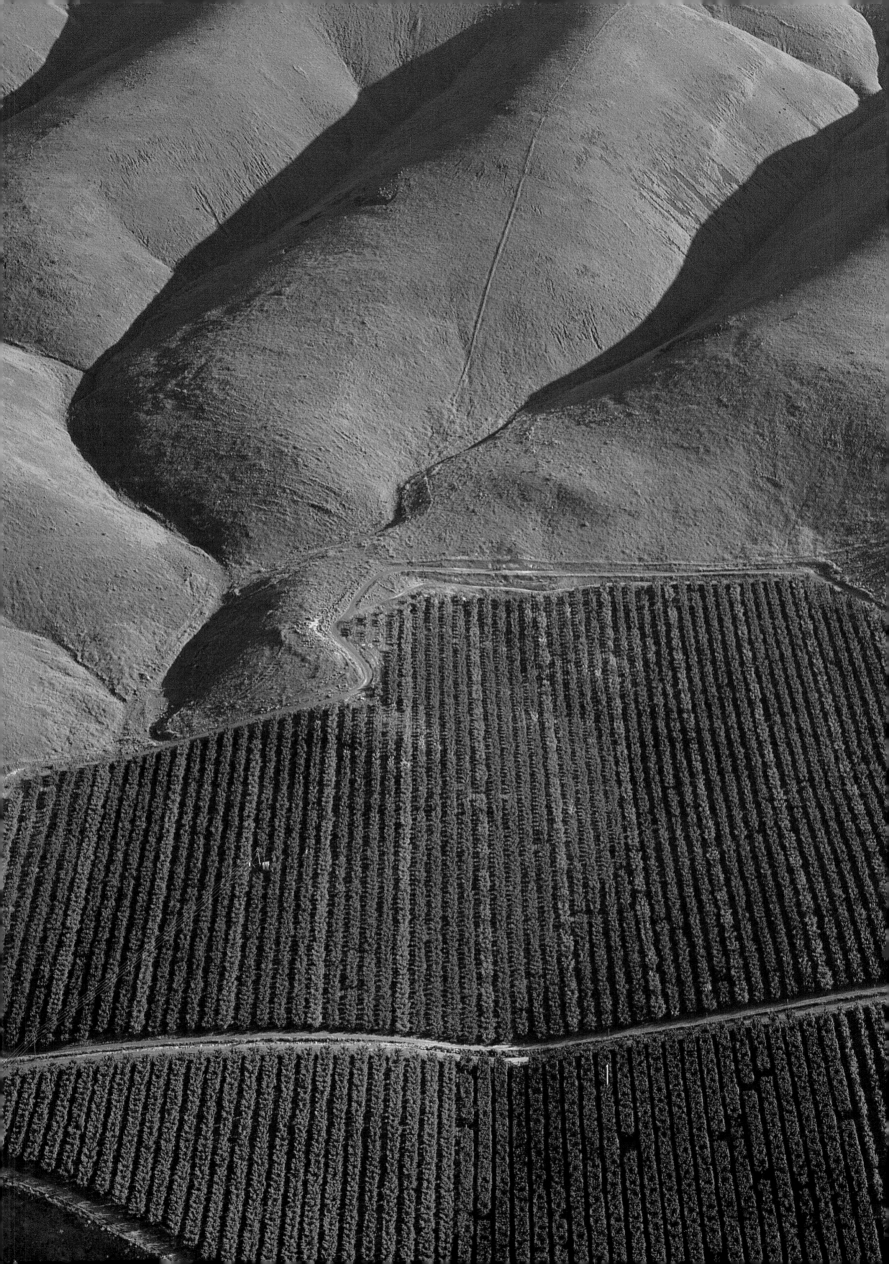

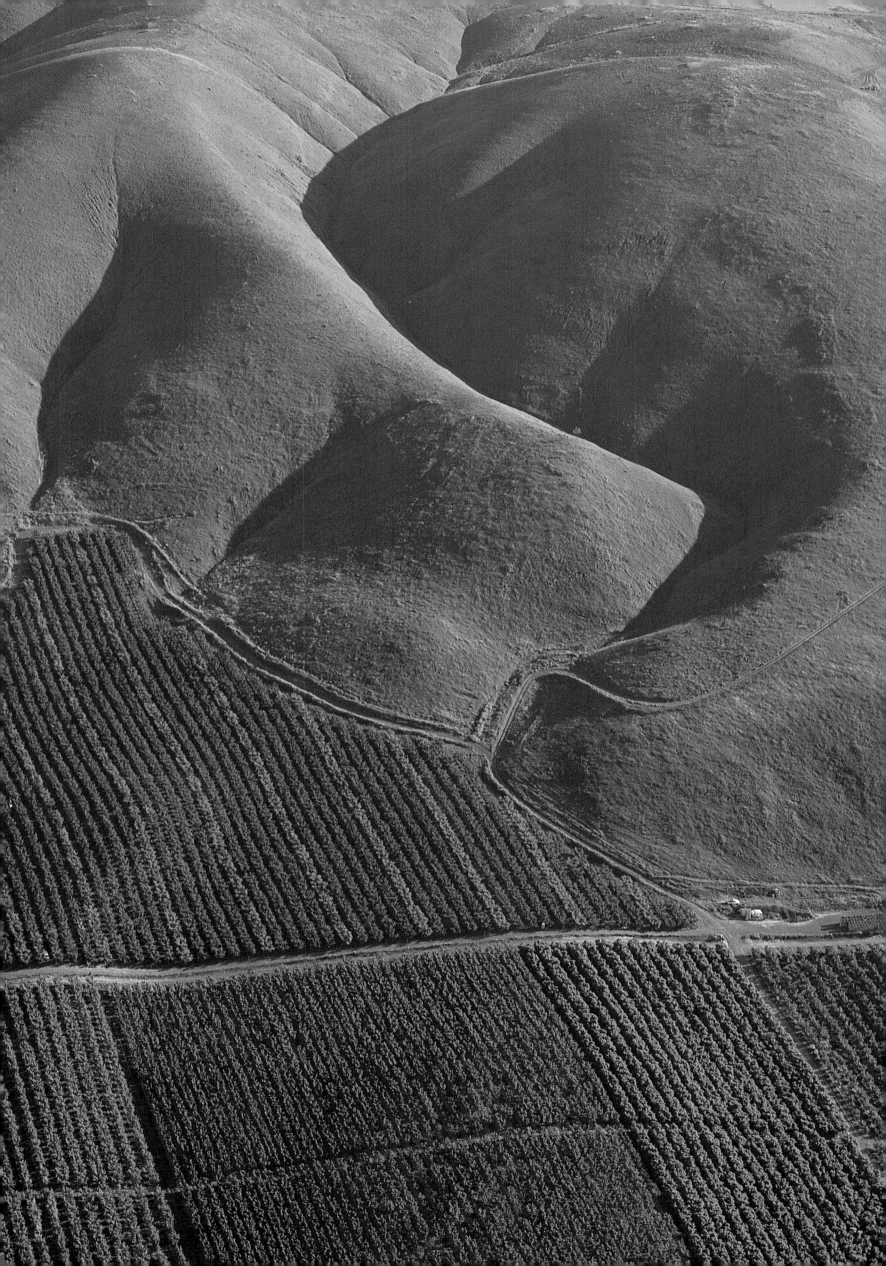

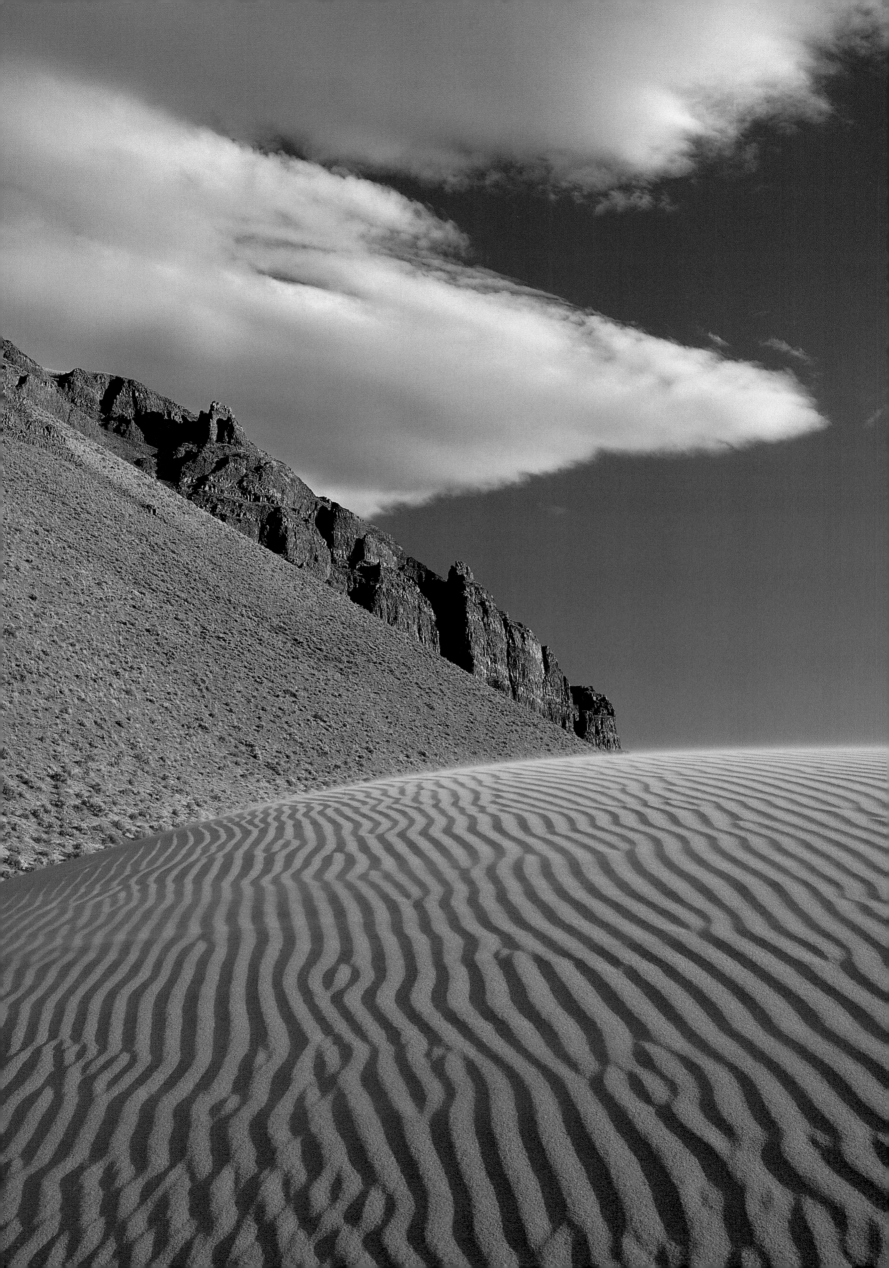

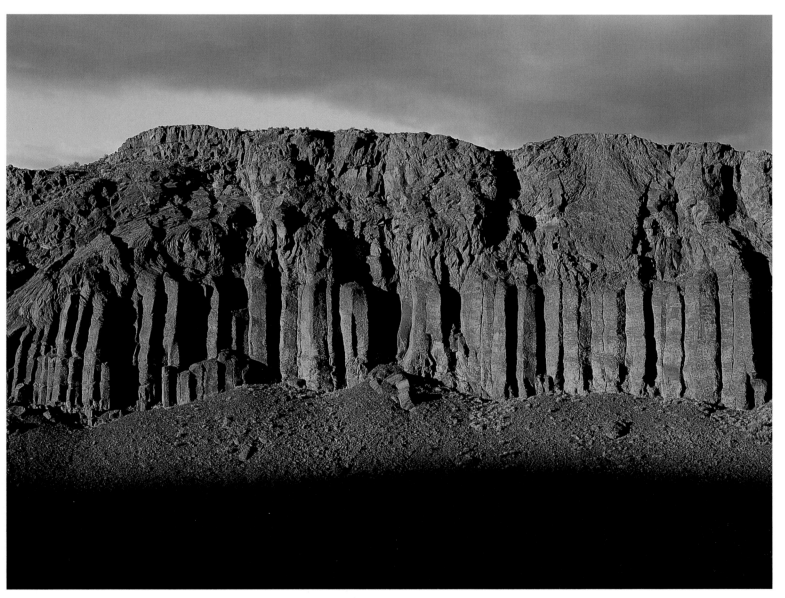

◄ Patterned sand dunes fill the lowland as cliffs of basalt march up into the Saddle Mountains, near Schwana in Grant County.
▲ Columnar basalt forms a rampart in the Quincy Lakes region.

Where I grew up — there are miles of these cliffs — I love them! They were formed during the ice age.

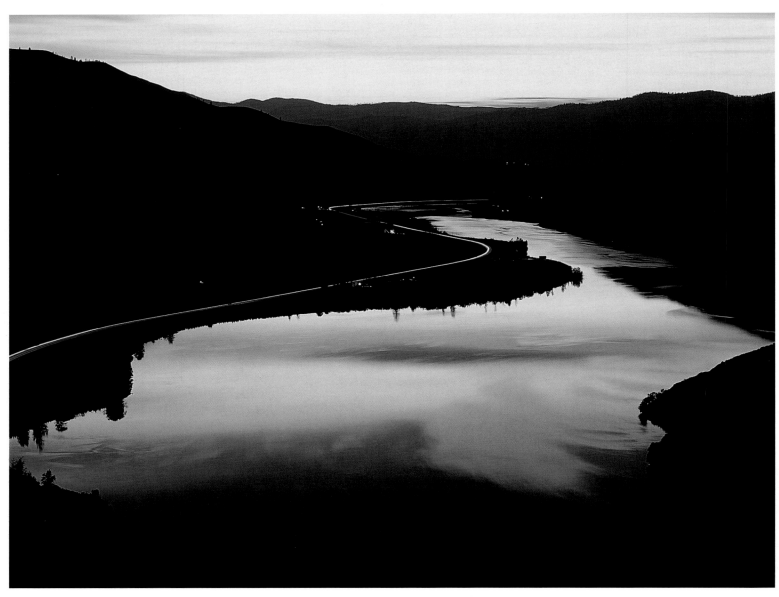

▲ A glowing ribbon of vehicle lights mimics the soft curve of the Columbia River near Chelan Falls Bridge in this time exposure.
► Assistant winemaker Frederique Vion, a native of France, makes a close check of the contents of oak tanks that are used to age red wines at Staton Hills Winery in the Yakima Valley.

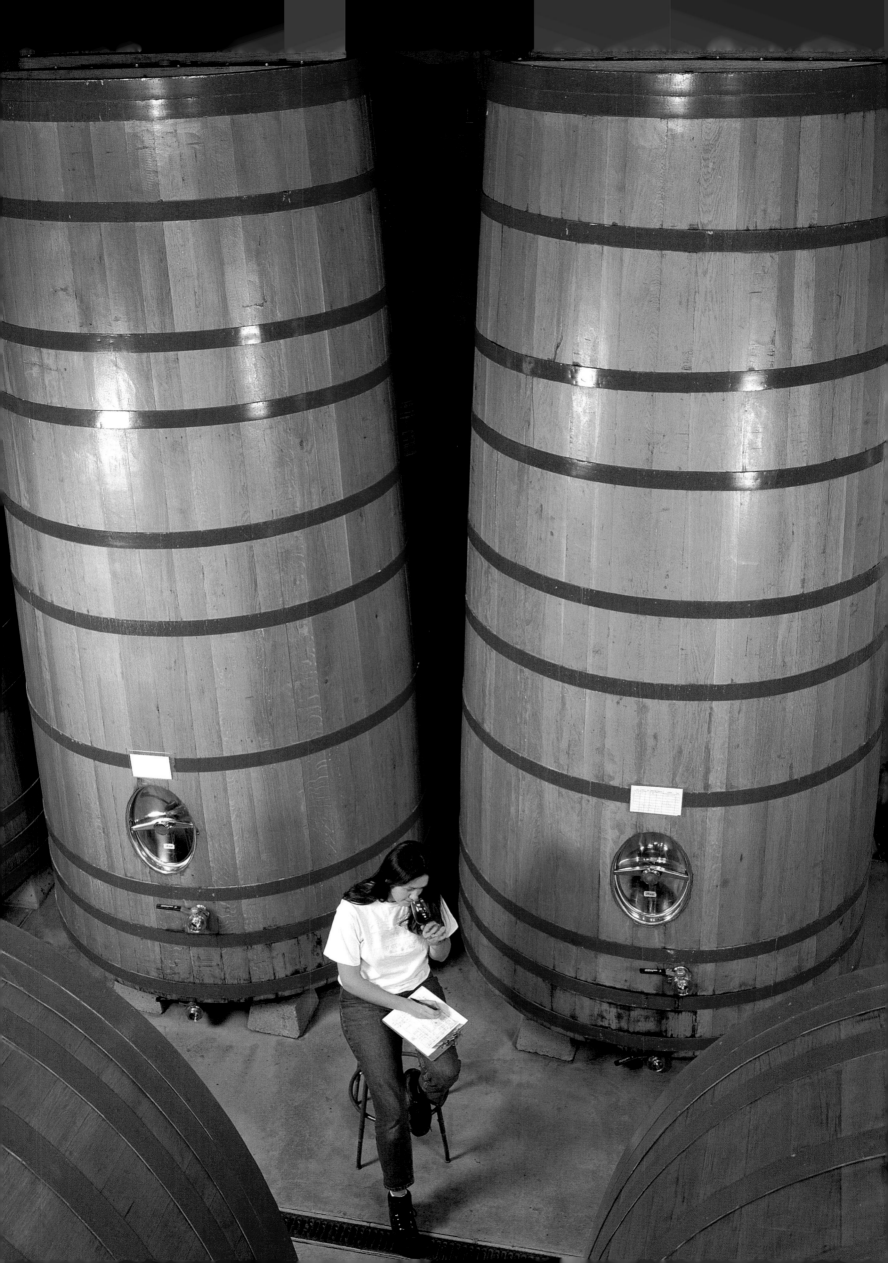

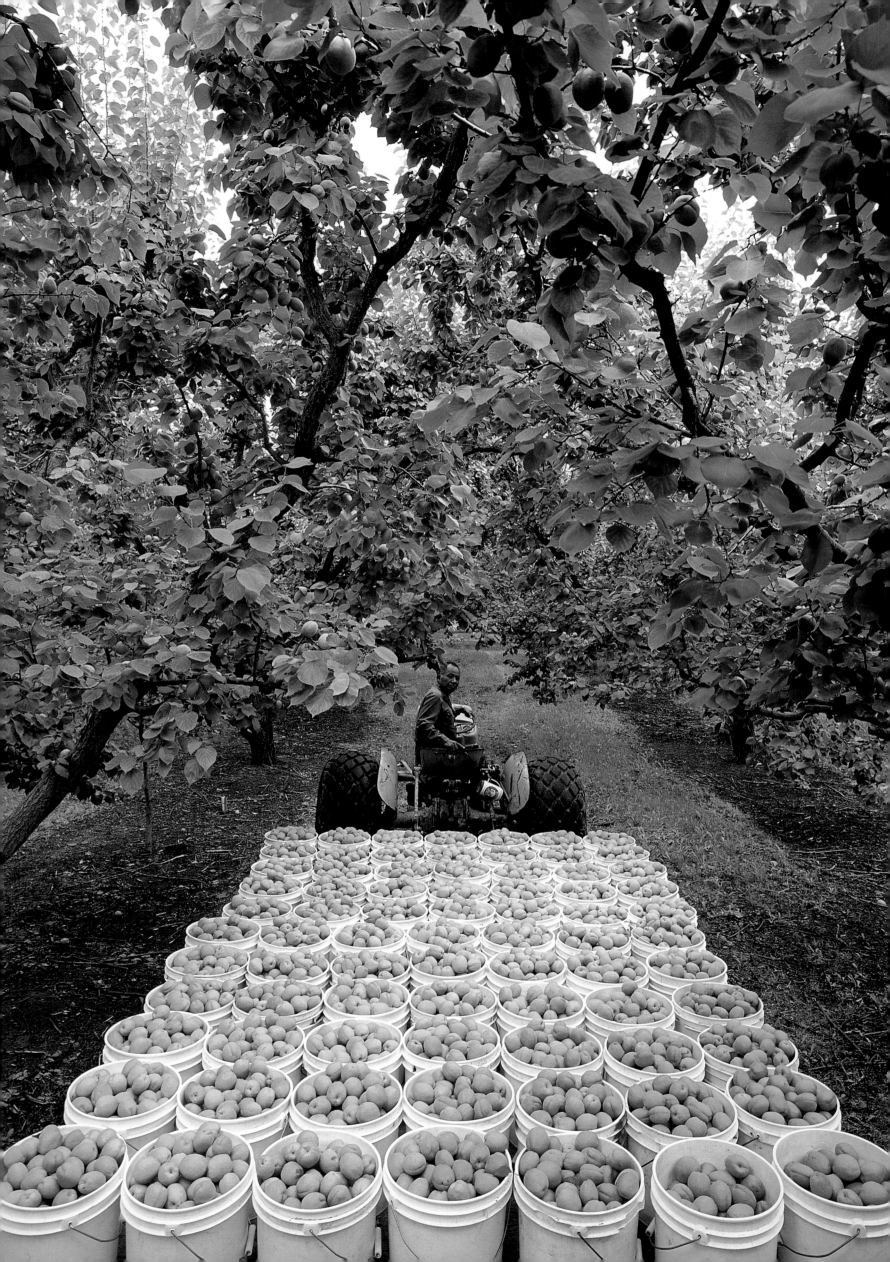

◄ Beneath a canopy of apricot trees, Francisco Lucero transports a bountiful harvest from the Edsel Reeves orchard at Baker Flats.
▲ Red delicious apples display their beauty near East Wenatchee.
►► The Burnett apple orchards thrive on the south shore of Lake Chelan, in the Twenty-five Mile Creek area.

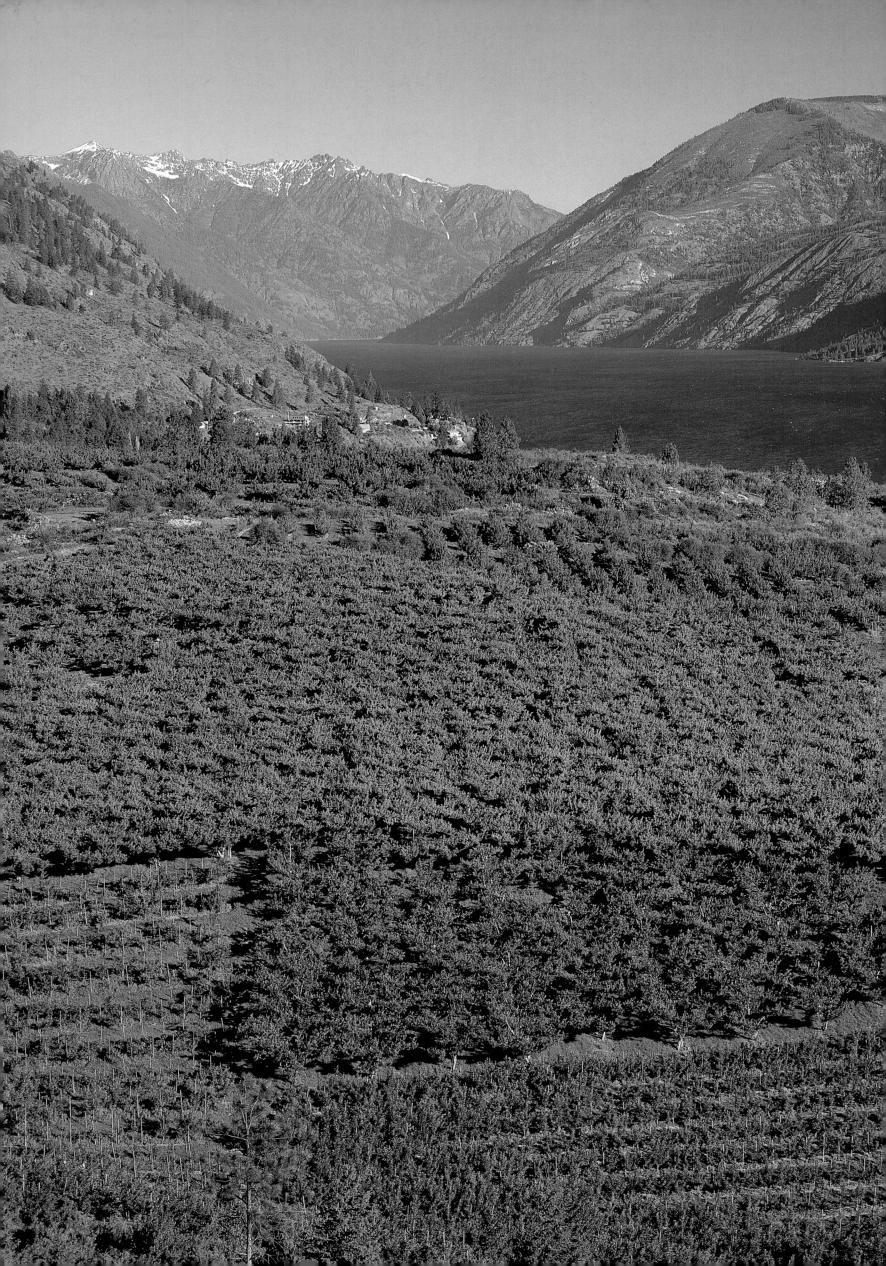

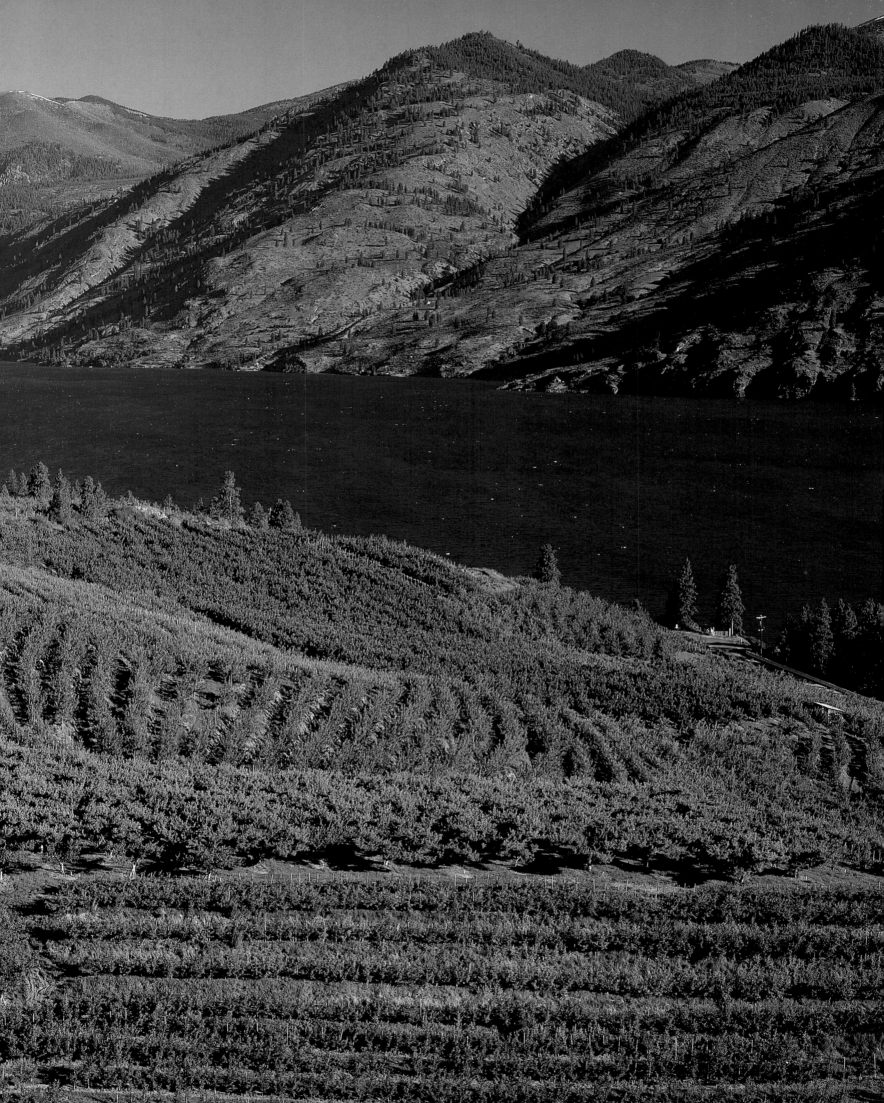

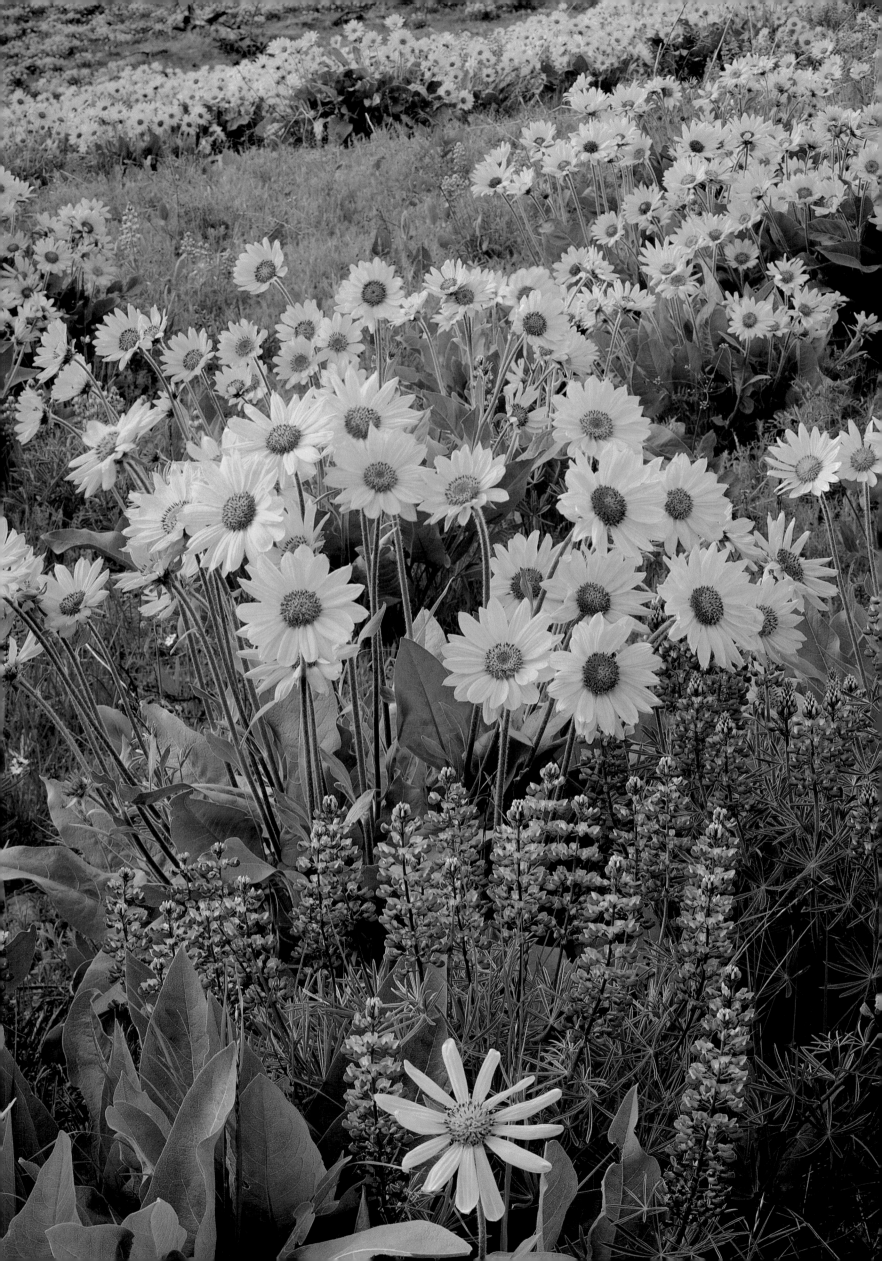

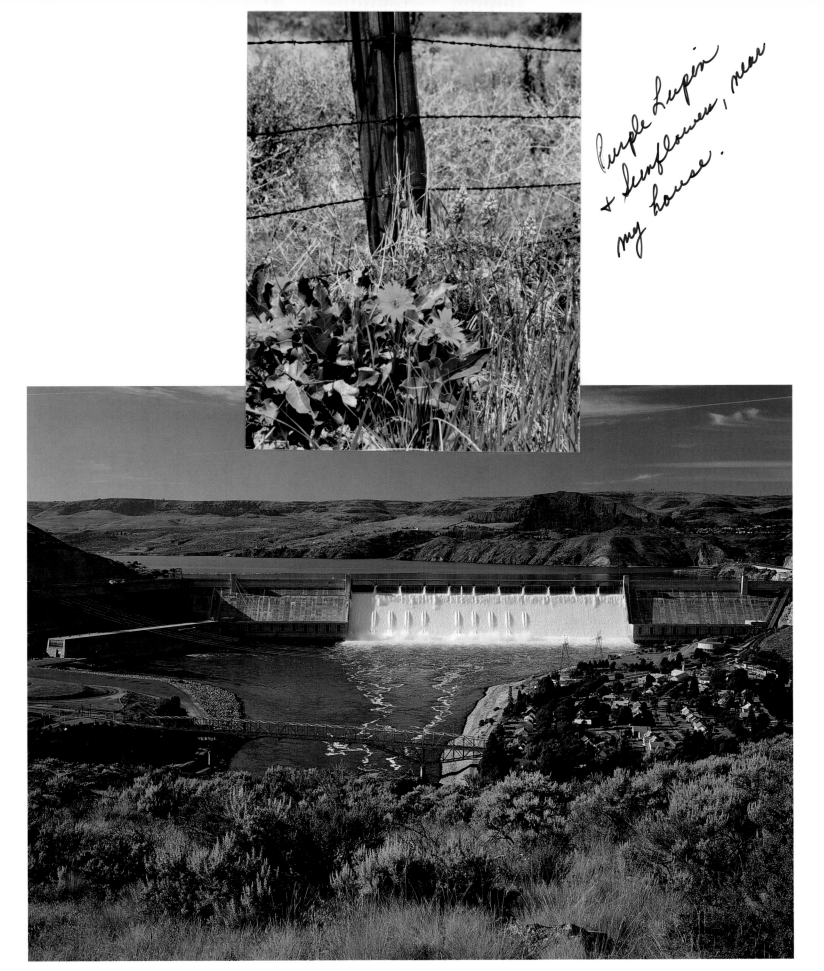

Purple Lupin + Sunflowers, near my house.

◄ Wildflowers—stalks of lupine and bright blossoms of arrow-leaf balsamroot—cover the Cascade foothills near Cashmere.
▲ Falling water turns the spillway to white at Grand Coulee Dam.

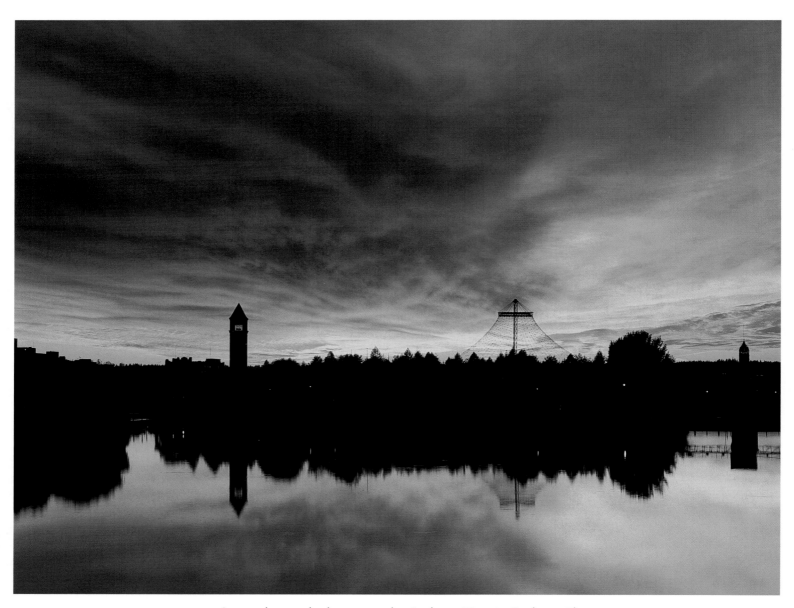

▲ Sunset throws shadows onto the Spokane River in Spokane. The tower of the Great Northern Railroad station rises to the left. The cross-shaped structure dates from the city's Expo 74 world's fair.
► Western larches in fall color stand out sharply from the firs and pines in Colville National Forest near Sherman Pass.

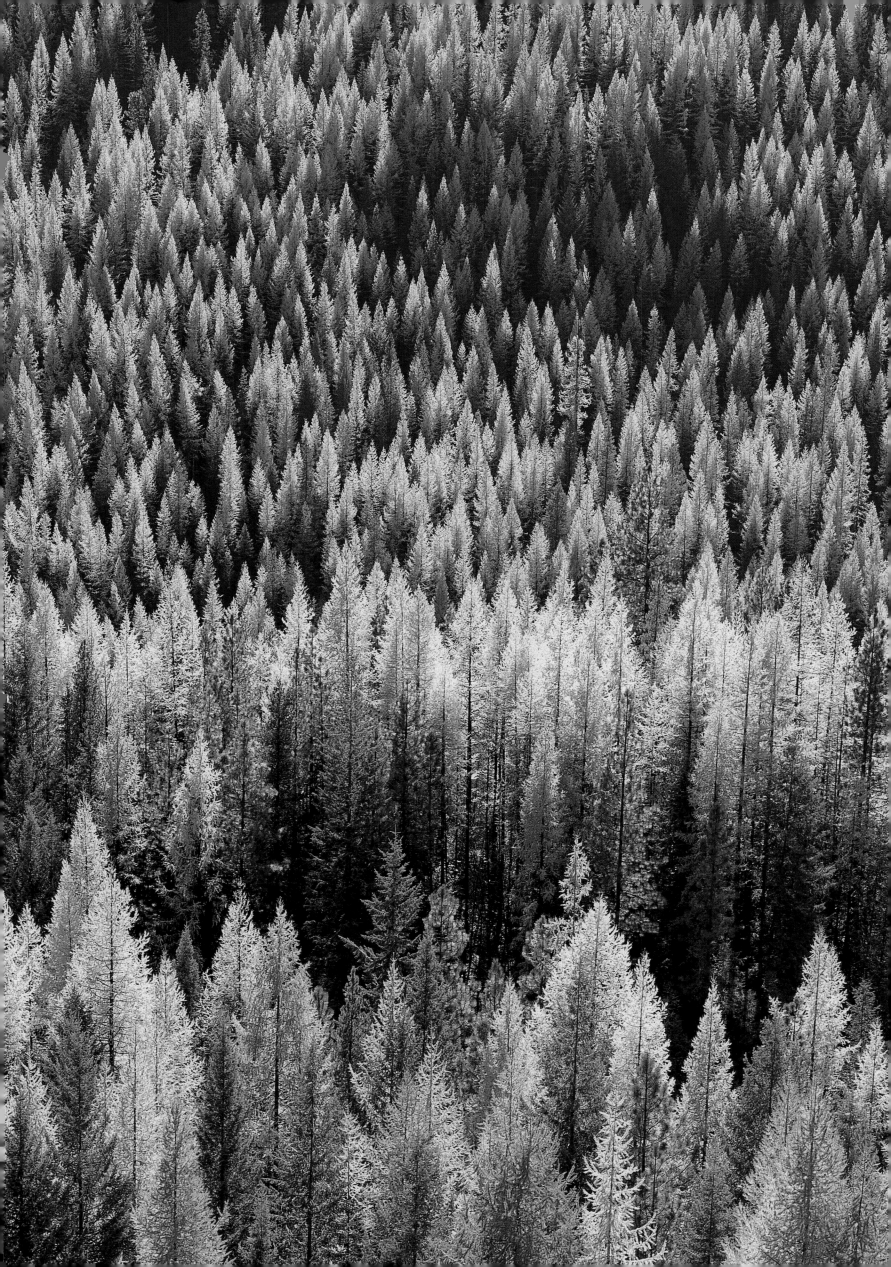

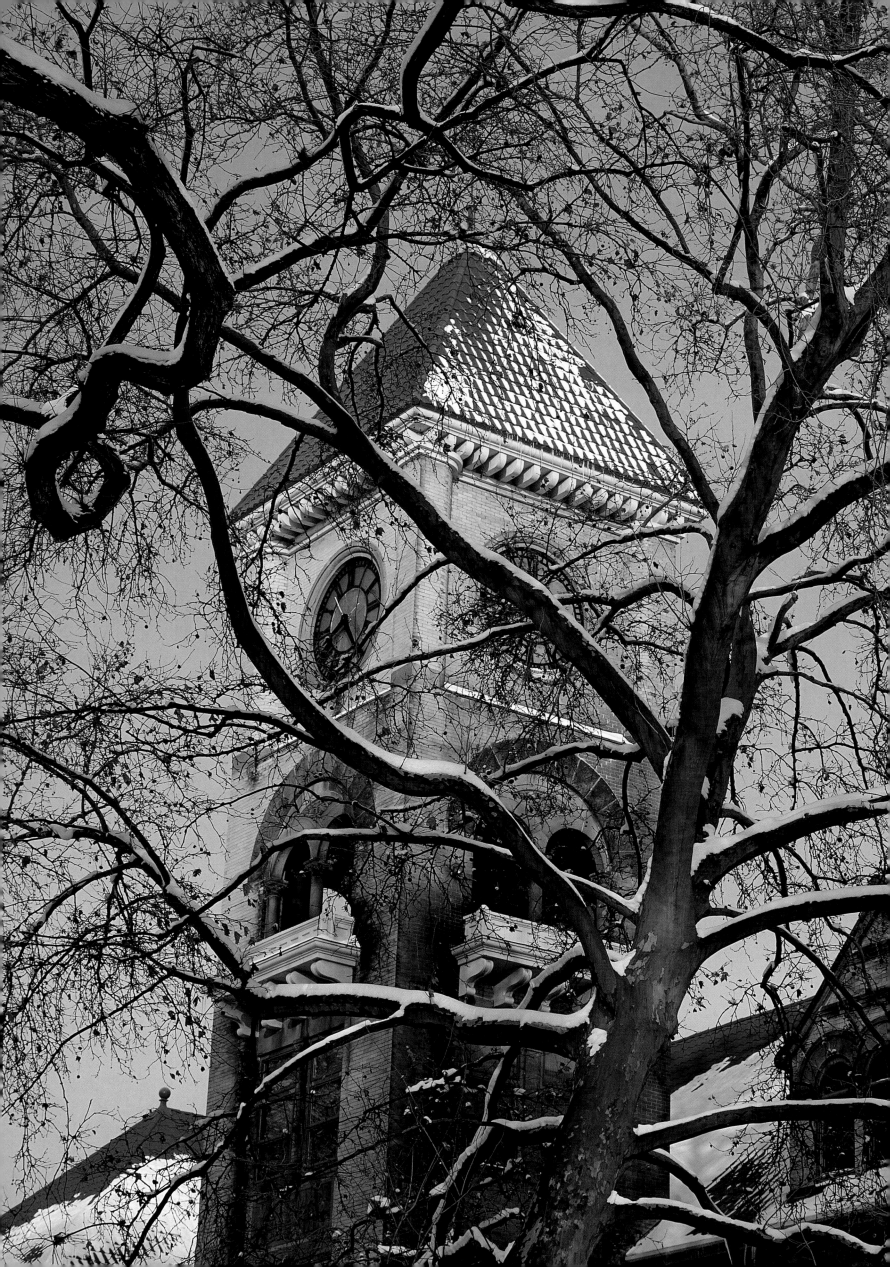

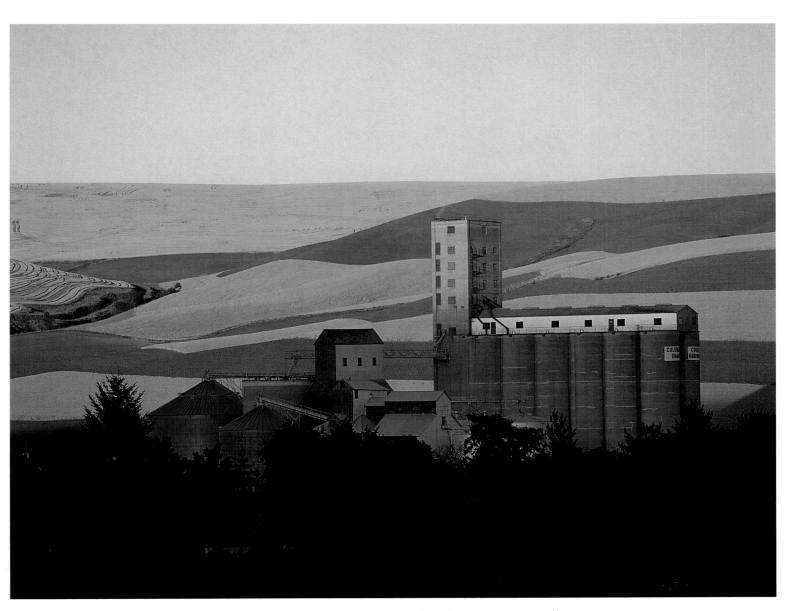

◄ The clock tower is a campus landmark at Whitman College, situated in the southeastern Washington city of Walla Walla. ▲ In the town of Dayton in Columbia County, a tall grain elevator stands ready to accept the bounty of the region's wheat harvests.

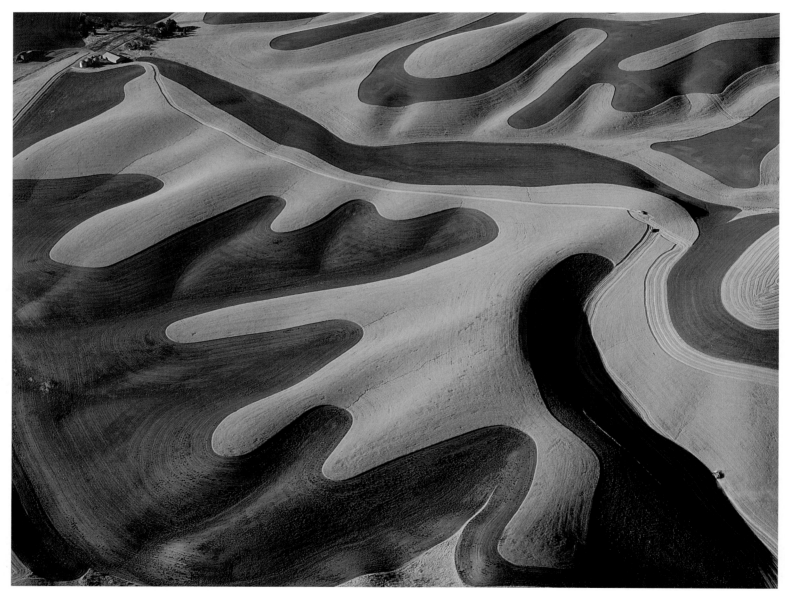

▲ Sinuous curves of color near Pullman distinguish boundaries between fields of partially harvested wheat (light color) and fields that lie fallow (dark brown). The green field grows a cover crop.
▶ Farmland sweeps gracefully into the distance above a century-old barn near Pomeroy, in Garfield County.

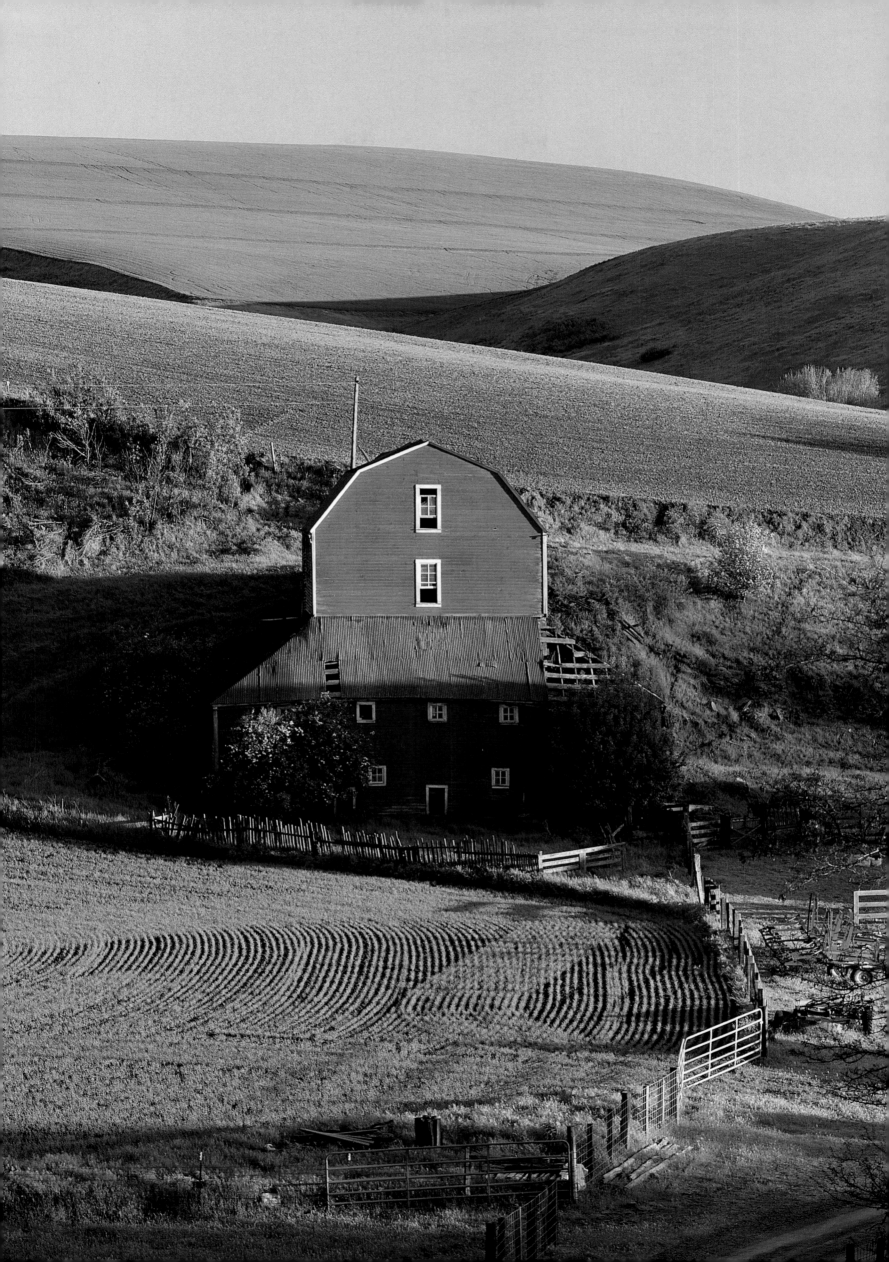

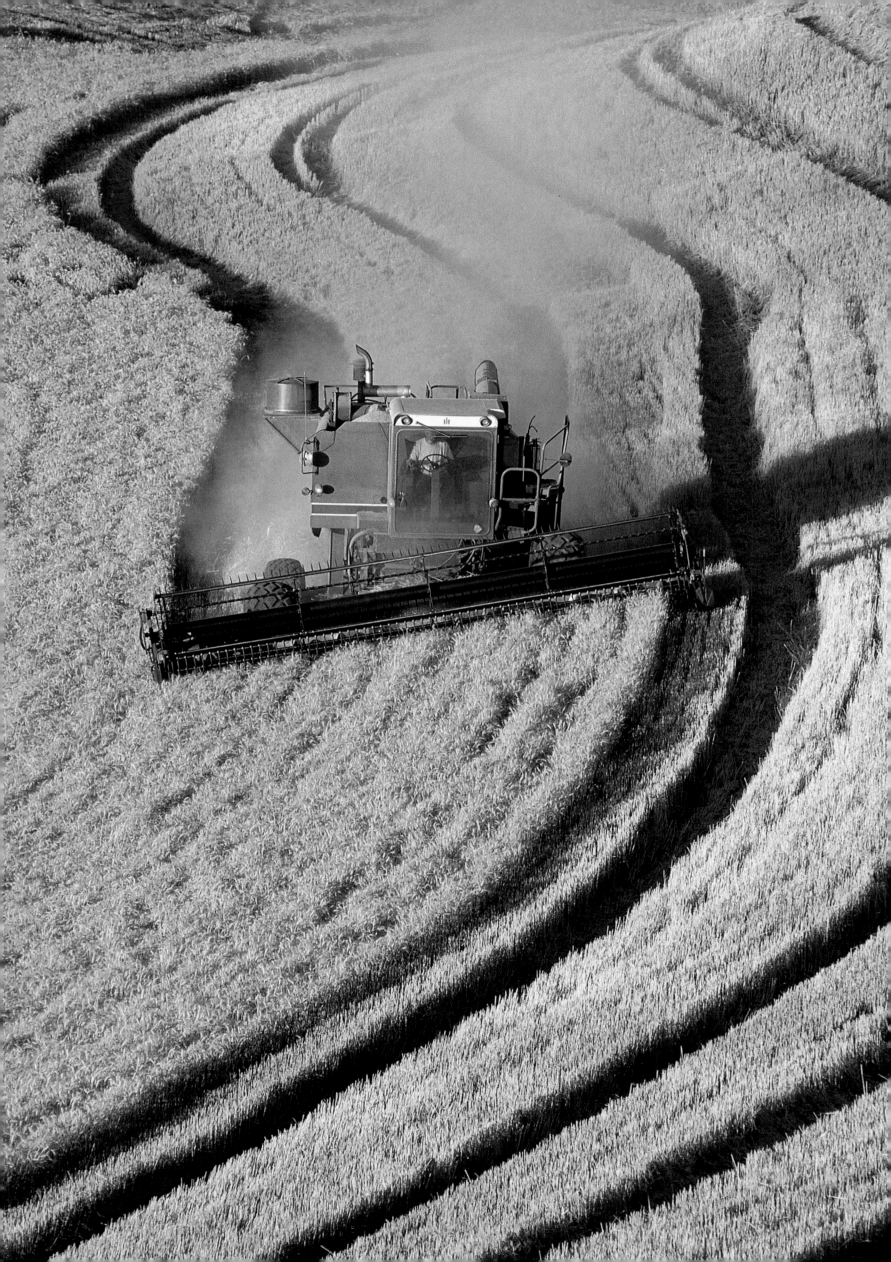

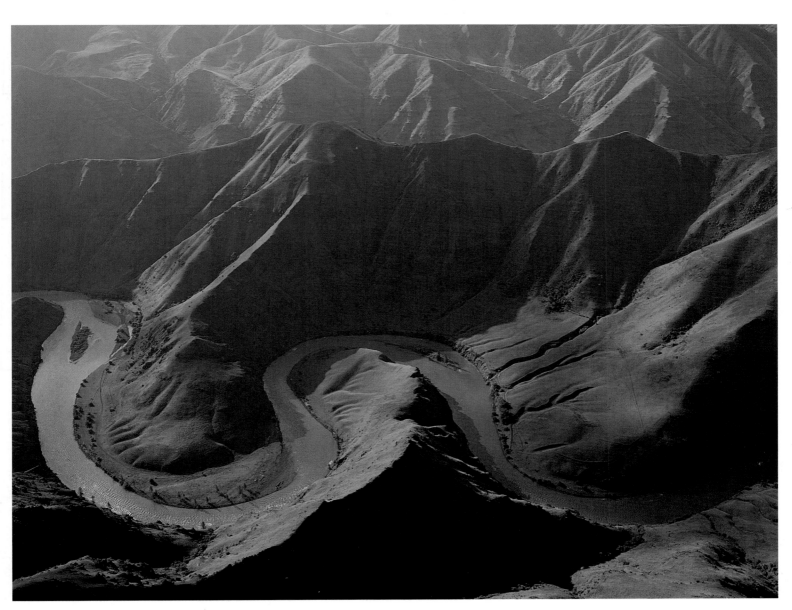

◄ A harvester winds its way through wheat fields near Diamond.
▲ The canyon of the lower Grande Ronde River flows half a mile
deep through hills of basalt in the southeast corner of the state.

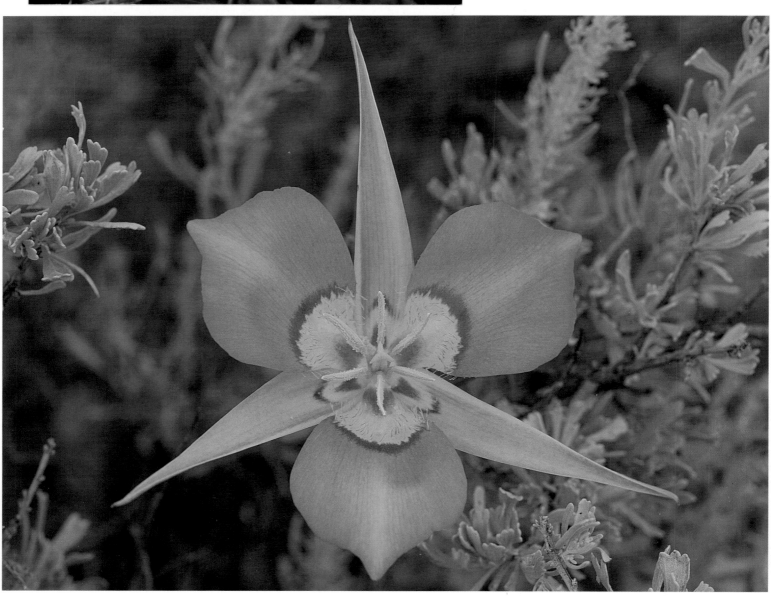

▲ A sego lily *(Calochortus nuttalli)* blossoms amid sagebrush near Banks Lake. Although most commonly a white flower, the sego lily, like its close relative the mariposa lily, can be found with vibrant magenta, lilac, or yellow tints.